THE ANIMALIERS

A Collector's Guide to the Animal Sculptors of the 19th & 20th Centuries

THE ANIMALIERS

A Collector's Guide to the Animal Sculptors
of the 19th & 20th Centuries

James Mackay

E. P. DUTTON & CO., INC. | NEW YORK | 1973

Published simultaneously in Canada by
Clarke, Irwin & Company Limited, Toronto and Vancouver
Library of Congress Catalog Card Number: 73-78331
SBN: 0-525-05498-7

Designed by Michael R. Carter
Text filmset by London Filmsetters Limited
Printed and bound in Great Britain by
Butler and Tanner Limited, Frome and London

Contents

Preface

Originally coined as a reproachful epithet for Barye by an art critic in the early 1830s, the term Animalier soon won wide acceptance by the general public, art-lovers and the artists themselves who specialised in the modelling or carving of animal sculpture. A more scientific, less unfeeling approach to the animal world in the early years of the nineteenth century, together with the more realistic, less academic styles in painting and sculpture, combined in the work of the Animalier school to form the figures and groups which attempted to show animals and birds as they really were. The realistic modelling of animals, however, was not enough; and many of the Animaliers went farther and tried to convey the emotions and mental characteristics of their subjects. In this they generally succeeded far better than their contemporaries working in oils or pastels. The mawkish sentimentality which mars so much of the paintings of animals in the nineteenth century fortunately never permeated the work of the Animalier sculptors. Their dedication to sculpting only what they saw, without projecting the whimsicality of human emotions in their work, has saved the sculpture of the Animaliers from the fate which has befallen the pictures by animal painters of the same period. Only Fratin, with his humanised bears, transgressed the unwritten law of the Animaliers.

The hey-day of the Animalier was the period from 1830 to 1890 and the home of the best Animalier sculpture at this time was France, the land of Bayre and the Bonheurs, of Frémiet and Fratin, of Mêne and Moigniez and many others. Their subjects ranged from the humble and domestic–dogs, cats, sheep and cattle–to the wild animals–lions, tigers, panthers, jaguars, antelopes and elephants. A major aspect of their work was the sculpture of horses, of the hunting field and the race-course, and a large part of their output in this *genre* was destined for export to Britain or the United States. A certain amount of Animalier sculpture was produced elsewhere in Europe, in Germany, Austria and Russia, but surprisingly little in Britain. On the other side of the Atlantic the American sculptors–Kemeys, Potter, Proctor, Borglum and Remington–developed their own highly distinctive style. To them equestrian sculpture meant cowboys and Indians, and the animals they modelled were the indigenes of the Old West–cougars, coyotes, elk and bison.

The movement away from realism and naturalism in sculpture at the end of the nineteenth century also affected the Animaliers and made itself manifest in the impressionism of Degas, Pompon, Bugatti and Gaudier-Brzeska in France, and by Gaul and Sintenis in Germany. In general, however, the first half of the

7

twentieth century produced little sculpture in the 'pure' Animalier tradition. Matisse, Braque, Picasso and many others, working in the cubist or abstract styles, have produced sculpture which derives its inspiration or conception to some degree from the animal works, but the criterion for the inclusion of twentieth century sculptors has been their attempt to depict animals as they are, or to convey the impression of animals in characteristic mood or movement.

During the past decade there has been a heartening return of interest in animal sculpture. Since the Exhibition of Animalier Bronzes by Mallet of Bourdon House in 1962 antique dealers and art galleries have been increasingly pre-occupied with this long-neglected aspect of art, and this, in turn, has encouraged the younger generation of sculptors, particularly in Britain, to take animals as their subjects. Although the main theme of this book is the work of the Animaliers in bronze, it deals also with their sculpture in other media, while their monumental statuary as well as the more commercial small table bronzes is also discussed.

JAMES A. MACKAY
LOCHMABEN
DUMFRIESSHIRE

Acknowledgements

I became interested in the work of the Animaliers as a result of frequent visits to Sladmore Farm where Jane and Harry Horswell had combined their interests in breeding ponies and collecting a wide variety of animals and wild-fowl with a deep appreciation of birds and animals as sources of inspiration in art. I went there not only to admire their collection of humming-birds (one of the finest to be found anywhere in Britain) but their collection of Animalier bronzes, the result of over twenty years endeavour in a field which was generally unconsidered or overlooked by dealers and other collectors at the time. In 1968 the Horswells opened the Sladmore Gallery in Bruton Place, Mayfair, and since then have gone from strength to strength with the rising tide of interest in animal sculpture. For this they can take no little share of the credit, for their exhibitions devoted to the work of the Animaliers have undoubtedly done a great deal to stimulate the interest now shown in this subject. Without the unstinted help and active encouragement of Jane and Harry Horswell I could never even have contemplated this book, far less brought it to completion. My thanks are also due to Miss Victoria Horswell and the staff of the Sladmore Gallery for their patience and attention at all times.

I would also like to thank Aylmer Tryon of the Tryon Gallery, for his help with regard to several of the present-day Animaliers, and to Jonathan Kenworthy I am indebted not only for the many pleasant hours in his company but also for shedding useful light on many of the artistic and technical aspects of animal sculpture today.

I have enjoyed the close co-operation of the major auctioneers in the Animalier field Messrs Sotheby, Wilkinson and Hodge, Messrs Christie, Manson and Woods, and Messrs King and Chasemore, have all supplied me with information, not to mention many of the photographs reproduced in this book. I am also grateful to the staff of Clark, Nelson Ltd for additional material relating to Sotheby's and the Tryon Gallery for whom they act as public relations officers.

Many of the black and white photographs were supplied by the Sladmore Gallery. I would like to express my thanks to Alan Holmes of Spinfield Mount, Marlow and Peter White of the Cavendish Photographic Co, London who took these photographs. The colour photographs were taken for me by William J. Grout by permission of the Sladmore Gallery.

Finally I must record my thanks to Joyce O'Halloran who typed the manuscript and assisted with secretarial matters arising out of the compilation of this book.

9

Chapter I

The Origins of Animal Sculpture

Although sculpture is one of the oldest arts known to man it is interesting that comparatively little animal sculpture in the pure sense was produced for almost 2,000 years. Numerous examples exist of animals sculpted on their own in classical times, ranging from the cats, monkeys and falcons of Egypt and the lions of Assyria, to the horses of Greece, the she-wolf motif of the Etruscans and the Roman dogs. After the fall of the Roman Empire, of course, sculpture in general, along with the other plastic arts, languished in oblivion, but when the art of bronze-working was revived in Italy during the Renaissance the artists and craftsmen of that period were primarily concerned with the depiction of the human form. Animals were regarded as of secondary importance, usually only as a foil to the human figure.

Equestrian statues were immensely popular from Renaissance times onwards, ever since Filarete set the trend by producing a reduced copy of the classical statue of Marcus Aurelius in 1465. The horse, more than any other animal, is to be found in European sculpture, but usually relegated to a secondary role – a fashionable accessory, but none the less a symbol of status and virility. Equestrian statues were usually cast in bronze rather than sculpted in stone, since it was well nigh impossible to produce a satisfactory statue in the latter medium. Even a figure of a horse, with all four legs firmly resting on a solid foundation, would have set up stresses and strains which stone could not have borne. A figure of a prancing or charging horse, moreover, would have been quite impracticable in stone, whereas the elastic qualities which bronze possesses made it the ideal medium for equestrian sculpture.

Although the Italians produced some notable bronzes in the *genre*, from Donatello's magnificent statue of Gattamelatta to Riccio's celebrated shouting horseman, it was undoubtedly the French who brought the art of the equestrian statue to its highest development. Desjardin, Lemoyne, Girardon and Bouchardon have left us notable examples of the French kings on horseback, while Falconet's colossal Peter the Great stands in Leningrad to this day. Animals also played an important part in quasi-classical groups ranging from Bertoldo's Bellerophon taming Pegasus to Jean Goujon's spirited study of Diana and the Stag. In these cases, however, the animals, though anatomically correct, are not the focal point of the sculpture.

It is not true to say that animals did not receive individual treatment at the hands of sculptors prior to the 1830s. There are numerous instances, by no means isolated, from the Italian Renaissance onwards, of animals sculpted in

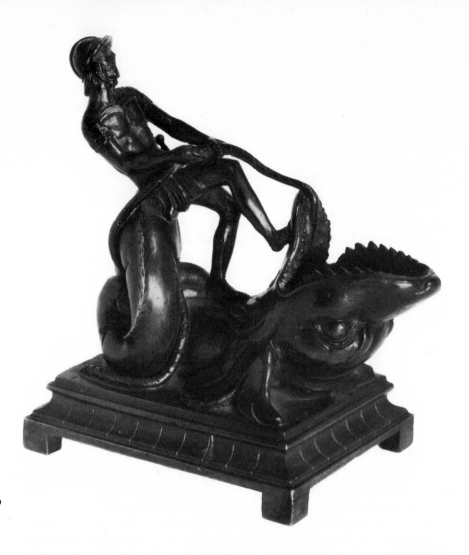

North Italian bronze group
of Orlando and the ark 6″
late 16th cent.

bronze *per se*. Small boxes in the shape of animals, serpents or fishes were
fashioned by Riccio and other sculptors of the Paduan school in the sixteenth
and seventeenth centuries. Small animal bronzes of this sort were often adapted
to some utilitarian purpose, such as candle-sticks, oil-lamps, ink-pots and
other household objects. The medieval aquamaniles (table vessels containing
water for washing the hands) were often in animal form, and lions and dogs
were favourite subjects for this treatment. The aquamanile tradition may well
have inspired the elaborate table fountains popular during the German
Renaissance. These massive and ornate objects, many of which have been
preserved in museum collections, often were embellished with hounds, stags,
goats, dragons, bulls, birds and even elephants and unicorns, more or less true
to nature. These elaborate fountains were a speciality of the bronze-workers
of Augsburg in the mid-sixteenth century. The only purely animal subjects in
bronze, produced without apparent utilitarian motive, were figures of lions,
unicorns, horses and other animals which seem to have had some heraldic
significance. Here and there we can detect a faint glimmer of the ideals which
came to full fruition under the Animalier school in the mid-nineteenth century,
but in general bronzes of animals on their own were not cast purely for the
love of it and invariably there was some functional or heraldic purpose.

12

The closest approach to the casting of bronze animals as works of art in their own right came in the latter years of the sixteenth century when the Flemish-born artist, Giovanni da Bologna (or Jean de Boulogne), working in Florence, produced a number of small bronzes of animal figures. The horses and bulls which came from his workshop were completely naturalistic in concept and execution. Although Giovanni da Bologna is best remembered nowadays for his allegorical and neo-classical figures of Mercury, Apollo, Venus and the Four Seasons, his prancing horses and charging bulls are now beginning to attract more attention. Giovanni da Bologna was responsible for the strong current of naturalism which pervaded the sculpture of the late sixteenth and seventeenth centuries, though it was seldom so highly developed by his contemporaries and successors as in his own case. Giovanni Bandini's group of Juno and the Peacock, for example, is noted for the lively modelling of the bird; but it should not be forgotten that in this instance the peacock was secondary to the figure of Juno. For a fountain in the gardens at Castelli Giovanni da Bologna sculpted a group of bronze birds which were so life-like that he was accused of having cast them from real birds. The only other artist who is noted for his bird studies was Caspar Gras, a seventeenth century German sculptor who produced a series of bronze birds for the Holy Roman Emperor, several of which are now preserved in the Bayerisches National-museum in Munich.

From the middle of the seventeenth century onwards bronze sculpture be-came increasingly stereotyped. Human figures, particularly in classical poses, became more fashionable and naturalism gave way to a formalised, academic outlook which restricted the subject matter as well as the manner in which it was presented. Nevertheless, while animals ceased to be regarded as fit subjects for bronzes on their own they often formed part of the decoration of useful articles such as fire-dogs and clock-mounts. This was especially true in eighteenth century France where fire-dogs elaborately decorated with hounds, boars, stags and other hunting subjects became very popular. Here again, the heraldic element was very strong, and more exotic beasts such as lions, tigers, griffins and elephants were often incorporated in ormolu clock-cases, candle-sticks and table centre-pieces.

Curiously enough, while animals were almost entirely neglected by sculptors they continued to be regarded as a proper subject for painting. Artists, from Dürer onwards, often showed an astonishing anatomical knowledge of animals in paintings, drawings, woodcuts and etchings. Rembrandt drew lions, tigers and elephants which he studied in menageries, Desportes painted hounds out hunting or at rest, Stubbs inhabited his landscapes with horses. Indeed, dogs and horses were perennial favourites in oils for generations before they received more than passing attention in bronze.

Philosophers in the seventeenth and eighteenth centuries speculated on metaphysics and the possible existence of beings superior to men. Eventually the pendulum swung in the opposite direction and an increasing amount of time and energy was devoted to the study of lower forms of life than mankind. Not until the early years of the nineteenth century, however, were scientists and philosophers prepared to admit that man could have any affinity or con-nection with the animal world. Darwinian theories on the origin of the species, revolutionising the whole concept of man's evolution, came at a time when people were beginning to acquire an interest in natural history. Linnaeus opened up new vistas in his examination of the nature of plant-life while, in England in the closing years of the eighteenth century, the elder Darwin seized on the romantic aspect of vegetable existence and tried to give it poetic expression. Cuvier was sufficiently practical and conservative to escape the hostility of those wedded to the narrower view that looked only towards heaven.

Lamarck, on the other hand, was spurned and rejected by his contemporaries on account of his radical views which, developed by Charles Darwin and Alfred Russell Wallace, offered a scientific explanation of evolution.

The early years of the nineteenth century were a time when mankind was beginning to accept that animals were capable of feelings, that certain birds were sensitive to music or could produce musical sounds, or even reproduce the human voice, that animals and birds, even some fishes, could construct homes for themselves, and there was even some speculation that animals might choose a partner with some regard to their beauty. Admittedly this degenerated into a somewhat whimsical view of the animal world, in which creatures were invested with human characteristics. This mawkish, over-sentimental view of nature is seen at its worst in some of the works of Landseer and his imitators. While much of Landseer's work has stood the test of time, and he is justifiably recognised as a great animal painter on account of his often acute observation of nature, his paintings which used animals to express abstract human concepts tend to inspire ridicule nowadays.

Occupying a position midway between Stubbs and Landseer came the Romantic animal painters of the late eighteenth and early nineteenth centuries, of whom Gericault and Delacroix were the prime exponents. Jean-Louis-Andre-Theodore Gericault (1791–1823) was schooled in the academic traditions of David and Guerin, but by 1810 had begun to produce canvasses devoted to equestrian subjects which, while nominally portraying the human element, tended more and more to emphasise the animal. The first major breakthrough in this direction was his splendid equestrian portrait of *M. Dieudonné, Lieutenant aux Guides de l'Empereur*, which was exhibited at the Salon of 1812. Although this painting was greatly admired at the time, it was also savagely attacked by some critics. Yet the consensus of opinion favoured Gericault, who was awarded a gold medal for it. Other pictures, such as his *Hussard chargeant* and *Exercice à feu dans la plaine de Grenelle* exhibited in 1814, established him as an animal painter first and foremost. After the Napoleonic Wars he switched to less martial subjects and during a sojourn in England produced some excellent studies of horses from Epsom and the Derby. It is interesting to speculate what Gericault might have done in later years had he not met such an untimely death at the age of 32. Shortly before his death, however, he sculpted two groups, Ox attacked by a Tiger and Man stopping a Horse. There is no doubt that, had he lived, Gericault would have exerted a very strong influence on the development of the Animalier school of bronzists. As it is, his influence, though indirect, must not be under-estimated. The so-called 'Pheidian' style of neo-classical sculpture which Gericault practised, and which was noted for its realism breaking free from academic stereotypes, made a considerable impact on the Animaliers and also served to inspire Rodin and the early Impressionists.

Ferdinand-Victor-Eugène Delacroix (1798–1863), seven years younger than Gericault, long outlived him and developed the romantic realism which he had done so much to initiate in painting. By the middle of the nineteenth century, when the animal as a popular art subject had reached its zenith, Delacroix was supreme among painters in this *genre*. At the great Exposition Universelle, held in Paris in 1855, Delacroix had an entire gallery to himself, devoted to his animal studies. As well as the more orthodox subjects – dogs, cattle and horses – Delacroix produced paintings and lithographs of exotic animals, largely as a result of his travels in North Africa following the annexation of Algeria by France in 1830. Lions and serpents, combats between lions and tigers, lions attacking Arab horses, lions fighting men or even crocodiles, Daniel in the lions' den, lionesses at their ease – these and many other subjects were recorded on canvas by Delacroix. A characteristic of all

14

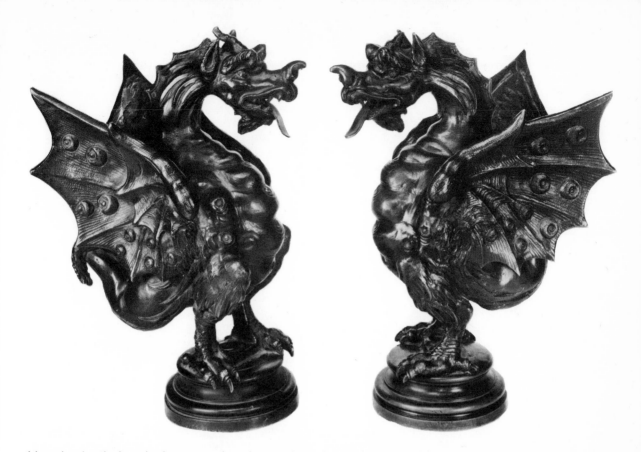

Pair of Italo-Flemish bronze
dragons 8″ late 16th cent.

his animal paintings is the tremendous impression of wild energy, and it was
this characteristic which highlighted the best work of the animal sculptors.
It has often been said that the Animaliers owed a great deal of their inspiration
to Delacroix and while this cannot be denied it is only fair to point out that
this inspiration was not in one direction alone. During the greater part of his
working life Delacroix was contemporary with Barye, Fratin, Mêne and the
greatest of the Animaliers and it would have been surprising if something of
their work had not rubbed off on his. Delacroix was known to be a great
admirer of Barye and an anecdote, recounted by Barye's biographer, Arsène
Alexandre, is worth mentioning in this respect. Barye presented to Lefuel, the
architect of the Louvre, two watercolours of tigers, before which Delacroix
used often to stop in admiration; and sometimes he took the trouble to pause
and make a rapid sketch of them. Occupied in a way so flattering to their
maker, considering the mastery he has shown in painting animals, Delacroix
exclaimed, "I shall never be able to give the curl to a tiger's tail as that fellow
can!" An examination of the bronzes sculpted by Barye of the various mem-
bers of the cat family bears out the truth of that remark. No artist before or
since Barye has ever rendered quite so well the expressions that cats, tigers,
lions and other felines register by the sinuous movements of their tails. It is
recorded that Barye and Delacroix, in their student days, visited the menagerie
at a fairground and spent many days sketching the wild beasts there. From
this early period date several watercolours and drawings by Delacroix later
utilised in his superb Lion about to attack a Serpent and the equally spirited
Tiger and Serpent, while the same theme may be observed in Barye's great
bronze Lion crushing a Serpent which stands on the river bank in the gardens
of the Tuileries.

15

In view of the scientific and artistic interest which was being shown in the animal world in the early years of the nineteenth century it is hardly surprising that a group of artists, such as we conveniently label the Animaliers, should have arisen. What is more surprising, however, is that they should have turned to bronze as the medium in which to preserve their work. The art at the beginning of the nineteenth century was at a very low ebb. It had, in fact, been in decline since the time of Giovanni da Bologna, and in the generations after his death and throughout the seventeenth and eighteenth centuries, artistic expression in bronze had become increasingly formalised. Originality was stifled by rigid adherence to academic traditions. Numerous bronzes, it is true, were produced in western Europe throughout that period and tremendous impetus to a kind of 'court' bronze was given by the kings of France in particular. So far as the general public was concerned allegorical studies based on classical models, and equestrian figures were all the rage. Thousands of bronzes, good, bad and indifferent, were produced for the benefit of the new middle classes of the eighteenth and early nineteenth centuries. The invention of sand-casting about 1818, and subsequently the introduction of electro-typing, permitted bronzes to be manufactured on mechanical, almost mass-production lines. Furthermore, the invention of a machine capable of producing a reduced version of a much larger work, led to the popularity of miniatures of well-known statues from museums and public places and countless examples of these bronze reductions ornamented the homes of the new bourgeoisie.

Although this material was out of favour in Europe in the millenium between the fall of the Roman Empire and the beginning of the Renaissance, bronze ranks as one of the oldest metals known to mankind. Artifacts, produced from this alloy of copper and tin, have been discovered in most parts of the world and the earliest of these may date back over 5,000 years, pre-dating the period in human development known as the Bronze Age. On account of its malleability and durability bronze has been a perennial favourite for the sculptor. Throughout most of its history the method used in the casting of a sculpture in bronze was that known as the *cire perdue* process. In this process a mould was formed over a wax model which was then melted out to leave a hollow space for the bronze. In its simplest form this method involved a solid model of wax, which, when melted out of the surrounding mould (baked of fire-clay) left a space which would be filled entirely by molten bronze, resulting in a solid cast. This method was wasteful in that it required a comparatively large amount of bronze. A refinement of this process was the use of a fire-clay core roughly modelled in the shape desired for the finished object. Over this was placed a skin of wax of sufficient thickness to permit the sculptor to model the required detail. The mould was then formed over the model in the usual way. While the core was held in position by means of pins the wax was melted out. Molten bronze could then be poured into the mould, occupying the space between the core and the mould in order to produce a cast which would be hollow inside. The disadvantage of this method was that the mould and the inner core then had to be broken away from the cast. The first two methods in the *cire perdue* category thus involved the loss of the original model and could be used only in the production of single casts.

The Greeks, however, devised a third method which, with various refinements, has remained in use to this day. By this method the mould was formed over the original model and then carefully removed. A coating of wax then lined the inside of the mould and on to this was poured an inner core of refractory material. Subsequently the wax was melted out and bronze poured into the intervening space. The mould and core had to be chipped away, as in the previous method, but the original model was preserved and could be used again and again in the production of further moulds.

16

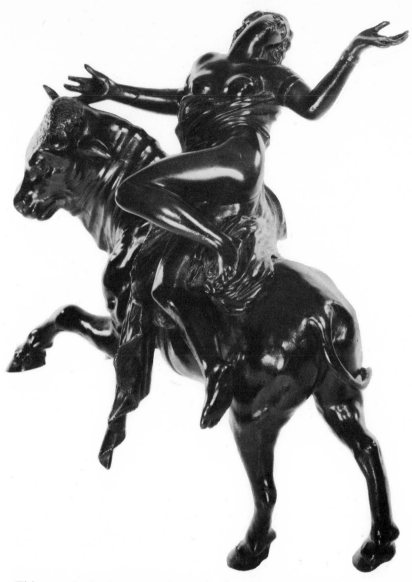

Italian bronze group of the
Rape of Europa, inspired by
Bologna 12″ long,
17th cent.

This was the basic process in use in the early nineteenth century when the
invention of electrotyping revolutionised the manufacture of bronzes, at least
for the mass market. Such bronzes were, and are, produced in vast quantities
and have little or no artistic merit, let alone potential antiquarian value. They
can easily be recognised by their 'tinny' quality, the relative thinness of the
material and the overall mechanical appearance of the work. Few of the
Animalier sculptors had their work cast by the *cire perdue* process, Barye being
a notable exception. Even he found this process uneconomic and lived to see
his models reproduced by the sand-casting methods which became increasingly
common during the nineteenth century. Sand-casting was an effective com-
promise between the traditional *cire perdue* method and electrotyping, in that
it was fairly mechanical, but still required some skill from the *ciseleur* in the
after-work of chiselling, chasing and filing away the lines where the individual
pieces had been joined together, or the rough excrescences on the surface
of the cast after it was removed from the mould. With the revival of interest in
animal sculpture in recent years, however, there has been a return to the more

17

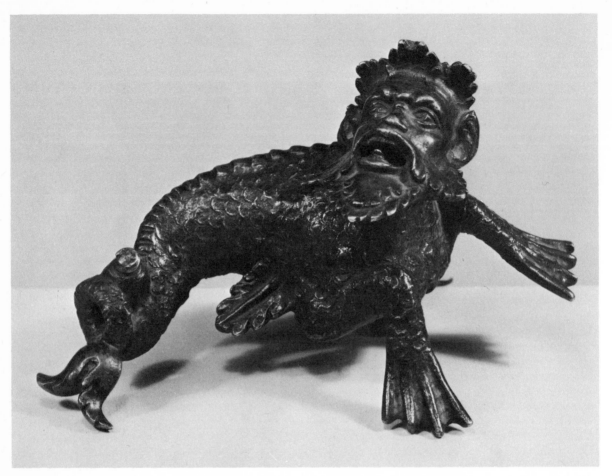

Sea monster, school of
Riccio, Padua 16th century

traditional *cire perdue* process for the casting of bronzes in limited editions.
With the exception of certain works of Barye, however, the majority of the
bronzes produced by the nineteenth and early twentieth century Animaliers
were executed in the sand-casting process.

For that reason it is often more important to know who the bronze-founder,
rather than the modeller, was. No matter how brilliant the model, in the hands
of an indifferent founder the end product could be second-rate. Few of the
nineteenth century Animalier bronzes could be regarded as autograph in the
true sense that the same hand had sculpted the original clay model, formed
the moulds, cast the bronze and carried out the delicate task of chasing and
filing the resulting bronze. While bronzes, like prints, rely essentially on the
artistic genius of their creator, the final version often depends on many skilled
craftsmen and the final work may be several removes from the original artist.
Some degree of mechanisation, diminishing the individuality of the object, is
inevitable when considering bronzes – even those cast in limited editions of six
or seven. In many instances the models for animal bronzes were in current use
for several years and in the vast majority of cases no attempt at numbering the
casts was made, or even thought to be desirable. Thus we can never be sure
just how many examples of Mêne's Derby Winner or Frémiet's Dromedary
are now in existence. One thing, however, is abundantly clear and that is the
fact that interest in the Animalier School has developed enormously over the
past twenty years and the supply of good animal bronzes is not keeping pace
with the demand, with the inevitable result that prices have soared enormously.

18

Yet the comparative availability of animal bronzes, and the wide range of prices (from £20 to £1500 at the time of writing) offer tremendous scope to collectors whatever their financial limits. The Animalier school stands out like an oasis in the artistic desert of the mid-nineteenth century, foreshadowing the revolution in sculpture heralded by Rodin towards the end of the century. Indeed, while the majority of the Animaliers were Romantics concerned with a naturalistic approach to their subject, several of the bronze sculptors around the turn of the century, notably Pompon and Bugatti, belonged to the Impressionist school. Indeed, a recent article by Denys Chevalier lists well over a hundred sculptors 'whose work has a place, large or small, in the world of the animals'. This list ranges alphabetically from Henri-Georges Adam to Jacques Zwobada and while it omits many of the sculptors who are truly regarded as Animaliers, includes many surprising names, such as Alexander Calder and Pablo Picasso. There is a far cry from the sinister insects of Germaine Richier and the equestrian figures of Maroni Marini to the delightfully naive pointers and setters of Jules Moigniez and the fighting cocks of Paul Comolèra. For the purposes of this book, however, the survey has been confined to those sculptors, principally of the nineteenth century, who specialised in animal studies. Generally speaking the Animaliers as a group may be said to begin with Barye and end with Bugatti, but the revival of bronze sculpture in the true spirit of the Animaliers, within the past decade, is also examined. In the hands of the romantic sculptors of the early nineteenth century the animal regained its dignity and independence as a fit subject for artistic expression. The Animaliers studied it and scrutinised it with the same passionate intensity which had hitherto been reserved for man. Generations of animal-lovers and art-connoisseurs since then have come to appreciate their work and its future, as a highly collectable subject, is assured.

19

Chapter II

Barye

Apart from the animal groups sculpted by Gericault shortly before his death, little attempt was made prior to 1830 to produce bronzes of animals as such. Virtually the only sculptor of note who persevered in this field was Jacques-Nicolas Brunot (1763–1826) who exhibited various animal studies in the Salon from 1808 onwards. In that year he showed his sculpture of *Un Cheval au trot*. Subsequently he produced a fine equestrian statue of the Emperor Napoleon, while at the Salon of 1812 he exhibited a study of an Asian bull from the *Jardin des Plantes* and a study of a cow. Two years later he showed an equestrian statue of Henri IV and a study of a deer. In addition he sculpted many other animal groups. Brunot's work aroused relatively little interest at the time and he found it more expedient to concentrate on equestrian groups for which there was a keen demand in the latter years of the First Empire. There is no evidence to suggest that Brunot influenced or inspired the generation of sculptors who succeeded him and stylistically his sculptures are steeped in the rigid academic tradition.

Art historians generally accord to Antoine-Louis Barye the premier position in the field of animal bronzes. While this is not strictly true, Barye's reputation as the finest and most original of the Animaliers has never been assailed and it would be impossible to over-emphasise his influence not only on French sculpture of the nineteenth century in general but also on the wider field of sculpture throughout the world right down to the present day. During his lifetime, however, his work was often criticised or dismissed contemptuously, though even his strongest detractors had to admit grudgingly that no one excelled him in the accuracy of anatomical detail and the realistic poses of his animals. Many of his fellow-artists blindly accepted this popular verdict on Barye and it is interesting to note that Rodin, up to the time when he began modelling his monumental Age of Bronze, could see nothing in the work of Barye which he could admire. It was only when Rodin himself cast off the shackles of academic sculpture and struck out on that path which eventually brought him to the forefront among sculptors, that he discovered his mistake. T. H. Bartlett quotes Rodin in *The American Architect* (June 1889) as saying, "Barye was the master of masters who clung to nature with the force and tenacity of a god and dominated everything. He was beyond all and outside of all art-influences, save nature and the antique. He was one of, if not the most, isolated of artists that ever lived. Emphatically original, and the first in the world in that kind of originality, was himself and himself alone. One thinks

of him and the Assyrians together, though it is not known that he knew any-thing about them. It is impossible to believe that he was affected by them, because everything that he did was Barye. He is too strong to be generally liked even in France. Neither is he understood; he belongs to the centuries, and only after them will he be loved. He is our great glory and we shall have to depend upon him in coming generations."

This remarkable eulogy may seem a trifle fulsome, but coming from the sculptor whom subsequent generations have regarded as of the highest import-ance in the revival of bronze sculpture, it cannot be disregarded. It certainly indicates the strong impression made by Barye upon a master of his craft after a thorough examination of a sculptor whom he once misconceived. Rodin even went so far as to place the sculptors of the preceding generation in some order of merit. He placed Barye before Rude, the sculptor of the high reliefs on the Arc de Triomphe, and ranked Carpeaux below both, as the three most important sculptors in the mid-nineteenth century. Succeeding generations, as Rodin had predicted, did not accord such generous adulation to Barye, as auction prices for his smaller bronzes, in the early years of this century, indicate. But almost a century has elapsed since his death and at this distance of time Barye and his work have been the subject of a marked re-appraisal. Posterity may not yet agree so wholeheartedly with Rodin in its opinion of Barye, but his work is certainly more keenly appreciated today than it was even twenty years ago, and this has also served to focus more attention on the work of the Animaliers in general.

Antoine-Louis Barye was born in Paris on 24th September 1796, the son of a jeweller from Lyons. His mother's maiden name was Claparède and she was the daughter of an attorney in Lyons. Barye's parents survived the dreadful events of 1793, when Lyons held out for seven weeks against the Convention. In the massacres and destruction of the city which followed its capitulation to the republicans, the elder Barye barely excaped with his life. Subsequently he and his wife moved to Paris where there was more scope for his craft than in the ravaged city of Lyons.

Barye's mother is an extremely shadowy figure. She neglected her son's education and left little impression on him. At the age of thirteen he was apprenticed to Fourrier, an engraver of military equipment, with whom he learned the art of steel-engraving. Later he switched to the jewellery trade and was apprenticed to one Biennais who taught him how to make steel matrices used for moulding reliefs from thin metals. At the age of sixteen he was conscripted into the French army. Fortunately for the future of French art he was not called upon to take part in Napoleon's disastrous campaign in Russia. Instead he was assigned to the cartographic section of the military department and engaged in the production of relief maps for the sappers and miners, with whom he completed his service. Many years afterwards he was to recount to Sylvestre how he "worked night and day on reliefs of Mont Cenis, Cherbourg and Coblentz, which are probably still preserved in the archives of the War Department." On 30th March 1814, when returning to barracks after a long walk in the countryside, he discovered that his unit had departed for Paris without him. Barye was penniless and thus unable to follow the retreat of the army, so he merely returned to his father's house.

The collapse of the Napoleonic regime and the surrender of Paris freed Barye from military service and he resumed his work as an engraver. In December 1816, however, he gave up his employment in the jewellery trade. As he himself has said, "I was tormented by my vocation for statuary. I applied myself with infinite zeal to drawing and modelling, but as I was not one to stir about, I neither knew how to find a master nor how to arrange matters so as to live as a student." Nevertheless he entered the atelier of the Monegasque

sculptor, Francois-Joseph Bosio. Bosio was a conventional sculptor of the old school, whose fashionability had brought him the *Legion d'Honneur* from Napoleon and the title of baron from Charles X. He lacked originality and strength, and his equestrian statue of Louis XIV in the Place des Victoires sadly demonstrates his incapacity for monumental work. In the four-horse chariot which he sculpted for the arch in the Cour du Carrousel he showed singular ineptitude in the modelling of animals. The horses in his equestrian statuary are particularly devoid of naturalness and show what a stranglehold the Italianate conventions of the eighteenth century had on sculpture during and immediately after the First Empire.

It is hardly surprising that Barye should have left Bosio's studio after barely three months. In March 1817 he entered the studio of the painter Antoine-Jean Gros and, through him, imbibed something of the spirit which influenced those artists who followed in the footsteps of David. Gros certainly wielded more influence over Barye than had Bosio. Gros, who also received a barony, may be regarded as a classicist by conviction, but the first of the romanticists by temperament. Arsène Alexandre has said of the artists who studied under Gros that "they observed what he did and listened as little as possible to what he said." Barye appeared in the midst of a passion of renewal which began to seize upon the French school. The study of history and the knowledge of foreign literature were enlarging the field of inspiration. With several artists this romanticism was signalled by a return to nature and science. Few might go to the lengths adopted by Gericault who painted the wreck of the *Méduse* on the spot and sketched the corpses of the drowned sailors as they were washed up on the beach. The resulting canvas, *Radeau de la Méduse*, was exhibited in 1819 when Barye was twenty-three and the stark realism of this painting is known to have had a profound effect on the young artist.

In that year Barye first took part in a competition for a prize awarded by the *École des Beaux Arts*. Barye was runner-up with his medal entitled Milo of Croton devoured by a Lion. The first prize, the opportunity to study in Rome, was awarded to Ursin-Auguste Vatinelle, who subsequently had a long but relatively undistinguished career as a medallist in the conventional sense. The medal which Barye sculpted has fortunately been preserved and the art historian, Gustave Planche, was later to write that the lion in this earliest recorded essay by Barye contained the promise of greater things to come. This is being wise after the event and commenting in the light of later developments. If anything this medal reveals Barye's power to express the human figure. The lion, on the other hand, is quite conventional in form, although the tearing of the flesh of the thigh by the lion's claws is well rendered. The characterisation of Milo is superb, expressing that invincible calm of human superiority which does not realise that death is so near.

The following year Barye entered the competition again, this time in the statuary section. With his Cain cursed by God after the death of Abel he won second prize, whereas Jacquot the winner is otherwise unknown to the arts. In 1821 he tried again, the subject set for the competition being the storming of a town in India by Alexander the Great. Unfortunately Barye's entry has not survived. Lemaire won the prize and it is thought that Barye destroyed his own work in disgust. In 1823 no prize was awarded, the exhibits being considered below the grade demanded. In 1824 Barye's work was not even accepted. One of his biographers, Charles de Kay, has commented colourfully on this incident, "The wave had closed over him and he had been rudely bidden by fate to remain at the bench for the rest of his life."

Indeed, it seemed as if Barye the artist would never struggle free from Barye the craftsman. In 1823 he had taken up employment with the goldsmith Fauconnier in the Rue du Bac and for eight years he worked as a jeweller

Antoine-Louis Barye
Sengalese Lioness with prey
9″

and abandoned the *Beaux Arts* entirely. During this period, however, he continued to practise the art of modelling in his spare time. He studied at the Louvre, sketching the Assyrian sculptures recently brought to France and the antiquities of Greece and Rome. He also studied books on nature and was familiar with the works of Buffon, Lacépède, Lamarck and Cuvier. Nothing was neglected by him during these years of self education and discipline that might contribute to the development of his talent. He had no theories to advance, at a time when controversy raged between the various schools of French art. He could not be regarded as a militant, although he had determined where and how to pursue his studies. None of his biographers has been able to turn up a single sententious statement from Barye to the effect that Nature was the first and last teacher to be consulted; yet this was clearly a decision which he had taken, and he quietly pursued the aim of making himself fully conversant with the natural world and in perfecting the techniques of modelling. He attended live modelling sessions at Suisse's atelier, but he also frequented the amphitheatre of the medical schools and by means of dissection familiarised himself with the structure of men and animals. At the same time he studied other branches of the jewellery craft and mastered all that could be learned concerning the melting and casting of metals.

Above all, the *Jardin des Plantes*, the great botanical gardens in Paris, provided Barye with the practical knowledge of animals which stood him in in good stead throughout his career as a sculptor. The *Jardin* was not merely a garden of exotic plants and a menagerie of wild animals, but also contained a series of museums devoted to different aspects of natural history and included a library, laboratories and lecture rooms. Thus Barye was able to study closely animals moving freely, to observe their attitudes and gestures, and also to examine skeletons and stuffed animals in the Museum of Zoology. He attended the lecture courses and whenever an animal died he was at once notified by a messenger, so that he could be on the spot when dissection took place. He measured, drew and sometimes modelled the animal before or after dissection.

During his years with Fauconnier Barye was responsible for a number of animal figures, either cast as separate objects or, more usually, incorporated as decoration on some larger work. Such items were sculpted anonymously, or are known only from the mark of Fauconnier, but we know that Barye was responsible for a stag on a soup tureen which failed to satisfy the customer

23

on the grounds that the beast was "too much like nature, not noble enough." The official report of the 1825 Exposition makes a passing reference to "a collection of good models for the imitation of various animals" exhibited by Fauconnier, and it seems highly probable that these were mainly, if not solely, the work of Barye.

In addition to the small figures which he produced for Fauconnier Barye modelled a number of animal miniatures which were cast for him by Tamisier. Some of these were intended for brooches or pendants and in this category come the tiny storks and tortoises. Others took the form of reliefs, generally unsigned, featuring eagles and lammergeiers, or hunting dogs and running deer. These small charms and plaques belong to Barye's formative period, in which the workmanship is concerned with fine detail and the artist was not yet confident enough to sacrifice detail in order to obtain the due effect of masses. At a later period he began producing minute figures of rabbits, cats and dogs, each of which is a masterpiece of individuality and originality. He was, at this time, a frequent visitor to the Parisian pet markets where he studied the animals and their traits at close quarters. He spent endless hours in the horse markets sketching these animals and mastering the difficult techniques of capturing the true air and fleeting movement of the horse.

In 1827 Barye again tried his hand at competitive exhibitions. In the Salon of that year he had two exhibits, neither of which testified to that love of nature which later established his reputation. His entries consisted of busts of a young man and a girl, and it is to be supposed that, in adhering so closely to academic traditions, Barye was pandering to the judges and trying to produce the sort of sculpture they wanted. In the event, however, he failed to win a prize. Another four years elapsed before he exhibited successfully at the Salon, and on this occasion his efforts were crowned by success. In the Salon of 1831 he exhibited both paintings and sculpture, including a study of a bear and a full-length terracotta of St. Sebastian. Of the latter the critic Stendhal remarked that here at least was a sculptor who did not make legs like a couple of radishes.

But it was with his large bronze work, Tiger devouring a Gavial of the Ganges, that Barye won wide acclaim and a well-merited Second Prize. With this beautiful work, which was bought for the Luxembourg and is now in the Louvre, Barye was at last launched as the greatest sculptor of animals the world had ever known. Charles Blanc wrote at the time, "The young romantic school was astonished and delighted by the accent of truth, liberty and the sentiment of life therein. For centuries ferocious animals had only been treated conventionally. The idea of studying them at the menagerie had never occurred to anyone." Quite apart from the meticulous attention to anatomical detail shown in this group was the brilliance of the sculptor in conveying the passion and feelings of the animals. On the one hand the great cat is crouched on all fours in an attitude of tense repose. The muscular fore-paws clutch the victim as if in a vice. He looks down on the writhing crocodile knowing that in a moment he will crush the life out of it. The gavial, on the other hand conveys the feeling of weakness in the grip of pitiless strength. In the subtle movement of the tiger's tail Barye hinted at the anticipation of pleasure not merely of eating but of destroying life.

The composition of this group is worth considering, in light of Barye's future development as an animal sculptor. The tail of the gavial wound round the tiger's neck, and its body turned towards its destroyer as the jaws vainly snap, form with the tiger a compact group which displays a very attractive outline of its own. Judged as a painting, the design might be regarded as too artfully composed, but in a bronze this artfulness is not out of place. The trait of composing well was evident in Barye even at this early stage, and although there were occasions later on when he was less happy in this respect,

24

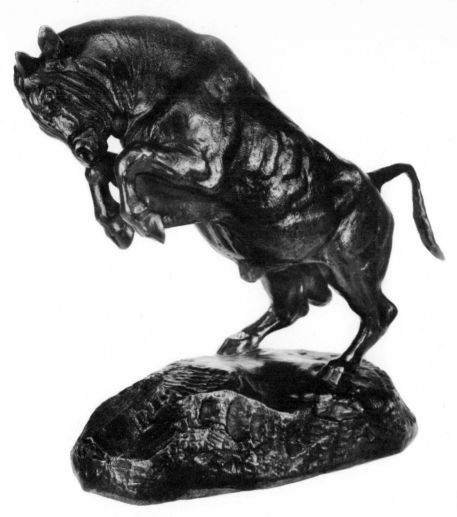

Antoine-Louis Barye
Bronze Bull, signed 8½″

because he felt the need of more natural positions, it is a quality which he possessed to the last. It should also be noted that the design and execution are alike; both are far more precise and deliberate than in his later works. At this time Barye had not attained the freedom and breadth of his maturity. Even the hairs on the tiger's coat are carefully delineated. The body lacks that tense muscularity, that feline ductility, which the living tiger of the *Jardin des Plantes* would have shown, and which Barye conveyed so brilliantly in his Jaguar of twenty years later.

Had Barye progressed no farther than this Tiger and similar masterpieces it is unlikely that he would have received the attention given him by the critics and the general public in subsequent years, or attained that degree of immortality accorded to him. He had certainly begun a trend towards greater naturalism, shown striking originality, and astonished and surpassed his contemporaries; but the calm breadth of execution, the majesty and dignity of immortal works, of his own later creations, are lacking. Fortunately Barye was never content to slacken his efforts to assure and broaden the foundations of his art through continued study of nature and of the masters, to give suppleness to his hand, exactness to his eye, by constant exercise and observation.

The year 1831 marked the turning point in Barye's career. Flushed by his success at the Salon he left Fauconnier's employ and set up for himself. From

25

this time onward he came increasingly in contact with other artists and writers of a like mind. Barye and Saint-Beuve were among the first to be admitted to a circle of artists established at the *Barrière du Maine* at the *Mère Saguet-Bourdon's*. The artist Charlet and the writer Alexandre Dumas were also members of this circle. In the 1830s Barye purchased a small cottage at Barbizon in the forest of Fontainebleu and commuted between there and Paris, spending the summer and autumn each year in his country retreat. Barbizon was to become, between 1825 and 1865, a remarkable focus for painters, sculptors, poets and novelists. Artists such as Corot, Millet and Rousseau lived and worked there and formed the nucleus of the Barbizon School of romantics who derived their inspiration from nature. Inevitably Barye gained a great deal from intercourse with the Barbizon School and undoubtedly imparted his ideas to them in return.

No Salon was held in 1832, on account of the great cholera epidemic that year, but at the Salon of 1833 Barye repeated his earlier success with his Lion crushing a Serpent. This work, which belongs to the same period of artistic development as the Tiger of 1831, was widely acclaimed and reinforced the popular view that here at last was a sculptor with an entirely different and more wholesome approach. Barye was decorated with the *Legion d'Honneur*. The sculpture was purchased by the State and a bronze cast was later placed on the Avenue des Feuillants in the gardens of the Tuileries. The appearance of this statue was not greeted with unreserved acclaim. The partisans of the academic school greeted it with a certain amount of astonished reserve which gave way to anger when the general public persisted in praising it, despite all the criticism of the academics.

Up to 1831 Barye was still casting bronze bas-reliefs of small dimensions, usually square, intended as decoration on clocks or pieces of furniture. At that time they had no higher purpose, but in later years they came to be regarded as works of art in their own right and were suitably mounted and framed. In this category come the profile leopard, panther, running stag and genet-cat, each of the four bearing Barye's signature and the date 1831. Barye continued to produce small, essentially two-dimensional bronzes of this sort as late as 1847 and ostensibly these were meant as ornaments on clocks and furniture but such was Barye's reputation with the collecting public that these plaques were treated as individual objects to be treasured for their own sakes. Nevertheless, even now, clocks and cabinets are occasionally found bearing Barye's bas-reliefs inlaid in their sides and tops. Apart from the Lion, Barye exhibited nine other works of sculpture in the 1833 Salon and these included an equestrian statue of Charles VI, a fifteenth century knight, a stag borne down by hounds and a bust of his patron, the Duke of Orleans, demonstrating the wide range of his talents and his versatility in the more conventional forms of sculpture as well as the animal studies which he was pioneering. He also exhibited an Asian elephant, a dead gazelle, plaster models of a horse and a lion, and several bears, including a group showing a bear fight involving Indian and American bears. Barye always had a penchant for bears and throughout his long career as an animal sculptor these lumbering creatures were a favourite subject. While his predecessors and many of his contemporaries would not have deigned to model any animals other than stags and lions, regarded as being among the nobility of the animal world, Barye would often sculpt bears which he endowed with a certain chunky humility and good nature. It is probably far-fetched to see in this predilection a revolt against the upper classes and a desire to democratise his work. This was claimed for Barye by his biographer, Charles de Kay, writing fourteen years after his death, but seems to be no more than a flight of fancy, in view of the fact that Barye himself became a figure of the artistic Establishment in France and enjoyed the

26

patronage of the wealthiest, most influential and highest-born of the aristocracy in his day. Yet it is significant that the satirical magazine *Le Charivari* caricatured Barye seated at a table modelling the figure of a bear, while his features were exaggerated to resemble those of a bear.

Nor should we lose sight of the fact that it was the larger members of the cat family which provided Barye with his most magnificent subjects and it was his bronzes of lions and tigers which are best remembered today. When his Lion of 1833 had been cast and installed in the gardens of the Tuileries, Alfred de Musset wrote "The bronze lion of M. Barye is as terrifying as Nature. What vigour and what truth! Where indeed has he found a way of making such models pose? Is his atelier a desert of Africa or a forest of Hindustan?" Another admirer of Barye's work, Charles Lenormant, said, "The more I saw that combat of the lion and the serpent, the more the impression grew; it seemed to me at first the lion moved, yesterday I heard it roar."

It is from this period, incidentally, that the term Animalier dates. Originally it was applied to Barye by one of his critics as a term of derision and contempt. Bearing in mind the universality of terms of reproach based on names of animals the effectiveness of an epithet such as Animalier can be understood. The term was taken up by Barye's detractors but, in later years, when animal sculpture had won a place of respect, it ceased to have its pejorative ring and was accepted as a convenient label for that category of sculptors who special-ised in animal studies. During the period (down to the end of the nineteenth century) when these sculptors were at work, the term never quite lost its contemptuous character but it is now used without reserve and has passed into the ordinary parlance of the art world.

Barye's next major work was in a different category altogether. In 1833 he was commissioned by the Duke of Orleans to produce nine silver groups to decorate a surtout, an enormous tray intended as the centre-piece to a dining table. In the centre of the surtout there was to be a large group depicting a tiger hunt in India. Four lesser groups occupied the sides while the corners were to be filled by four small groups. The largest of these groups contained three animals and three men, while the smallest consisted of two animals. The principal group showed Hindu and Moslem huntsmen on the back of an elephant defending themselves against two tigers. Barye's skill in depicting tigers comes across very strongly in this group. One tiger was shown clamber-ing up the side of the elephant almost within striking distance of the howdah, while the other had fastened his fangs and claws in the left hind foot of the elephant. The side groups also featured various aspects of hunting. One group was entitled the Hunt of the Elk and showed Tartars on horseback and their dogs bringing down two elks. Another, the Hunt of the Wild Ox, depicted a beast which was, even then, almost extinct in Europe. The hunters in this case were two fifteenth century knights. The other groups showed the Hunt of the Lion and the Hunt of the Bear, the latter being particularly well executed. The smallest groups consisted of four pairs of animals locked in combat and these were meant to stand at the four corners of the Tiger Hunt.

The design of the surtout and its overall supervision was entrusted to Aimé Chenavard whose grandiose scheme was quite impracticable. Had he had his way the finished surtout would have weighed almost 20,000 pounds. When the first part alone was completed it was discovered that the table would not support its weight. Chenavard dismissed such a trivial problem and ordered an entirely new table in oak of the proper solidity. Unfortunately he failed to take into account the dimensions of the dining room. When the new table was installed it was found that no space had been left for the dining chairs. Again Chenavard was not to be baulked by mere trivialities; he now proposed to push back the walls of the Tuileries to increase the size of the room. This suggestion

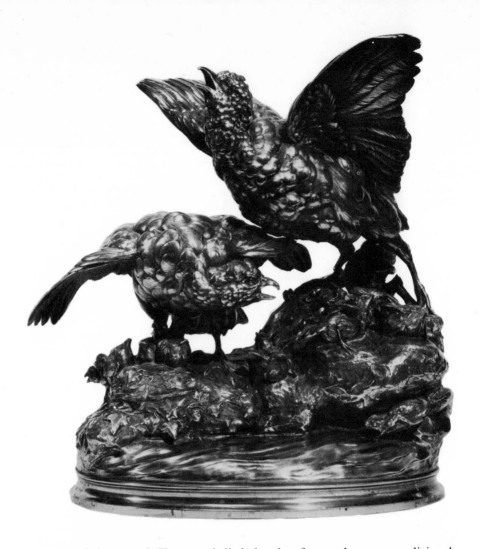

Antoine-Louis Barye
Family of Partridges

was turned down and Chenavard died shortly afterwards, some maliciously saying that this was because of a broken heart at not being permitted to add an eighth to the Seven Wonders of the World. Although Chenavard had a successor the great surtout was never completed. Barye was still at work on the groups when the Revolution of 1848 swept the monarchy away. In 1863 the individual groups were sold at the auction of the property of the widowed Duchess of Orleans. The Walters Gallery in New York eventually acquired the Tiger Hunt and three of the main hunting scenes; the remaining group, the Lion Hunt, stayed in France. These groups were, in fact, bronze casts produced by Honoré Gonon, the bronze founder to whom Barye entrusted most of his work.

The animal groups for the giant surtout had a curious reception from the Salon of 1834. Barye himself felt diffident about exhibiting them, but the Duke of Orleans was anxious that they should be shown. Barye declined to act and when the Duke approached the committee of the Salon he was astonished to find that the committee had refused to accept them. He even went so far as to approach his father, King Louis-Philippe, on this matter but the king felt obliged to stand by the decision of the committee. As a result the hunting groups were not exhibited; nor, in fact, did Barye consider exhibiting at the Salon again until 1851, after the old brigade had been cast aside

28

along with other institutions of the monarchical Establishment. Jules Dupré the landscapist tells how he happened to meet Barye one day and asked him how the work was progressing. "Very well, indeed," replied Barye, "they have refused my groups for the Duke of Orleans." When Dupré expressed his surprise and disgust Barye remarked, "Why, it is easy enough to understand. I have too many friends on the jury."

Although the committee rejected his *chef d'oeuvre* in 1834 it grudgingly accepted a few minor works. These consisted of bronzes of a bear and a dead gazelle and a plaster model of a stag surprised by a lynx (subsequently cast in bronze). The following year Barye almost boycotted the Salon but relented sufficiently to submit a study for his monumental statue of a Tiger devouring a Stag. This was ultimately sculpted in Charence stone and erected in Lyons, his paternal birthplace. Later Barye produced a reduction of this statue which, cast in bronze, originally retailed at 120 francs. In this year also Barye produced his group entitled Lion holding a Giuba Antelope.

In 1835 he was approached by the government to execute a colossal statue, but nothing came of the various schemes proposed. These included an eagle of 70 feet wing-span to be erected on the top of the Arc de Triomphe. In the end Barye sculpted a much humbler subject – a statue of St Clotilde for the Madeleine. Although it is undoubtedly a fine work Barye was never happy with the human form as such and from then onwards concentrated solely on animal subjects.

The years which followed his rejection by the Salon form a distinct phase in Barye's career. From 1837 onwards Barye turned his hand to the more practical side of his craft, casting bronzes from the plaster originals himself. He hired skilled workmen, supervised the casting himself and attended to the more commercial aspects of the business but unfortunately with a singular lack of business acumen. Although many of Barye's best animalier bronzes belong to the years from 1837 to 1848 the business which he conducted was not a success and as early as 1838 he began to run into debt. This sorry state of affairs lasted for a decade and in the financial crisis of 1848 which attended the Revolution of that year, the moneylenders demanded repayment which Barye was unable to make. Barye had no alternative but to declare bankruptcy and one can but imagine his intense chagrin when his finished bronzes, his models, moulds and equipment were taken over by a bronze-founder named Martin who proceeded to execute inferior casts signed with Barye's name. These inferior copies present little difficulty to the *cognoscente* since they were produced by the much more economic sand-casting technique. Nevertheless it was many years before Barye's reputation recovered from the trauma of 1848 and the sand-cast bronzes of the period from 1848 to 1857 are still giving trouble to the unwary purchaser.

Few students of animalier bronzes would go so far as to say (as Barye's biographers wrote a century ago) that he was "without question the most accomplished bronze-founder in the world". But it would be true to say that, like the bronze artists of old Japan, or the Florentine sculptors in the age of Cellini, he was versatile in the modelling and casting of bronzes. His early training with Fauconnier certainly fitted him well for this task. Quite apart from his skill in the *cire perdue* process, however, Barye was a colourist of the first order. He gave a great deal of time and energy to securing the correct patina on his bronzes and experimented with different colours, ranging from a brilliant green which resembled that found on objects excavated at Pompeii, to deep browns and an almost black hue. He was not content to patinate his bronzes uniformly but strove to create an effect of varied tones. In particular he was enchanted by the green patina lurking in the folds and crevices but absent from the higher planes, as though worn away by rubbing and constant

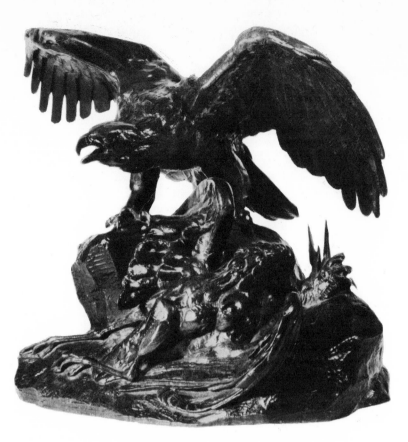

Antoine-Louis Barye
Eagle with dead Heron 11½″

handling. Eventually he was able to produce deep velvet greens and reddish browns which contrasted with the golden browns of the higher points. More than any other artist of the Animalier school, Barye appreciated the value of a fine patina on bronze and regarded the correct coloration as equally important to the modelling and casting. Unfortunately for his business, Barye's business rivals put about a rumour that the green patinas used by him were injurious to health and this may have adversely affected his sales.

Bronzes cast in the *cire perdue* process by Barye during this period are invariably signed BARYE and often, though not always, bear a numeral, punched into the base of the bronze after casting. Barye was a true artist and was exceedingly conscientious in numbering the casts of his bronzes so that his customers knew exactly what they were purchasing. Bronzes by Barye are seldom found with numbering higher than 100 and towards the end of this period he seems to have dispensed with numbering altogether, but in general the numbers punched on bronzes between 1837 and 1848 are a useful guide to the collector.

Barye's talents as an artist were not matched by any skill as a salesman. Instead of telling the people who came to see him in his out-of-the-way shop that casts had been purchased by various members of the royal family and the nobility (as indeed they usually were), he left the visitor entirely to his own devices and often appeared reluctant to part with his bronzes. If the buyer was an amateur collector Barye would hold forth at length criticising the bronze. Often he would insist on various improvements or even a fresh cast before letting it go. In addition he was quite unable to delegate various minor aspects

30

of the work to his colleagues and employees. Whereas bronzes entrusted to Barbédienne to cast were usually of a uniform quality in execution those which Barye cast himself were sometimes variable in quality. Since he was conscientious to a fault Barye would rather scrap a second-rate cast than see it sold in his shop. Often enough he would devote an inordinate amount of his time to a new model, neglecting the more routine, but just as necessary, elements of the business.

When one realises that the years from 1837 to 1848 were the most prolific in Barye's career it is difficult to understand how he could have failed to make a commercial success of it. During this period he enjoyed the patronage not only of the Duke and Duchess of Orleans but also of the Dukes of Nemours, Luynes and Montpensier, as well as many members of the lesser aristocracy. In addition he was at work on an important state commission, the animal figures embellishing the Bastille memorial column. It is interesting to compare the lion at the base of this column with the lion of 1833. The details which weaken the lion of 1833 have disappeared; Barye was by now working with greater freedom and breadth though not yet attaining the full majesty which he ultimately attained. The head of this lion, in particular, is full of nobility and quiet dignity, conjuring up, as Charles Blanc once remarked, "the image of the people guarding their dead."

To this fruitful period belong such minor masterpieces as the Lion devouring a Doe (1837), the little Listening Stag (1838), the Panther and Java Deer, and the Tunisian Panther (1840). Also sculpted at this time were the Recumbent Bull seized by a Bear, the Defensive Bull and the Rearing Bull, the Python crushing a Doe, and numerous lesser works depicting eagles, storks, horses, dogs, pheasants, crocodiles, serpents and turtles. These wild and tame creatures are well modelled and executed despite their small size. The fact that they were small and sold comparatively cheaply did not diminish their importance in the eyes of the sculptor and for the same reason they are highly prized today. Each of these smaller objects was signed in exactly the same careful manner as his more monumental works and Barye also made a habit of signing the more functional articles from his workshop, such as candlesticks and ink-stands.

At the same time Barye continued to produce occasional sculptures on the grand scale and in the classical manner, though investing them with the subtle overtones of the romantic realist. In this category come his magnificent Theseus and the Minotaur, sculpted in 1846 and the Sitting Lion of the following year. The latter was purchased by the government to make amends, it is said, for not giving him the commission to decorate the Arc de Triomphe. Originally this statue was placed in the gardens of the Tuileries, not far from the Lion and Serpent, but later it was removed and now faces the Seine at one of the entrances to the Louvre. Emmanuel Frémiet, who also ranks high among the animalier sculptors, visited Barye's studio while the Sitting Lion was being modelled. Later he described how "all the lines were fixed. The preparation was anatomical. All the important bones of the skeleton were in place, each separately added, the skull, the vertebral column, the cage of the ribs, the bones of the anterior and posterior members..." This insight into the care taken by Barye in the modelling of his life-size studies is particularly interesting.

Between 1846 and 1848 Barye also produced the group showing a centaur being slain by a Greek hero. To this period belong the equestrian statuettes of Charles VI, Gaston de Foix and yet another of the Duke of Orleans. These human equestrian groups follow conventional lines, but Barye showed his originality even in this field with his unusual group of an ape riding on the back of a gnu. This group can scarcely be regarded as one of Barye's more

attractive bronzes, yet there is a strange, bizarre appeal about the subject, tinged with the exotic. Although this group is one of the most remarkable to emanate from Barye's atelier it lacked popular appeal and consequently few casts of it are now believed to exist.

One of the last of Barye's royal commissions (executed for the Duke of Montpensier, youngest son of Louis-Philippe) was the Elephant crushing a Tiger. The modelling of the great bony framework of the elephant is superb and its concentration of power is beyond all praise. For Montpensier he also produced a stately pair of candelabra with the three Graces at the top and the three Goddesses who made of Paris their judge near the foot. Between were three chimeras and at the base three ornamental masks. Along with these candelabra went a centre-piece of Roger carrying off Angelica on the Hippogriff, one of the famous incidents in *Orlando Furioso*. With these pieces Barye may be said to have attained the full mastery of his art, showing himself to be equally at home with human figures and mythical subjects as he was with animals.

In the year 1847 Barye decorated the Iena Bridge over the Seine with the large eagles which may still be seen on it, while for the Pont Neuf, he modelled almost a hundred mascarons or architectural masks.

Although the Revolution of 1848 lost Barye his royal patrons and precipitated the collapse of his business venture, he gained in other respects. Ledru-Rollin, leader of the Republican Party which came to power that year, became Minister of the Interior. He was a friend and admirer of Barye and secured for him the appointment of Conservateur of the Gallery of Plaster Casts and Director of the Louvre Studio of Moulding. Prior to Barye's time this appointment had been regarded as a business opportunity. The Louvre studios furnished duplicate casts for the other galleries of Europe. The moulds, purchased by the director, were made to serve as long as they would hold together, to the detriment of the Louvre's reputation and the interests of art in general. Barye changed all this, selecting new works for casting, ordering new moulds and surrounding himself with a staff of skilled craftsmen.

Barye's tenure of office at the Louvre was productive of much fine work, the most outstanding piece conceived in this period being the group known variously as Theseus in combat with the Centaur Biénor or the Lapith and Centaur, a subject based on one of the bas-reliefs now preserved in the Elgin Marbles. Barye had barely finished the plaster model for this group when, in 1850, there was a sudden political change in France and as a result his appointment was abruptly terminated. Barye was peremptorily ordered to pack up his belongings and vacate his office. In order to get the model from the Louvre to his home on the other side of the Seine at the Montagne Sainte-Geneviève, Barye hired a hand-cart. He walked along behind the hand-cart, picking up the fragments of the model as they were broken off by the jolting over the cobblestones, and when his house was reached there was nothing left of the model but the pieces. Barye was undaunted by this ill fortune and persevered with the remodelling of the group which was ultimately accepted by the Salon of that year for exhibition. This group was destined to become one of Barye's most popular works, Barbedienne offering it, as a *bronze d'edition,* in no fewer than four different sizes, the largest being retailed in the 1880s at 6,000 francs.

Barye was replaced at the Louvre by Frémiet, then the protégé of M. de Nieuwerkercke who had been appointed as Director of the Louvre. By way of compensation, however, Barye was offered the post of Professor of Drawing at the Agricultural School in Versailles, but the appointment was suppressed the following year. It was at this time, in what seemed his darkest hour, that Barye began to receive the recognition from the critics which he justly deserved. In the July 1851 issue of *Revue des deux Mondes,* Gustave Planche, who had

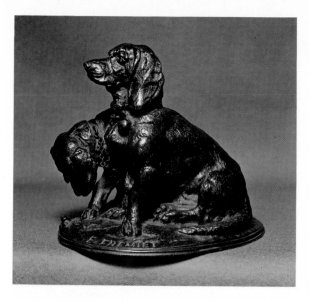

Emmanuel Frémiet
Two Basset Hounds 9¾″

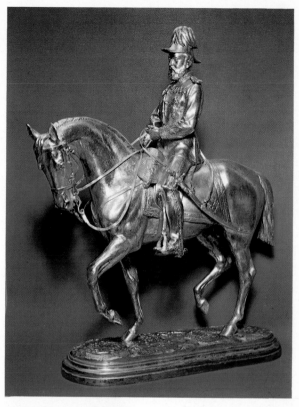

Isidore Bonheur
Prince of Wales (Edward VII)
on horseback (silvered
bronze) 16″ × 16¾″

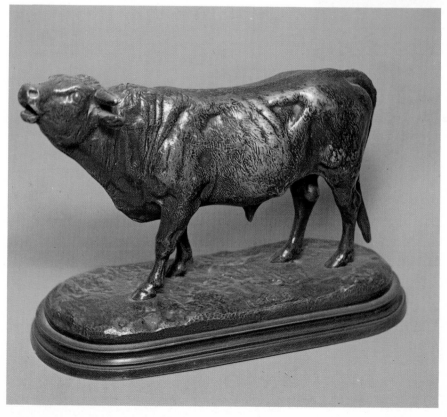

Rosa Bonheur Bull 6½″ × 10″

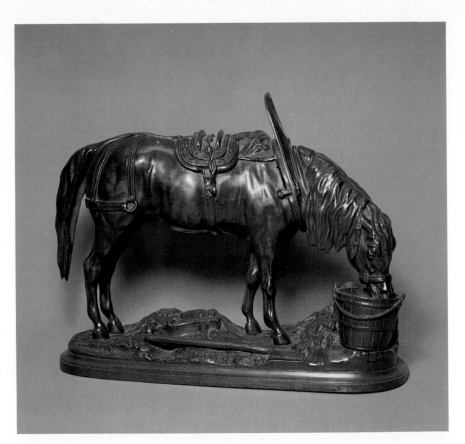

Pierre Lenordez
Welsh Mountain Pony
8″ × 9″

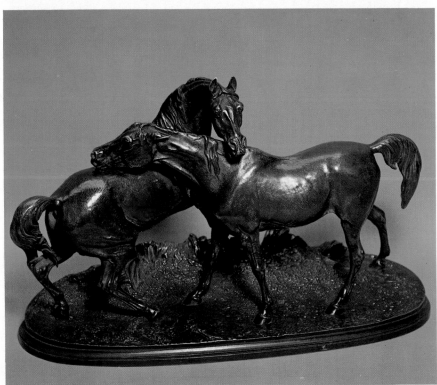

Pierre Jules Mêne
L'Accolade – Arab Mare and
Stallion (No 27 in Mêne's
catalogue) 12″ × 17″ circa
1850

long been a discerning admirer of Barye's work, published the first full-length article on Barye and brought him to the notice of scholars and art connoisseurs not only in France but all over the world.

The following year the Salon accepted a bronze of a Jaguar devouring a Hare, in which Barye succeeded brilliantly in capturing that mood of gluttonous enjoyment of its prey which characterises the cat family. The modelling of the jaguar's head and shoulders was of the broadest, giving it an almost impressionistic quality, and it is a miracle that the jury accepted it at all. One must remember that, among other things, the Revolution of 1848 had overthrown the former Art Establishment and installed artists and sculptors of the contemporary school on the committee of the Salon. This group was not only popularly acclaimed but also received the approbation of the state which purchased it for the Luxembourg collection, whence it was later transferred to the Louvre. Many years after Barye's death the painter Bonnat was to write, "How many times have I gone to the Luxembourg merely to see his Jaguar devouring a Hare! How often I have crossed the Tuileries in order to look at the talons of his Lion and Serpent – those tragic talons so marvellously analysed and modelled!" The Jaguar and Hare was also a popular group with the collecting public and copies of it enjoyed relatively high prices. At the sale of Barye's models and bronzes after his death Sichel bought the copy now in the Walters Gallery in New York for $580. Ten years later, at the Sichel sale, Walters paid $1880 for it. In 1888 Bonnat paid the equivalent of $5,000 for a similar copy.

The publicity which accrued from the sale, in 1853, of the Orleans surtout groups, indirectly brought Barye once more to the notice of the authorities and resulted in his appointment the following year as Professor of Drawing in Zoology at the Museum of Natural History in the *Jardin des Plantes* at a salary of 2,000 francs a year, raised nine years later to 2,500 francs. From then onwards Barye had financial security and by 1857 was able to pay off all his debts and recover the models and moulds which had been sequestrated nine years earlier.

In 1856 Theophile Silvestre published his *Histoire des Artistes Vivantes* which contained an appreciative chapter on Barye. Silvestre's remarks are worth quoting at some length:

"He is fifty-nine years old, and of a size above the middle height. His dress is careful, without extravagance or foppery. His manner and gestures are precise, correct, quiet and dignified; and he brings into conversation nothing that is dry, or flabby, or pedantic. His watchful straightforward eyes look you always in the face frankly and profoundly, neither with a provoking stare nor with impertinence. His brow is losing its short and whitening hair; his nose is slightly turned up; the planes of his face are strongly carved and united by delicate modelling. Barye observes you and waits, listens to you with singular patience and penetrates your character without fail. The most stubborn melancholy and the most concentrated self-respect escape as if without his knowledge from the depths of his thought and show themselves on a face which is of a clear, transparent tone."

In 1855 France, emulating Britain's Great Exhibition of 1851, staged the *Exposition Universelle* in Paris. Barye was a member of the juries of admission and of awards. He himself exhibited his Jaguar and Hare in the section of Beaux Arts, but in the section of Industry he showed a whole collection of his smaller animal bronzes for which the International Jury unanimously awarded him the Grand Medal. In addition he was elevated to the rank of Officer in the *Legion d'Honneur*. Eight years later, when the Central Union of Beaux Arts Applied to Industry was formed Barye was named its first president. In 1868 he was elected to the Academy of Beaux Arts.

Gradually Barye rebuilt his business on much sounder lines than previously. In 1855 he lived in the Montagne Sainte-Geneviève but retained his former residence in the Marais quarter in the Rue Saint-Anastase, for his workshop and store. It is recorded that, in 1855, he had for sale over one hundred different bronzes ranging in size from a tiny turtle two centimetres high and six long, intended for wear as a pendant, to the group of Roger and Angelica on the Hippogriff, which measured 53 by 67cm. The prices at which he sold his bronzes were cheap, even by the standards of that time. A small rabbit, for example, retailed at two and a half francs (about ten pence or half a dollar at the then rate of exchange) while the turtle pendant sold for about thirteen pence (60 cents) and the Hippogriff for about £28 ($140 at mid-nineteenth century rates of exchange). Certain pairs or groups of bronzes cost more. The great nine-figure candelabra sold for £40 ($200) the pair while another group consisting of ten figures retailed at about £56 ($280), the highest price asked by Barye for any of his *bronzes d'edition*. These prices remained more or less constant throughout the last twenty years of Barye's life.

Significantly a greater interest was shown in Barye's work in America than in any other country outside France and this largely arose from the enthusiasm of William T. Walters of Baltimore who first discovered Barye in 1859. During the American Civil War Mr Walters resided in Paris and took the opportunity to build up a fine collection of bronzes by the greatest of the Animaliers. In later years Walters did much to arouse interest in Barye in particular and in the Animaliers in general in the United States. As chairman of the committee of the Corcoran Gallery he purchased from Barye a specimen of every bronze which he had in stock in 1874, the year before the sculptor's death, and a total of 120 bronzes was despatched to America that year to form the nucleus of the great Barye Collection since preserved there. After Barye's death Mr Walters had several bronzes of Barye's erected in various public places in the United States and was president of the Barye Monument Association in the United States, responsible for an important retrospective exhibition which was held in 1889. During the last twenty years of Barye's life a vast quantity of his bronzes was shipped to America and served to maintain interest in Barye during the lean years of the early twentieth century. Since the work of the Animaliers has again become fashionable it is in the United States, as much as in France, that the bronzes of Barye and his contemporaries have been in the greatest demand.

At the same time it should not be overlooked that Barye's reputation stood high in Britain. Bayle St. John, author of a book on the Louvre (published by Chapman and Hall in 1855) was the first British writer to draw attention to the genius of Barye and in subsequent years a strong following for the Animalier school developed on the other side of the Channel.

Ironically Barye had entered his declining years before honours were heaped on him and he began to get more orders and public commission than he could cope with. As he once remarked sadly to a friend, on receiving an important state commission, "I have waited all my life for patronage and now it comes to me just as I am closing my shutters." No one realised better than Barye himself that he had spent the best and most productive years of his life on small bronzes which, while masterpieces in their own right, must have seemed rather pitiable to an artist who felt capable of the largest and grandest examples of his profession. The majority of his larger sculptures belong to the last quarter century of his long life and comparatively few are, in fact, in the true Animalier spirit. In a way, the tragedy of Barye was that he too had become an Establishment figure. His genius and originality were stifled to some extent by the effort of producing monumental statuary to government specifications. His equestrian statue of Napoleon I, erected at Ajaccio in 1863 without his supervision, comes perilously near to being a failure. Two years later he com-

34

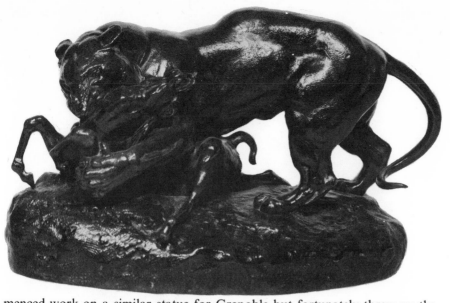

Antoine-Louis Barye
Tiger and Kill 13″

menced work on a similar statue for Grenoble but fortunately threw up the commission in favour of the sculptor Mercie. A model for this statue is in existence and though skilfully executed, it lacks the full power which one associates with Barye and undoubtedly the full-scale statue would have been unsuccessful.

Nevertheless Barye's output in his latter years was still quite formidable. To this period belong the bronze bas-relief symbolising war, over the entrance to the Carrousel court at the Louvre, an equestrian statue of Napoleon III dominating allegorical figures of History and the Arts, a triumphal piece in the Roman Imperial style, and two reclining river-gods which were also destined for the Carrousel. In 1866 he carved a marble statue of Sainte Clotilde for the Madeleine. The statue of Napoleon III was plastered over, following the ignominious defeat of the emperor at Sedan in 1870 and the collapse of the Second Empire. Barye often regarded the group of Napoleon III as one of his failures, partly because he was not permitted to model it in high relief as he had wanted, and partly because he had to submit to the whims and dictates of various petty officials who all had their own ideas of how the emperor should be depicted. It may be doubted how far Barye would have been successful with his subject, even had he been left to his own devices, for Napoleon III, whatever his virtues in seeking to foster the arts or dictate the course of history, was not the man to inspire the artist. Barye lived to see his Napoleon III plastered over to protect if from the fury of the Commune but later it was discreetly removed and placed in a government warehouse–where it may be even to this day! In 1869 he produced a statue of a Nereid arranging her Necklace, a statue which conforms to the classical tradition. Barye sculpted little of note after that, and in 1873 declined a commission for a great vase with centaurs and lapiths sculptured in relief, on the grounds that he might not be able to complete it.

During the last decades of his life, however, Barye continued to produce fine animal groups, many of which compare favourably with those pieces sculpted in his heyday. Among these may be noted the silver version of Barye's walking lion which he executed in solid silver for the Grand Prix at the Longchamps races. This prize was won by the Comte de la Grange with the racing mare *Fille de l'Air* and the trophy was eventually acquired for the Walters Collection in Baltimore. Incidentally there is a curious anecdote in connection with this

35

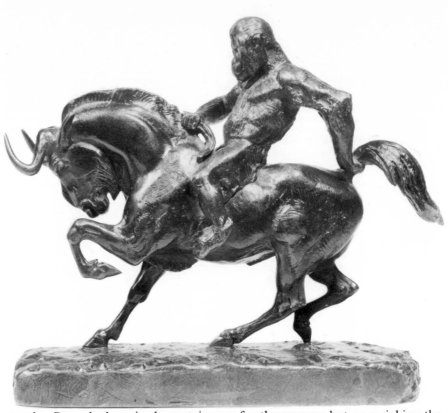

Antoine-Louis Barye
Orang-utang mounted on a
Gnu 9½″

trophy. Barye had received a certain sum for the purpose but on weighing the lion after casting he discovered that there was less silver by weight in the object than he had received. To equalise matters, and at the same time make it impossible for any charge against his honesty when all who knew the circumstances were dead, he cast some silver in flat bars and screwed them on the bottom of the stand without saying a word to anyone, thus bringing the whole up to the weight desired. This was only one case in point; he was always extremely sensitive of his personal honour and at times suffered in pocket more seriously than this in order to keep his self-respect intact.

Nor was that spirit of enquiry, which marked Barye's earlier work, dead. He was as frequent a visitor to the *Jardin des Plantes* in his old age as he was when a young man. Walters recalled that on one occasion, in 1863, when he visited Barye's premises on the Quai des Célestins he found that Barye was absent. Madame Barye smiled in explanation "Ah, monsieur, there is no use calling for at least three weeks. A new tiger has arrived from Bengal; until its wildness has gone – no Monsieur Barye!" It was about this time that he received the commission to sculpt four colossal stone groups for the Chateau d'Eau in Marseilles. Two of the groups featured tigers engaged in combat with a stag and a doe respectively, while the other two featured lions attacking a boar and an antelope respectively. Plaster casts of these groups were exhibited at the *Exposition Universelle* of 1867, the groups being completed and installed the following year. At the *Exposition* of 1867 Barye was awarded the Grand Gold Medal and a few months later he succeeded at long last in gaining membership of the Institute. Although this set the seal on an artistic career spanning half a century it is doubtful whether Barye esteemed it greatly. Two years earlier he had been unsuccessful in his application for membership to the Institute and it is unlikely that he had forgotten or forgiven the Institute

36

whose members had provided the jury of the Salon which had refused his work in 1834. On the other hand membership of the Institute of France carried a pension for widows of members and such was the snob appeal of this honour that an artist's work would undoubtedly fetch more. Barye was not left long to enjoy the honours which had been heaped upon him. Although he was fairly active right to the end of his life he produced no major work after 1869 when he sculpted an arab riding on a camel. He died in Paris on June 25th 1875 leaving a wife and eight children, not to mention two daughters by a first marriage.

A retrospective exhibition of Barye's bronzes, sketches and water-colours was held at the *École des Beaux Arts* in October 1875, but although it excited no little interest it was insufficient to attract the right response to a sale, held at the Hotel Drouot, of Barye's bronzes, models, moulds and other effects. The bronze-founder Barbédienne managed to purchase most of the Barye stock together with the models and moulds. During the time of Barye's bankruptcy his models were cast first by E. Martin and latterly by Barbédienne and during the last years of his life Barye had a certain association with this firm. Many of the bronzes on offer today, though signed by Barye, are in fact later casts which may be instantly recognised by the mark of the bronze-founder. For many years, down to the end of the century, Barbédienne operated a lucrative business in Animalier bronzes, not only from models by Barye but also from those sculpted by other artists.

During his lifetime Barye was beset by trouble from various imitators and falsifiers who tried to pass off interior bronzes as his work. Several people were prosecuted in France for copying Barye's signature on these bronzes but it is difficult to estimate the extent of their activities or output. In addition examples of recasts from genuine Barye bronzes have also been met with in recent years – an unfortunate reaction to the increasing popularity of animalier bronzes. Alexandre in his biography of Barye mentions how his wife was dusting the bronzes in the shop one day and said to him, "You should cut the names on these groups clearer." To which he replied, with prophetic insight, "Within twenty years, my dear, people will be studying my signature with a magnifying glass."

Barye's son, Alfred, inherited something of his father's skill but very little of his genius. In the Salons of 1864–6 he exhibited a great number of bronze figures of racehorses and in the Salon of 1882 showed a perfectly horrible bronze of an Italian jester of the sixteenth century. Alfred Barye also cast bronzes from his father's moulds and signed them posthumously. This practice was regarded by certain art connoisseurs as entirely reprehensible and impious to the good name of Antoine-Louis Barye. But while the after-work on these bronzes edited by Barye *fils* is not of the same high standard the bronzes themselves were, after all, cast from Barye's original models and are therefore not without some interest and value on that account.

Bronzes which may truly be regarded as autograph, that is to say, modelled, cast and chased by Barye himself, bear the characteristics of the *cire perdue* process (though later he had to content himself with the *font au sable* or sand-casting method) and are signed in one of several ways. Barye's mark either incised or stamped, consisted of his surname in block capitals. A variant of this also included his initials 'A-L'. Some bronzes bear a signature and a second signature with the number of the cast. Bronzes from Barye models but cast by Barbédienne bear the impressed mark of the bronze-founder and these are also highly prized, on account of the generally high standard of casting and after-work shown on Barbédienne bronzes. At this juncture it is perhaps appropriate to mention that it is important to purchase Animalier bronzes only from a reputable dealer or through one of the major auction houses who

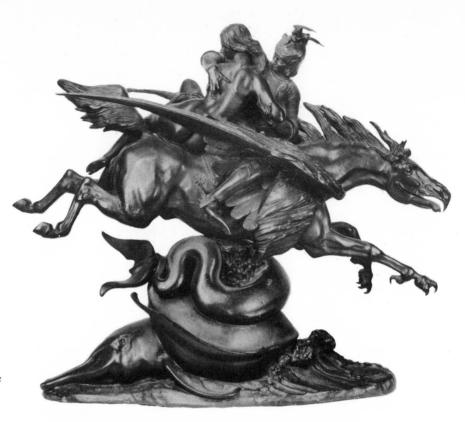

Antoine-Louis Barye
Roger and Angelique on the
back of the Hippogriff,
signed 25″

now conduct specialised sales devoted to these sculptures.

In retrospect it can be seen that Barye was undeniably one of the greatest sculptors of the nineteenth century. Yet there was a fundamental realism and sense of humility in the man which accounts largely for much of the criticism which he had to endure. Barye proved on many occasions that he was capable of producing sculpture in the full classical tradition: his modelling of the human figure in the noble poses beloved of the classicists bears this out. Yet he preferred to sculpt animals, basically more difficult subjects than human beings. Moreover he never regarded as beneath his dignity, or unworthy of his art, the sculpture of objects which could have a utilitarian purpose, and this also incurred for him the displeasure of critics and connoisseurs whose snobbery clouded their judgment.

More important than his actual work, however, was Barye's influence on other sculptors of his own and succeeding generations. For the first time animals were sculpted exactly as seen in nature and not in symbolic or decorative form. Barye's choice of subjects often revealed the more seamy side of nature in the raw, and for this reason it has sometimes been stated that his work had little appeal to women. Nevertheless the attitude of the general public toward the animal world had changed radically between the 1820s when Barye first produced animalier bronzes, and the third quarter of the century when he died. He initiated a movement which others joined, and though none surpassed him there were several whose work may be regarded as his equal. Although the number of Animalier sculptors was never large, their output was such that they occupied an important niche in the art of the nineteenth century, and with the revival of interest in the work of this period the Animaliers have enjoyed an upsurge of interest in recent years.

Chapter III

Emmanuel Frémiet

The majority of the members of the French Animalier school are sculptors who were relatively obscure. Barye was a notable exception to this, in that he was also one of the most outstanding general sculptors of the nineteenth century. Only two other Animaliers occupied a prominent position in the world of art in general. One of these, Rosa Bonheur, owes her immortality not so much to her work as a sculptress but to her skill as a painter and book illustrator. The other artist of the first rank was Emmanuel Frémiet, who is perhaps better known today on account of his monumental pieces. Both of these artists, by virtue of their eminence in the art world, did much to establish the reputation of animal sculpture and to make it increasingly fashionable with the collecting public. Their careers were strangely parallel in that both began with animal sculpture but subsequently graduated to other art forms, painting on the one hand and large-scale sculpture on the other.

Frémiet, unlike many of the other Animaliers, had the benefit not only of a very thorough artistic education but an intimate family relationship with Rude. Frémiet's parents, Auguste Frémiet and Joséphine Frochot, were married in 1823 and he was born on 6th December of the following year. The family were members of the French upper middle class. One of Frémiet's uncles had been a Préfet under the First Empire and his cousin Sophie had met and married the sculptor Rude, who represented the artistic Establishment in the first half of the nineteenth century. It was from cousin Sophie (who was very much older than Frémiet and who, in some works of reference, is mentioned as his aunt) that the young Frémiet received the basic knowledge of sketching and modelling. Frémiet also received a great deal of encouragement from his mother who had artistic leanings. From a very early age Frémiet seemed destined for an artistic career. At the age of five he started his formal schooling at a private establishment in the Rue des Prouvaires near the Halles. The schoolmaster was an enthusiastic entomologist who used to take his pupils to the *Jardin des Plantes* to study the insects preserved there. A year later came the 1830 revolution which swept away the last of the Bourbons and brought the Orleanist dynasty to power. Frémiet, on his way from school one day, found a corpse lying in the street where there had been a skirmish on the barricades. He ran home in a state of shock and the memory of this frightful event stayed with him throughout his life. Subsequently the family moved for safety to the countryside and it was here, amid comparative peace and tranquillity, that Frémiet was able to develop his intense love of nature.

When the tumult and political upheavals had died down the family returned to Paris where Frémiet was presently enrolled as a pupil at the College Henri IV, the school which was attended by the younger children of the 'Bourgeois-King' as Louis-Philippe was affectionately known. Frémiet's mother at this time was engaged in numerous social and public works. For several years she also worked in various hospitals including the *Clinique de la Pitié* Young Emmanuel often accompanied his mother on her hospital visits and, with his experience of 1830, he soon appreciated that there was a less happy, more macabre side to nature. When he was eleven, however, his father and mother separated; Auguste Frémiet took with him his younger son, Charles, leaving Emmanuel with Madame Frémiet.

Thenceforward Frémiet came increasingly under the influence of François and Sophie Rude who he admired very greatly. From this period his artistic education was intensified and, at the age of thirteen, he won first prize among the 200 candidates for entry to the Royal School of Design, Mathematics and the Sculpture of Ornament, whose verbose title was later shortened to the *École des Artes Décoratifs*. In 1839 he began entering the annual competition and with his début won the second prize for a copied design and the first prize in the section for an animal picture.

Frémiet's formal education came to an end when he was sixteen. In 1840 he was apprenticed to the painter Jacques-Christophe Werner (1798–1856), who held the appointment of official painter to the natural history museum at the *Jardin des Plantes*. Werner is best remembered for his remarkable 'atlas' of European birds and many of his watercolours of birds and animals have been preserved by that museum to this day. Frémiet was employed in Werner's atelier as a lithographer, preparing drawings and watercolours for reproduction. In addition, however, Frémiet was called upon to produce anatomical drawings of animals and eventually of men also. In connection with the latter tasks Frémiet frequented the city morgue and the establishments of the embalmers, sketching and modelling cadavers. In such spare time as he possessed he attended lectures at the School of Medicine where he subsequently modelled anatomical specimens in wax. All the time Rude was in the background, helping and advising his young protégé, criticising and encouraging his work. The practical side of his artistic education was rounded off by visits to the Louvre where he studied the best of classical sculpture. Even then he was drawn rather to the sensitive modelling in a horse's head by Phidias, than to the somewhat stylised poses of gods and heroes.

Like Barye before him Frémiet valued the knowledge and experience gained from first principles, studying anatomy and nature itself. This practice gave him at an early age a thorough grounding in both human and animal anatomy and laid the foundation for the accuracy of his later work which was very much admired.

Frémiet worked with Werner for about two years but in 1842 he left him to join his mentor Rude. At this time Rude was at the height of his fame as a sculptor of monumental pieces. By contrast Frémiet was content, as his son quaintly put it, to sculpt *"chiens, chats et chevaux"*. His salary when he began working for Werner, had been five francs a month; by now it had increased to five francs a day.

One of the tasks on which Frémiet was engaged was the sculpture of comparative animal anatomy, the wax and plaster models being destined for the *Musée Orphila*. During this period Frémiet visited the *Jardin des Plantes* and the Menagerie studying live animals and often, as Barye had done before him, dissecting their corpses. On one occasion he obtained the corpse of a lion and having examined it carefully he flippantly adopted the stance of the hunter on his vanquished prey. He placed his foot on the animal's side, whereupon there

40

was an escape of gas from the intestines. The sound, which was like a ghostly wail, so startled the sculptor that he overbalanced and fell in an undignified huddle beside the corpse. Despite his early traumatic experience at the barricades of 1830 Frémiet seems to have been quite unconcerned about the spectacle of death in animal or human form. At the Morgue he worked with the famous Dr Suquet and assisted him in what was always regarded in later years as Suquet's masterpiece – the reconstruction of a young lady whose jealous husband had murdered her, cut up her body and thrown the pieces into the Seine. Suquet and his associates fished the pieces out of the river, reconstituted and restored the corpse, "so that her beauty surpassed their wildest hopes and she looked as good, if not better, than she had done in life", as Philippe Fauré-Frémiet graphically described it.

Thus Frémiet was not content to go back to nature for inspiration, but had to lay bare the very fundamentals of life itself in his quest for accuracy. This is the common denominator in all his work, even though the work he produced was exceedingly diverse in its range. Specialisation within the field of sculpture was foreign to him; wherever the sense of power was richest, his imagination loved best to dwell. This is the reason for his preference for beasts of prey, for hounds, and above all for horses. But while the dramatic aspects of his work were paramount, the scientific aspects were also important. Every detail in his sculptures – the weapons and armour of his Medieval Knight, the clothing of his old-fashioned coachman or the finery of his equestrian statue of Velasquez – depended on the same precise learned research which allows so many of his works to serve as educational material. His equestrian statues of Gallic and Roman soldiers in the *Musée des Antiquités Nationales* in St Germain and the Stone Age Man (based on neolithic finds) in the *Jardin des Plantes* fulfil that role.

At the age of nineteen Frémiet entered his first sculpture at the Salon, an Algerian gazelle. Although it did not possess merit in the eyes of the jury sufficient to deserve a medal it was a creditable piece of work in which all the characteristics of Frémiet's art were present, if in a form which was not yet fully mature. Bearing in mind the moribund atmosphere of the Salon in the years immediately preceding the Revolution of 1848, Frémiet's lack of success is hardly surprising. Yet he exhibited regularly at the Salon from 1843 onwards. In 1846 he exhibited a sculpture of a dog and in the following year showed a dromedary. In 1848 itself he produced a cat and her kittens, two studies of dogs and his fox entitled *Renard d'Égypte*.

Frémiet's friends in the years before the Revolution included such young intellectuals as Charles Marchal and Ernest Christophe, and above all Gaspard-Felix Tournachon, better known to posterity by his nom de plume, Nadar – pioneer photographer, caricaturist and balloonist. These young men were Frémiet's constant companions and often involved him in their escapades. During the Revolution Frémiet carried a red flag and took part in the seizure of the Lobau arsenal from which the insurgents obtained much of their weapons. Frémiet, however, had only a dilettante approach to warfare and his part in the Revolution had a festive, if not farcical air about it.

Nevertheless the Revolution had a marked effect on Frémiet's career. In art, as in politics, it had far-reaching results, resolving the long-standing feud between the classicists and the romanticists and marking the emergence of greater naturalism and realism in painting and sculpture. Charles Blanc, who had helped Barye, also extended his aid to Frémiet who, in 1849, obtained his first state commissions – Marabout struggling with a Cayman and his *Chien blessé*. The Marabout was subsequently executed in bronze in an edition of only four examples. The *Chien blessé* was purchased for the Luxembourg and for many years graced the left side of the stairway at the entrance. In the

Emmanuel Frémiet
Little Cat 3¼"

41

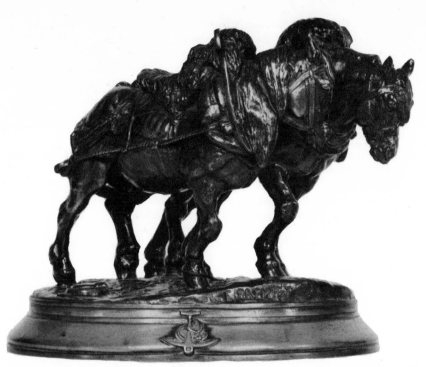

Emmanuel Frémiet
Two Barge Horses 9″

same year he also sculpted a family of cats in marble for the same gallery. In the ensuing years Frémiet was fortunate to enjoy the patronage not only of Blanc, but also of Gustave Larroumet and the Comte de Nieuwerkerke who held high cultural office under the Second Empire. The decade from 1860 to 1870, in particular, was one of great prosperity for Frémiet and many public commissions for statuary on the grand scale.

Under Nieuwerkerke, who was *Surintendant des Beaux Arts* in the reign of Napoleon III, Frémiet was engaged in the redecoration of the Louvre. This was the period in which he sculpted the great capitals depicting falconry, the trophies of the chase and the horse heads, the pairs of dogs and gazelles, the eagles in bas-relief and the crouching lions of the Carrousel. Romieu, successor to Blanc, commissioned bronze figures of basset hounds for Compiègne, the bronze *Abbatage d'un Cheval Percheron* for the Veterinary School of Alfort and the prehistoric group showing a plesiosaurus for the Museum in Paris. Apart from the great sculptures for the Louvre, Frémiet obtained from Nieuwerkerke the commission for the great *Pan et Ourson* in marble. For the *Musée de St Germain* he sculpted his Gallic horseman and the complementary Roman horseman. Neptune Changed into a Horse was commissioned in 1866 and, about the same time, he executed the equestrian statue of Napoleon I for Grenoble which Barye had declined. Among the other large public works which he sculpted during the Second Empire were the four fantastic animals, in stone, for the staircase of the Chimeras of Pierrefonds, an equestrian statue of Louis d'Orleans in bronze, the sea-horses for the fountain of the Luxembourg and the large collection of men, horses and equestrian statues illustrating types of the French Army which was unfortunately destroyed in the Tuileries fire of 1871. This collection comprised no fewer than 62 figures of soldiers in different costume, together with a group of cannon drawn by four horses. These statuettes were conceived as a present for the young Prince Imperial (who was later to die, as a British officer, in the Zulu War of 1879). This collection presented a unique documentary record of the dress and equipment of the military units of the Second Empire and its loss in the sad

42

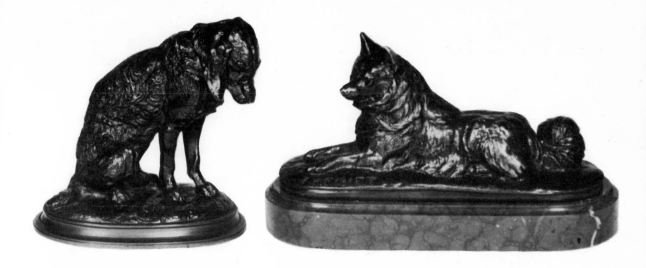

Emmanuel Frémiet
Seated Setter 6″
Emmanuel Frémiet
Reclining Husky 2¾″

events which followed the downfall of the House of Bonaparte was a grievous one indeed.

In October 1870, shortly after the Germans laid siege to the capital, Frémiet and his family fled from Paris and took refuge at Prunay, in the neighbouring countryside, until the turbulent events of the siege and the disastrous months of the Commune had passed. His house in Paris was looted during his absence and Frémiet suffered financially by the war and its aftermath. But fortunately his old patron, Blanc, was re-appointed as *Directeur des Beaux Arts* under the Third Republic and lost no time in commissioning Frémiet to carry out the repairs on various statues which had been damaged during the recent conflict. In 1872 he sculpted his magnificent Jeanne d'Arc which was erected in the Place des Pyramides, and, at the same time, he worked on the tragic allegorical group entitled *La Guerre* which was destined for the fountain in a private park.

So far as Frémiet may be said to have preferred one kind of work, he had a penchant for equestrian statues. In this category came his statue of Stephen the Great for Jassy in Roumania (1882), the Torchbearer in the Paris town hall (1833), the Velasquez in the gardens of the Louvre (1891), the Du Guescelin in Dinan (1902), Colonel Howard in Baltimore (1903) and Francis I (1904). The gilded bronze group of St George fighting the Dragon, which decorates the entrance hall to the Petit Palais in Paris, also belongs to this category though it is outstanding for its vigour and sense of dramatic movement. It must be admitted, however, that many of Frémiet's larger works do not rise above the mediocre. The figure of Francis I, for example, is stereotyped and lifeless, while the vast rhetorical giant statue of Ferdinand de Lesseps at Port Said (1899) has an empty, mechanical quality which seems strangely at variance with Frémiet's sensitive Jeanne d'Arc. Likewise his great statue of Gregory of Tours in the Paris Pantheon is usually dismissed as a piece of hack-work which detracts from Frémiet's greatness as a sculptor.

It is in his smaller works, however, that Frémiet's genius emerged and it is by them that he deserves to be better remembered. Although the majority of his animal bronzes were produced in the early part of his career it is significant that he continued to produce examples of this sort right down to the end of his long life. In 1850 he modelled a Heron, the following year he produced his Chicken of Cochin-China, a group showing A Man and a Bear Locked in Combat, and some six or eight small bronzes of dogs, cats and chickens. During the 1850s it was, indeed, a case of *"chats, chiens et chevaux"* (cats, dogs and horses), culminating in the six horse groups of 1859 – *Cheval de*

43

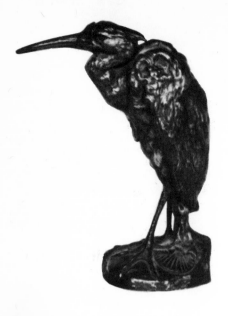

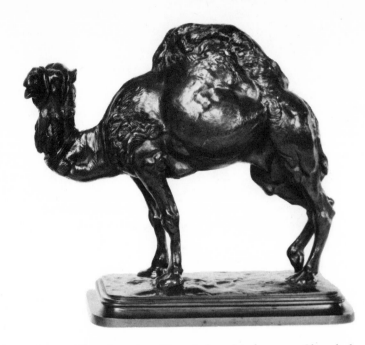

troupe, Cheval au piquet, Cheval arabe, Cheval de saltimbanque, Cheval de chasse and *Cheval au corbeau*. In the same year he produced the curious and exotic group of Gorilla seizing a Negress – a theme to which he returned on several occasions, either in bronze or in marble.

In the 1860s he sculpted a Centaur and Bear for the Chateau de Meudon and the little two-month-old kitten (1861), the famous marble of Pan kissing a Bear (1867) and the Lions of the Carrousel (1868), but from 1860 to 1880 he also cast the majority of the animal bronzes which bear his signature. To this period belong approximately 32 bronzes ranging in subject from Newfound-land Dogs, to Chickens with a Rat. Most of Frémiet's smaller animal bronzes were devoted to the homelier kind of animal, unlike Barye who favoured more exotic breeds. Moreover, Frémiet was not concerned, as was Barye, with the depiction of animal combats or predators devouring their prey, but with animals nursing their young, animals at play or merely resting. Even after 1880 he continued to produce the occasional animal bronze, such as the charming group entitled *Au Secours,* showing a cat and her kittens stalking a bird (1893). There is a strong classical motif, however, running through much of Frémiet's later work, as seen in the bronzes of the Man and Bear in Combat (1885), the Centaur wrestling with a Bear, Love attacking the Peacock of Juno and the group showing Minerva in a Chariot drawn by Three Horses (all 1900). In 1875 Frémiet succeeded Barye as Professor of Drawing at the *Jardin des Plantes,*

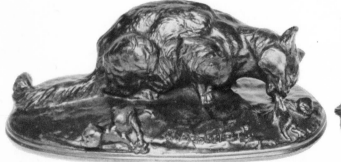

Emmanuel Frémiet
Wounded Dog 3½″

but his best and most original work derived from nature had been accomplished before that date and it seems unlikely that he did much to inspire the rising generation of sculptors to follow in his footsteps, though his daughter Marie later became an animal painter of minor importance.

Frémiet, like Barye, edited much of his work himself both in bronze and in plaster. Later some of his models were purchased by Barbédienne who continued to cast them in *bronzes d'edition* to the end of the nineteenth century. The latter bronzes, of course, always bear the impressed stamp of the bronze-founder. Although not regarded as being in quite the same class as Barye, the bronzes of Frémiet now rank among the most highly prized of the Animalier school and several of the earlier 'autograph' works have fetched between £500 and £1000 at auction in Britain in recent years.

Emmanuel Frémiet
Bronze equestrian group,
signed 21″ long

45

Chapter IV

The Bonheurs

A striking feature of the Animalier sculptors is the way in which so many of them were linked, either as friends of long standing, or as pupils and masters, or by family ties. In the latter category came the Bonheurs, Isidore-Jules and Marie-Rosalie and their brother-in-law, Hippolyte Peyrol, who between them made a notable contribution to this branch of sculpture in the second half of the nineteenth century.

They came from an artistic family, their father, Raymond Bonheur, being a painter and drawing-master from Bordeaux, while their mother was a teacher of music. Although Rosa and Isidore alone concern us directly, in that they were the only members of their family to produce animal bronzes, their brother Auguste and sister Juliette also distinguished themselves artistically as painters of animal subjects. Indeed, it is as a painter that Rosa is better known, her work enjoying a tremendous vogue in Britain and America, and it is probable that she, like Degas, only modelled in the round as part of the preliminary work to her painting. Unlike Degas, however, all her models were cast in bronze during her lifetime and were also exhibited by her on several occasions.

Rosa was born on 16th March 1822 at Bordeaux, the eldest of four children born to Raymond Bonheur and his wife. From her earliest infancy she showed signs of the talent which was later to make her famous. Before she could walk she would amuse herself for hours with a pencil and a piece of paper. Writing of her childhood she has said, "I refused formally to learn to read, but before I was four years old I already had a passion for drawing, and I covered the white walls as high as I could reach with my shapeless sketches. What amused me also was to cut out subjects; they were always the same. To begin with I made long ribbons, then with my scissors I used to cut out, first a shepherd, then a dog, then a calf, then a sheep, then a tree, invariably in the same order. I spent many days over this pastime."

Raymond Bonheur left Bordeaux and went to Paris in 1828 in search of a better job. For a year he worked in the capital before his wife and family joined him. The correspondence which passed between the Bonheurs has been preserved and in it there are many references to Rosa and her artistic precocity, but also her obstinacy and independent spirit. "I cannot understand", wrote Madame Bonheur, "why this child who has intelligence should have so much difficulty in learning. I believe that it is obstinacy; but she is very good. She has drawn a landscape which I send you." And in a subsequent letter, "I cannot

tell what Rosa will be, but of this I feel sure, she will be no ordinary woman." Rosa's mother never lived to see her prophecy come true, since she died in 1833, four years after the family settled in Paris.

The Bonheurs' first home in Paris was opposite a pork-butcher's shop, which had a wild boar of painted wood for a sign. Rosa recalled that, as a little girl, she would frequently stop by this sign and stroke the animal's head, indicating the subconscious love of animals which manifests itself in all her work. Her formal education took an unusual course for that time, in that she attended a small private school for boys and was the only girl enrolled. "I was not frightened by having only boys for my companions", she wrote in her memoirs, "and when we went during the recreation period to play in the garden of the Place Royale I was the leader in the games, and did not hesitate, when need arose, to use my fists." Herein lay the first inkling of those masculine traits of character which developed in adulthood. Her brother Auguste was born in 1824, Isidore three years later, and Juliette in 1830.

In the latter year the Revolution had an adverse effect on Raymond Bonheur, who lost most of his pupils and for two years the family were in straitened circumstances. Just as things were beginning to look up Madame Bonheur died. The eleven-year-old Rosa was sent off to live with an aunt who kept a small *pension* near the Champs Elysées, but the girl was unhappy and soon returned to her father. Although Rosa was undoubtedly her father's favourite he did his best to dissuade her from following in his footsteps and had her apprenticed to a dressmaker. The apprenticeship lasted all of twelve days before Raymond was forced to yield to his headstrong daughter. She was next placed in the charge of his friends, the Bissons, who earned their living from heraldic painting. Rosa was soon set to work on family crests and armorial bearings and although she found this very congenial she was taken away not long afterwards and sent back to school. Here, however, her unruly, tomboyish nature got the better of her and she was promptly expelled for wrecking the schoolmistress's garden. Raymond finally resigned himself to allowing Rosa to do what she wanted and fitted out a room in their home so that she could have her own studio.

Raymond was duly impressed by his daughter's industry and decided that she should study art seriously. For a time she was a pupil of Léon Cogniet, the historical and portrait painter, but fortunately for Rosa she preferred to follow her own bent, untrammelled by the academic classicism of the period. Nevertheless she spent a great deal of her time in the Louvre, sketching the statuary there and copying the works of the Old Masters. Even at this stage her masculinity was self-evident and she had developed the eccentric habits for which she was later renowned. While still in her teens she formed a lesbian association with Nathalie Micas with whom she lived for fifty years, while her mode of dress was increasingly mannish. The other students at the Louvre nicknamed her 'The Little Hussar' on this account. These sexual character-istics may explain to some extent why she excelled in what was still essentially a man's world. Other woman painters there might have been, but, at that time, woman sculptors were unknown.

In 1841 Raymond Bonheur married again and the family moved to the outer suburbs of Paris where Rosa and Isidore could study nature at first hand. It was here that Rosa began to observe animal life with a minuteness extra-ordinary in so young a girl. For several months she even lodged with a peasant family near Neuilly for the sole purpose of studying animals, their habits and movements. She always declared that every animal had an individual character and it is this spirit of individuality which makes her paintings and bronzes so notable. Before even beginning to work on the study of a horse, a dog or a sheep she made herself familiar with the anatomy and bone structure of each

47

one, even going so far as dissection, as Barye and Frémiet were doing. When she returned to her father's house she got his consent to keep a sheep on the terrace and for two years it served her as a model both for painting and sculpture. This is the period to which most of her three-dimensional work belongs. It was her custom at this time to make clay models of animals in order to gain a mastery of every line and every muscle, so that when she painted she had actual knowledge of form beside her acute observation. These models, when finished, she used to sketch by candlelight which, she said, threw the shadows into higher relief.

At the age of nineteen, in 1841, she submitted her first picture to the Salon – *Two Pet Rabbits nibbling Carrots* – and also sent a drawing of *Sheep and Dogs*. Although both were accepted they excited no comment. The following year she sent three paintings and a sculpture in terra cotta of a Shorn Sheep. These works attracted considerable attention; her sculpture and, in particular, one of the paintings showing the effect of evening light on a pasture, drew forth acclaim from the critics. In 1843 she was again represented at the Salon in both media, with a painting of horses and a sculpture of a bull done in plaster but many years later edited in bronze. Her work now began to receive the attention of art lovers and all her paintings were sold. This enabled her to go into the country and study closely from nature, with the result that she sent five pictures to the Salon in 1844, all of which enhanced her growing reputation.

As has already been mentioned, the conflict between the classicists, with their reproductions of scenes set up in the studio, and the romantics, with their historical inaccuracies and waxen sentimentality, was at that time approaching its climax. In the final analysis the Revolution of 1848 tended to undermine both sides and favoured the emergence of the Barbizon school whose work was distinguished for its naturalism and realism. Rosa Bonheur had been drawn to nature before the work of Barye, Corot, Millet and Rousseau had achieved full recognition. In a very real sense she grew up with the movement back to nature and her work developed at exactly the right time. Her horses, sheep and cattle were always represented in a landscape which was never artificially contrived. The animals were always masterful studies, but by placing them in their natural surroundings she brought a sense of the open countryside and fresh air to the vapid walls of the Salon. Raymond

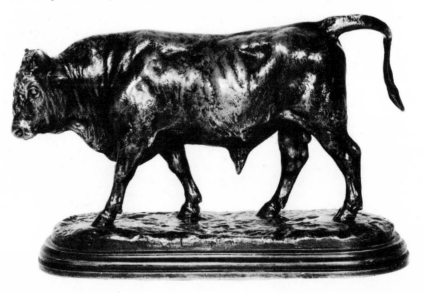

Rosa Bonheur Bull 6″

48

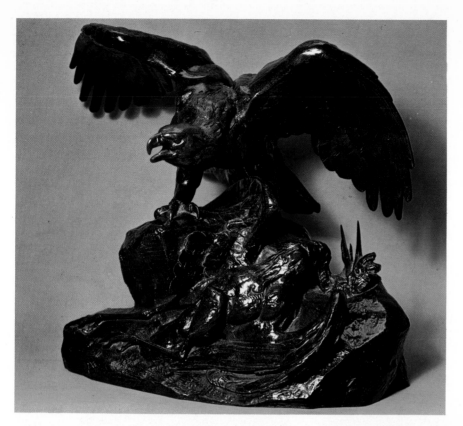

Antoine-Louis Barye
Eagle with dead Heron $11\frac{1}{2}''$

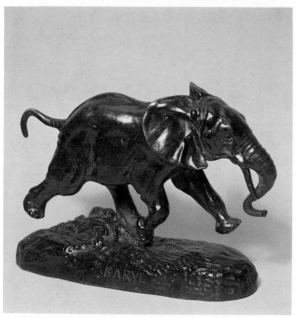

Antoine-Louis Barye
Running Elephant

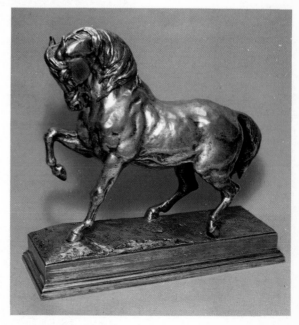

Antoine-Louis Barye
Turkish Horse (silvered
bronze) $11\frac{1}{4}'' \times 12''$

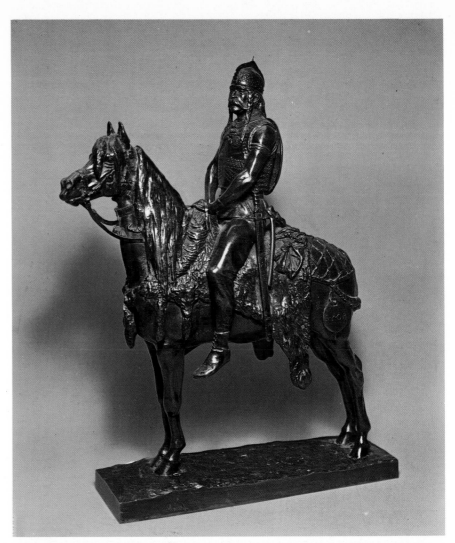

Antoine-Louis Barye
Tartar Horseman $7\frac{1}{2}'' \times 6\frac{1}{2}''$

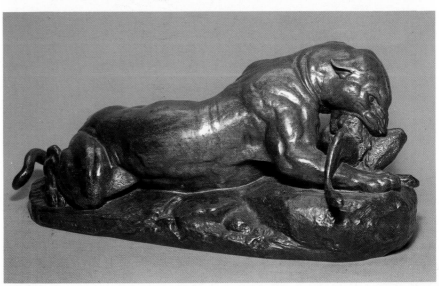

Emmanuel Frémiet
Leopard with kill $3'' \times 8\frac{1}{2}''$

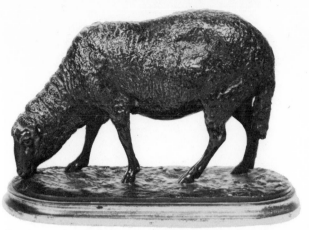
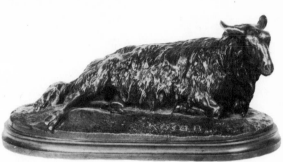

Rosa Bonheur
Grazing Ewe 5¾″
Rosa Bonheur
Reclining Ewe 4″

Bonheur, the drawing-master who had never got beyond the status of a minor painter, watched his daughter's success and wrote approvingly, "she has secured for herself a position far above the reach of the malignant criticism of cabal, and is independent of the worthless puffing to which many of her rivals, whom she has left behind, owe their notoriety...I should fear, if I were less convinced of the high character of her mind that she might suffer to be unduly elated."

In the Salon of 1845 she had six animal and landscape paintings and two animal sculptures which won for her a third class medal, a valuable Sèvres vase and a state commission to paint a picture showing draught animals. In her memoirs Rosa stated that it was not then the custom for the medals to be presented at an official function. Instead the recipients had to go to the Director of the Beaux Arts who gave them their medals in the name of the King. When Rosa received hers, amid many compliments, she astonished the Director by replying, "Thank the King I beg you on my behalf, and have the kindness to add that I shall try to do better another time." She relates that forty years later she was dining with the Duke of Aumale, a son of King Louis-Philippe. "At dessert," she wrote, "whilst smoking a cigarette I showed the poor little medal with the effigy of his father. 'It has brought you good fortune,' he said. And that was true indeed."

In the years that followed the young artist certainly carried out her promise to do better. In the Salon of 1846 she exhibited five pictures of animals which she had studied in the Auvergne, and the following year she showed four pictures reproducing cows, sheep, oxen and horses. These were so true to life that they raised heated discussion between those members of the jury who were still bound by the old tradition of conventional animals conventionally represented, and the followers of the newer school whose theory was that nature, under all its forms, should be reproduced as it is seen. In the Salon of 1848 which, as a result of the Revolution, accepted all the works submitted to it, Rosa had six pictures and two sculptures. Instead of the jury of former times, a commission of forty members was elected by the artists themselves to make the awards. The commission awarded Rosa a gold medal of the first class.

Rosa was a lifelong admirer of the authoress George Sand and it was the latter's novel *Mare au Diable* which is said to have inspired her masterpiece *Ploughing in Nivernais*, exhibited at the Salon of 1849. In connection with this work she studied cattle being slaughtered in the abbatoir of Roule not far from her home. "I went there every day" she wrote, "in order to perfect myself in the study of nature. One must have a *culte* for one's art to be able to live in the midst of horrors and amongst those terrible people." The slaughtermen were very surprised that a young woman should take such an interest in them and their work. Their reaction was to make things as unpleasant for her as

49

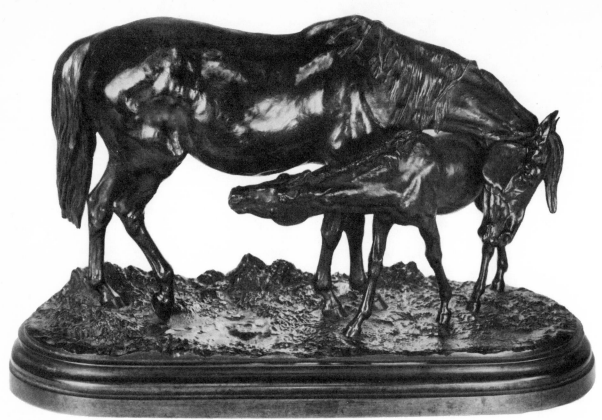

Isidore Bonheur
Mare and Foal, signed
I. Bonheur 12½″

possible, though a friendly butcher prevented the worst pranks being played on her. Rosa was quite unperturbed by all this. She sketched the animals as they were being driven into the slaughter house and as they were being killed, making studies of every variety of violent action which she found invaluable later on.

Her great painting showed three pairs of oxen in harness, drawing a heavy plough with their enormous and muscular bodies. The simplicity and force of the performance, contrasting with the feeling of autumn and the clear tone of nature, combined to produce a picture which Rosa never surpassed and only once equalled. The picture was an immediate success, although the Ministry of Fine Arts could only find 3,000 francs for its purchase. The painting is now in the possession of the Luxembourg and still ranks as one of the most notable in its modern collection.

Four years later she exhibited *The Horse Fair*, which was destined to make her famous not only in France but also in Britain and America. In preparation for this painting Rosa attended horse fairs disguised in male attire. Although, as has already been noted, Rosa had a predilection for male clothing this seems to have been the first occasion on which she paraded it openly. From then until her death in 1899 she seldom wore anything else. She always preferred a black coat and man's waistcoat, male collar and cuffs and wore her hair short and swept back severely from the forehead in male fashion. For work she preferred the blouse and baggy trousers of the French peasant. She even obtained permission from the Prefect of Police in Paris to wear male clothing, but this did not save her from arrest on at least one occasion. On one occasion her strange appearance when in the normal dress of her sex led to her apprehension by the police who mistook her for a man masquerading as a woman!

The Horse Fair of 1853 marks the turning point in the career of Rosa

50

Bonheur. After this date with one notable exception she never modelled animals, and thus her relevance as an Animalier ceases from this point, but her subsequent career is not without some bearing on her importance as an animal sculptor, particularly to collectors of the present day. *The Horse Fair* was greatly admired at the Salon but had a chequered career from the financial viewpoint. The Beaux Arts would have wished to purchase it but their funds were low at the time. Subsequently this great painting was exhibited in Ghent and Bordeaux, being offered to the latter municipality for 12,000 francs. When this was refused Rosa's agent, M. Gambard, took it to London where it was shown in a gallery in Pall Mall. There it was an immediate sensation and in the ensuing publicity Rosa's reputation was greatly enhanced. Queen Victoria expressed a wish to see it and Thomas Landseer made an engraving of it which sold in large numbers. The painting then went on a tour of provincial cities in Britain and the successful reception which it won everywhere encouraged Rosa to visit Britain in 1856. Her sojourn in Scotland is of interest to collectors of animal bronzes since it was as a result that she later modelled the group known as A Scottish Raid as well as the figure of A Scottish Shepherd and the study of Skye Ponies. She said herself that she had made enough studies in a few weeks to occupy her for twenty years. The Highland cattle, with their rugged strength, fascinated her and were to form the subjects of several paintings.

From 1849 to 1860 Rosa was director of a drawing school, in succession to her father. She ran this school in partnership with her sister Juliette, but pressure of work forced her to give it up in the latter year and thereafter she concentrated on paintings. Her output during the last forty years of her life was phenomenal but it cannot be denied that her art suffered proportionately. She never again produced a canvas the equal of *The Horse Fair,* although *Haymaking in the Auvergne,* which won her a gold medal in the Universal Exhibition of 1855, shows something of her original genius. *The Horse Fair,* in the end, was purchased by an American dealer for the sum of 23,000 francs (£920 or $4,600 at the then rates of exchange). In 1877 Gambard offered to repurchase the picture but it was eventually auctioned in New York at the Stewart sale in 1887, being purchased by J. Vanderbilt for the equivalent of 268,500 francs and later presented by him to the Metropolitan Museum of Art in New York.

It seems curious that Rosa Bonheur, the greatest woman artist in nineteenth century France, should have been comparatively despised in the art circles of her home country, yet widely acclaimed abroad, particularly in Britain and the United States. After 1855 she devoted herself wholly to supplying the demand for her work in other countries, leaving Paris in 1860 to settle at the Chateau of By in the Forest of Fontainebleu where, in the depths of the country, she could have her numerous living models properly housed. Here, surrounded by sheep, gazelles, deer, goats, birds, horses, cows, every breed of

Isidore Bonheur
Bonnasus from the
workshop of I. Bonheur,
signed 10½"
Isidore Bonheur
Two Pigs from the workshop
of I. Bonheur, signed 8½"

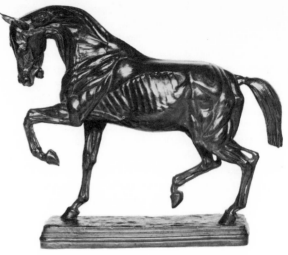

dog, boars, bulls, ponies from Skye and Iceland and more exotic creatures such as American mustangs, lions, monkeys and parroqueets, she spent the remainder of her life. Her work was seldom exhibited in France, but she scored successes at the Great Exhibition in London (1862), the Paris *Exposition Universelle* (1867) and the Columbian Exposition in Chicago (1893). She enjoyed the friendship and patronage of Queen Victoria and this ensured that her work was highly fashionable among the British upper classes. In 1865 the Empress Eugénie called at By unexpectedly one day. "I have here a little jewel that I have brought to you on behalf of the Emperor. He has authorized me to announce to you your appointment to the Legion of Honour." She then pinned the Cross of the order on Rosa's jacket and, kissing the painter, said that she "was happy to be able thus to reward her talent in which, as a woman, she felt great pride".

It is popularly believed that the Empress had wished to secure this decoration for Rosa, whose work she greatly admired, but Napoleon III had refused on the grounds that no woman could be admitted to its ranks except for bravery or charitable works. Eugénie took advantage of her position as Regent, during the Emperor's absence in Algeria, to make this award herself. The official announcement of the award appeared in the *Journal Officiel* of 11th June 1865, the day of the Emperor's return from Algiers. A few days later she was asked to lunch with the Imperial Family at their palace of Fontainebleu nearby. Notwithstanding this singular mark of favour Rosa Bonheur was reviled in the French press for pandering to the British market. One leading critic of the period always referred to her as *Miss* Rosa Bonheur and once wrote that "since her adoption by the English her work has been scarcely seen in French exhibitions, and not even in picture sales". Indeed, after the *Exposition* of 1867 no paintings by Rosa appeared in a French exhibition till the year of her death when some of her work was hung in the Salon of 1899.

That Rosa was highly regarded outside her own country is further demonstrated by the fact that, during the Franco-Prussian War of 1870, Crown Prince Frederick Charles, son-in-law of Queen Victoria, guaranteed her protection though Rosa would not accept any favours from the conquerors of her country. During the armistice the prince, who had a sincere admiration of her work, expressed a wish to visit her, but she refused to see him. He came to her studio a few days later unannounced but was not able to see her and contented himself with inspecting the studio in her absence. The visit of President Carnot in 1893 was a much happier one, for he came to present her with the cross of an

Officer of the *Legion d'Honneur*. In her last years Rosa experimented with charcoal and pastels, but, as ever, her subjects were animals right to the end.

After her death her pictures suffered the inevitable re-appraisal. Even in her lifetime she was attacked as a 'manufacturer' of pictures rather than a painter and it must be admitted that many of her canvases from the period between 1860 and 1890, bear the marks of haste and lack the vigour and warmth of her earlier works. She never had any great appeal to the artistic intelligentsia, but derived her great popularity from the ordinary public who understood what they saw and could appreciate the great anatomical knowledge, dexterous technique and charming and seductive colouring. In her later years she carried on an extensive export trade with Britain and America and her pictures were by no means the worst to find their way across the Atlantic.

There can be little doubt that her indefatigable industry actually weakened her artistic powers and that by her passion for work she acquired a facility which made her content with results of a lower standard than that which she reached in *Ploughing in Nivernais* or *The Horse Fair*; that her work gradually declined from vigorous strength to mere mastery of technicalities, and that had she painted less her claim to a more enduring fame would have been the greater. It is somewhat ironic, therefore, that while her paintings are now usually dismissed from serious consideration, her sculpture should be so highly regarded. During her lifetime it was her painting that received the bulk of her time and energy and her sculptures she regarded merely as visual aids to her more important work. There is no doubt, however, that had she prosecuted this form of art to any great extent she would have achieved as great a success as a sculptor of animals as she did as a painter. As it is, the few sculptures which she produced today rank among the most important, and most desirable, of all the Animalier bronzes. Although she probably modelled many pieces as preliminary studies to her paintings only some thirteen works have survived in completed form and of these eleven were exhibited during her lifetime.

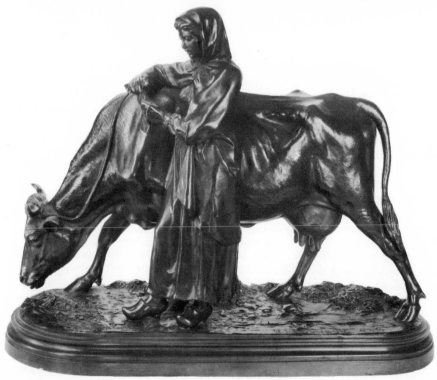

Isidore Bonheur
Bronze Group, signed 16″

53

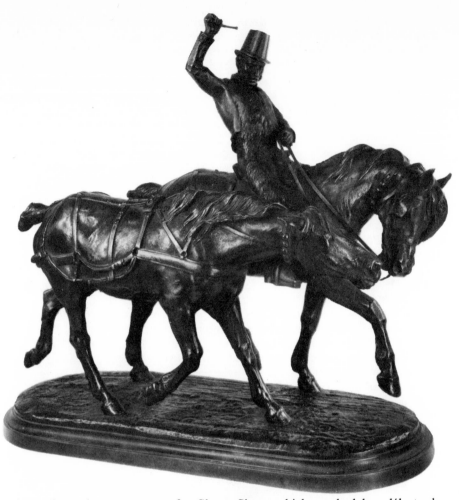

Isidore Bonheur
Equestrian Group,
signed 15″

Apart from the terra cotta of a Shorn Sheep which marked her début, she showed Stags Traversing an Open Space, A Scottish Raid, Deer in Repose, Skye Ponies, A Scotch Shepherd, An Ox Lying Down, A Ram Lying Down, A Sheep, A Bull Walking and A Bull Bellowing. Two others, A Bull and *La Vieille Rosse* (an old horse) were never shown to the public. The bull was regarded as her finest sculpture, but only one cast was made of it and it remained in her possession.

By comparison Rosa's brother Isidore-Jules is a shadowy figure, though he left a greater mark in the world of Animalier bronzes. Isidore was born at Bordeaux on 15th May 1827, the third child of the Bonheurs and five years younger than his talented sister. Isidore also showed great artistic aptitude from an early age and was taught painting and drawing by his father. In 1849 he enrolled at the *École des Beaux Arts* but, in fact, made his debut at the memorable Salon of 1848 with a painting entitled *African Horseman Attacked by a Lion* and a plaster model of the same subject. He exhibited regularly at the Salon from then on but only his picture *Pepin le Bref dans l'arene*, shown in 1874 is regarded as outstanding in any way. In 1875–76 he also exhibited paintings and bronzes at the Royal Academy in London and won a gold medal in the *Exposition Universelle* of 1889. As a painter, however, Isidore never appealed to the public in the way that his sister did. In the sale of her private collection in 1900, following her death, the highest price for a picture by Isidore was a mere 25 francs for *L'Etape*, and after his own death in 1901
54

interest in his animal and landscape paintings disappeared entirely.

His sculptures fared rather better and several monumental pieces are still to be seen. These include the monument to Rosa which stands at Fontainebleu and the two stone lions which ornament the steps of the Palais de Justice in Paris. He is best remembered, however, for his small animal groups which were cast for him by his brother-in-law, Hippolyte Peyrol, the husband of Juliette Bonheur.

Like Rosa, Isidore favoured sheep and cattle as the main subjects of his bronzes. Several of his works were, in fact, modelled as a complement to figures which she sculpted. In this category come the Merino Ram which was paired with the Ewe modelled by Rosa, and her bulls were often paired with cows sculpted by Isidore. Cattle held a special fascination for Isidore and he constantly turned to this theme in his bronzes. He produced a fine example of a Normandy Cow, so perfect in its anatomical detail that authorities on cattle have been able to deduce from it how little the breed has altered in over a century. He also sculpted a Roman Cow from the Compagna and a spirited Bull of the Camargue. Whether in capturing the placid attitude of cows or the aggressive restlessness of bulls Isidore excelled in reproducing the characteristic postures of cattle. He was equally at home in the modelling of sheep and produced several studies of ewes or rams as well as an excellent bronze of a dog and a sheep together. .

Like many of the other Animalier sculptors working in France in the mid-nineteenth century, Isidore Bonheur was fully aware of the fact that the market for their work was more appreciative in Britain than in their native country, and this accounts for his representation at the Royal Academy in the 1870s. To this period belongs a fine equestrian figure which he modelled of the Prince of Wales (later King Edward VII) and which was produced in silvered bronze. Bronzes of horses were particularly fashionable in England and Isidore sculpted several figures which catered to this market. These include a pair of carriage horses with a postillion in the saddle, a sensitive study of a mare and foal, a group with a groom showing off the paces of a stallion, a horse and jockey, an English stallion and a group of horses. Two of Isidore's horses were commissioned for the palace of the Sultan in Constantinople.

For the same reason Isidore also modelled various hunting groups. Among the best of these was a spirited group showing a hound leaping on to a boar, but he also produced a fine bronze of the setter Cora and figures of dogs with cattle or sheep. His figure of an eight-point Stag echoes Landseer's *Monarch of the Glen*, but he also did a splendid group of a Stag at Bay. He sculpted several other figures of hounds and hunting subjects but did relatively little work with birds, although his Hen Pheasant Pecking at a Snail reveals that he was perfectly capable of modelling them.

Bronzes by Rosa Bonheur are usually signed 'Rosa B.' while those of her brother are signed 'I. Bonheur.' Rosa's bronzes are extremely rare and are seldom seen on the market these days. It is interesting to note that, at Mallet's exhibition of Animalier bronzes held at Bourdon House in 1962, the most expensive items were a pair of bulls by Rosa priced at £260. These or a similar pair would fetch ten times as much in the depreciated currency of the present day. Though Isidore's bronzes are not in the same class of rarity they have also increased greatly in value and are now in the £100–£500 range. At Sotheby's in March 1970 Isidore's bronze of a Mare and Foal fetched £580 – about the same price as is currently paid for Rosa's animal paintings. These, incidentally, after being out of fashion for many years, are now gradually returning to public esteem, though not as yet enjoying the same value as her bronzes.

Chapter V

The French School

Although animal bronzes were produced in several countries during the nineteenth century the importance of France in this field was paramount. Not only was France the birthplace of the Animalier school of sculpture and had given the style its name, but France produced by far the greatest number of sculptors who devoted their careers to this branch of art. The most important artists, or those whose works are generally regarded most highly today, have already been dealt with separately. This is not to imply any disparagement regarding the work of the other Animaliers; for reasons of space it would be impossible to devote the same detail and attention to the lives and careers of all the sculptors who specialised in this form. Nor is it claimed that every sculptor who worked in this *genre* is mentioned below. As far as possible all the artists whose animal bronzes have come on the market at some time within the past five years is listed, but as the popularity of the Animaliers and their work develops no doubt other sculptors will be discovered. It is hoped that, although the following notes may be tentative, they will serve as a basis for further study of the Animaliers. For ease of reference the sculptors are listed in alphabetical order.

ARSON, Alphonse-Alexandre (1822–1880)

Born in Paris, he studied sculpture under Joseph Combette, subsequently specialising in bird studies. He exhibited at the Salon, making his début in 1859 with a bronze of a Hen and Chicks, a bronze entitled *Lavandiere et ses Petits* (Washerwoman and her Children), and a spirited group of Fighting Cocks. At the Salon of 1863 he showed the wax model for a group of Pheasants and the following year exhibited a Pheasant and Young. A Partridge surprised by a Weasel was shown in 1865 while a study of Pheasants (1866) and Partridge and Young surprised by an Ermine (1867) marked his contributions to the Salon in later years. Nothing else is known of his life and work and his bird figures are comparatively rare. Small figures of a Cock Pheasant and a Golden Pheasant were exhibited at the Sladmore Gallery (Animalier II) in 1968.

BECQUEREL, André-Vincent

Pupil of Prosper Lecourtier (qv), he exhibited at the Salon between 1914 and 1922, specialising in studies of racehorses. The best known of these is The Finish, showing two race-horses in a photo-finish.

BOYER, Emile (flourished 19th century)

Born in Saint Etienne, Boyer spent most of his working life in St. Petersburg where he specialised in ornaments for mantels and chimney-pieces in malachite

and gilt bronze. His best known works were monumental in scale – the equestrian statue of Tsar Nicholas and the Alexandrine column in St. Petersburg – but bronze reductions were made under the direction of Horace de Montferrand and several of these were disposed of by Madame de Montferrand at a sale in Paris on 29th April 1868. Boyer has tentatively been identified with a small bronze horse stamped *Boyer à Paris*, sold at Sotheby's in July 1969.

BUREAU, Léon (1866–)

Born at Limoges on 17th September 1866, he was employed in the atelier of J. A. J. Falguière and educated at the *École des Beaux Arts*. He was an exhibitor at the Salon from 1884 onwards, specialising in bronzes of the more exotic animals. At the Salon of 1897 he exhibited a group of an Abyssinian Lion and Lioness while other works include a Wild Stallion and a Stalking Tiger.

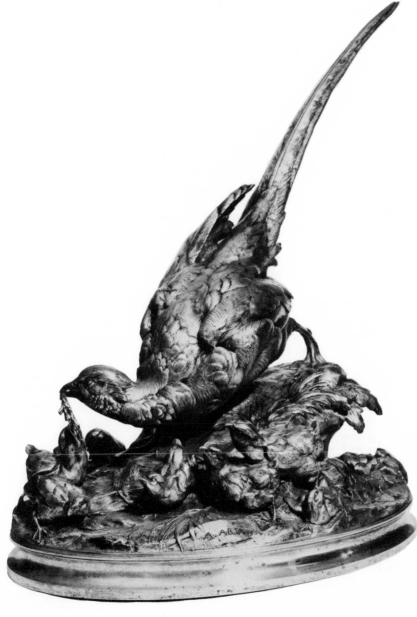

Alphonse-Alexandre Arson
Pheasant and Chicks 10″

CAIN, Auguste-Nicholas (1822–1894)

Born in Paris on 16th November 1822, he began his career as a joiner but came under the influence of P. J. Mêne (qv) whose daughter he married. Cain studied sculpture under Rude and Guionnet as well as Mêne and first exhibited his work at the Salon of 1846, making his début with a wax model of a Linnet defending her nest against a Rat. This group was subseqently edited in bronze and shown at the Salon of 1855. In 1847 he exhibited a Falcon surprised by a Serpent in wax and this also was later cast in bronze. Several of his wax models sculpted in this period were given a metallic oxide coating to simulate bronze and in this category come his Trigonacephale destroying a nest of Linnets. Later works shown at the Salon included Egyptian Vulture (1851) for which he won a third class medal, Eagle defending its Young (1852), an Ibis fishing (1852), a Family of Partridges (1853), Eagle pursuing a Vulture (1857), Falcon chasing Rabbits (1859), Pheasant surprised by a Marten (1859), a bas-relief of a Falcon hunting Rabbits, and a group of Partridges and Chicks (1859), Fox chasing Chickens, and a Cock-fight (1861), Vulture, and Buzzard hunting Partridges (1863) which won another third class medal, Saharan Lioness and another version of a Cock-fight (1864), Saharan Lion (1865), Trophy of the Chase (1866), Family of Tigers (third class medal at the *Exposition Universelle*, 1867), and a Lioness (1868). Among his later works were the Lion and Ostrich in the Luxembourg Gardens (1874) the Tiger and Crocodile in the Tuileries Gardens and a Bull for the Trocadero. The small animal bronzes which are keenly sought after by collectors date from the period prior to 1868; after that date he concentrated on monumental statuary and battle-scenes. His *chef d'oeuvre* was undoubtedly the colossal equestrian statue of Duke Karl von Braunschweig which he executed in 1879 for the city of Geneva. As a memorial to him his statue of a Lion and Lioness fighting over the corpse of a Bear was erected in the Place Montholon in Paris. Cain was the father of Georges and Henri Cain who both became painters of portraits and historical subjects. Among the other subjects found as bronzes are reductions of his *Coq Francais* which he exhibited at the Salon of 1883.

CARTIER, Francois-Thomas (1879–)

Born at Marseilles in 1879, Cartier studied under Georges Gardet (qv) and exhibited at the Salon from the beginning of this century. He won an honourable mention in 1908 and a gold medal in 1927. Cartier is best known for his small bronzes of dogs – retrievers and bull terriers.

CLESINGER, Jean-Baptists-Auguste (1814–1883)

Born at Besançon, Clesinger received all his artistic training from his father, Georges-Philippe Clesinger, a sculptor in the academic tradition and himself a pupil of Bosio. J. B. A. Clesinger made his debut at the Salon in 1843 with a marble of the Vicomte Jules de Valdahon. Subsequently he specialised in portrait busts and equestrian statues or neoclassical statuary on a grand scale. All his work was done in marble and he only merits inclusion in this book by virtue of the fact that his statues were popular subjects for reductions by Collas for casting in bronze by Barbédienne or Susse. In this category come such statues as the Young Fawn (1846), Roman Bull (1859) and Combat of Roman Bulls (1864). His equestrian statue of Francis I, at one time exhibited in the Louvre, was also the subject of bronze reductions which were fashionable in the latter half of the nineteenth century.

COMOLÈRA, Paul (1818–1897)

Born in Paris, Comolèra was a pupil of Rude who specialised in animal studies and first exhibited at the Salon in 1847, making his debut with a study of a Golden Pheasant. In subsequent years he showed a Dog and Indian Cock, and a female Golden Pheasant (1848). A Quail caught in a Snare (1849), Partridge and Thrush (1851), Heron wounded by an Arrow (1852), Hare (1859),

58

Paul Comolèra
Deerhound 8″
Paul Comolèra
Fighting Cockerels 17½″

Pheasant (1863), Grouse and Weasel (1864), Wounded Partridge (1865), Dead Partridge (1866), Water Rail (1867). Other bronzes by Comolèra include a Bull, Birds Fighting, a Game Cock, Fighting Cockerels, a Dead Finch, a Group of two Dead Birds, a Cock and Hen (also reproduced in fayence by Boulanger of Choisy), and the Crowing Cock known as *Le Reveil de la Gaule*. Bronzes were edited for Comolèra by Susse and also A. Gouge. Moigniez (qv) was one of his pupils.

CUVELIER, Joseph (–1878)
Very little is known of this artist, other than that he was born in Commines and died in 1878. He exhibited at the Salon between 1868 and the year of his death and produced a number of animal studies, mainly horses and ponies.

CUMBERWORTH, Charles (1811–52)
Despite his English name Cumberworth was born at Verdun on 5th October 1811 and died at Paris on 19th May 1852, having spent his entire life in France. He entered the *Ecole des Beaux Arts* in 1829 and first exhibited at the Salon in 1833, with the portrait bust of a young child. Cumberworth specialised in portrait busts and allegorical statuary, in the prevailing classical tradition, but a few minor studies have come from his hand. A lidded inkwell in the form of a turtle, 4 inches high and bearing his signature, was sold at Sotheby's in February 1970.

DELABRIERRE, Paul-Edouard (1829–1912)
Born in Paris on 29th March 1829, Delabrierre was a pupil of the painter Delestre who later turned almost exclusively to animal sculpture. His first works to be shown at the Salon (1848) were a Terrier holding a Hare and a Wounded Deer. Among his later works were Stags Fighting, *La dernier Pas* (a hunted deer) and Deer attacked by two Wolves (1849), Boar pursued by Dogs, Basset Hound, Bear Family, Family of English Dogs and Lion bitten by a Snake (1851), The Sorrows of a Mother – a bitch with her young, Bengal Deer seized by a family of Jaguars, Tiger and Crocodile (1852), Danish and Chantilly Dogs, Wounded American Stag (1853), Lion and Crocodile, Tiger and Serpent (1855), Horseman surprised by a Panther, Royal Tiger of Bengal, Panther of Java, French Stag (1857), Indian Panther devouring a Heron, Indian Panther (1859), Setter guarding Game (1863), Bengal Tiger, Deer of Cochinchina (1864), Bengal Tiger (1865), Lion and Antelope from Senegal (1866), Lion and Roebuck (1867), Dog and Rabbit (1868), Dog and Pheasant

59

Paul-Edouard Delabrierre
Bears sparring 8¼″

(1868). Delabrièrre exhibited regularly at the Salon till 1882 and among his later works may be mentioned his Tired Racehorse, Retriever, two Game-dogs looking at a Bird, a group of Cocks, Hens and Chicks, Sparrow-hawk, Fox and Wild Duck, Arabs hunting with Birds, Picador, Greyhound and Tortoise, Pointer, Pheasant and Bears Sparring. Delabrièrre's most important work was his large composition entitled Equitation, for the façade of the Louvre. His Indian Panther devouring a Heron is preserved in the Museum at Amiens.

DEMAY, Germain (flourished 19th century)
Nothing is known of this sculptor other than that he was a pupil of Barye and exhibited at the Salon between 1844 and 1848. A bronze retriever by this artist was sold at Sotheby's in March 1970.

DEVREESE, Godefroid (1861–)
Born at Courtrai on 19th August 1861, this Belgian artist studied at Brussels under Simonis and Van der Stappen. He made his debut in Paris in 1895 at the Nationale des Beaux Arts and exhibited regularly at the Salon from that date onward. Devreese specialised in human figures and his statues of the Philosopher and the Fisherman are in the Museum of Courtrai and the Luxembourg respectively. He also produced some small bronzes of animal subjects, particularly equestrian subjects. A figure of a woman riding side-saddle was sold at Sotheby's in February 1970.

DUBUCAND, Alfred (1828–)
Born in Paris on 25th November 1828, Dubucand was a pupil of Lequien. He first showed at the Salon in 1867, making his début with a Dead Pheasant modelled in wax. Among the more important of his works are Valet restraining the Dogs (1868), Griffon attacking a Duck (1868), Spaniel and Hare (1869), Stag and Hind, Return from the Hunt at Courre (1870), Egyptian Gazelle Hunt (1873), Hunting in the Sahara (1874), an Ostrich Hunt in the Sahara (1875), Ass-driver of Cairo (1876), Persian Hunter (1878). Many of these works were exhibited as wax models and subsequently edited in bronze. Dubucand produced bronzes of famous racehorses, including the stallions Niger and Kaolin. Other works which he sculpted include Two Labradors, Tired Pony carrying a Deer, Pointer carrying a Hare, Cock Pheasant with a Lizard and Stalking (a pony and two staghounds).

60

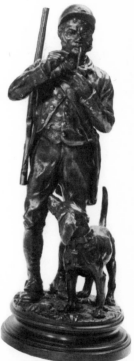

Godefroid Devreese
Bronze equestrian group,
signed and dated '86 23″

Alfred Dubucand
Huntsman and Hound

FAUGINET, Jacques-Auguste (1809–1847)

Born in Paris on 22nd April 1809, Fauginet was a pupil of Gatteaux and entered the *École des Beaux Arts* in April 1826 where he studied medal engraving before switching to sculpture. In 1831 he was awarded a second prize for a medallic engraving of Oedipus explaining the riddle of the Spinx. At the Salon of 1831 he showed portrait busts and two years later exhibited medallions and plaques, but some indication of the way in which his art was developing was shown in the plaques of horses and ponies commissioned from him by Lord Seymour in 1833. At the Salon of 1835 he exhibited a bronze bas-relief of a Thoroughbred Racehorse and a bronze figure of a Pointer. Among the later works which he showed at the Salon were the horse Sylvio (1834), African huntsman fighting a Lion, the Arab Stallion 'Arghal' and the English Thoroughbred 'Sweeper' (1836), Two Horses and a Bull (1837), Dog and Fox (1838), Child seated on a Swan (1839), the Racehorse 'Beggarman' (1841), and the English Mare 'Volante' (1842). His last works to appear at the Salon (1846) were a plaster bas-relief of the Baptism of Christ and a portrait bust of Dr Champion of Bar-le-Duc. Fauginet died in Paris the following year.

FRATIN, Christophe (1800–1864)

Born in Metz, Fratin was the son of a taxidermist and undoubtedly gained his sound anatomical knowledge of animals from his father. Fratin studied painting under Pioche and later the celebrated Gericault from whom he acquired an affinity for horses and equestrian subjects. His début, at the Salon of 1831, was with wax models of the English Thoroughbred 'Farmer', and a study of two

61

Christophe Fratin
Equestrian Group,
signed 38″

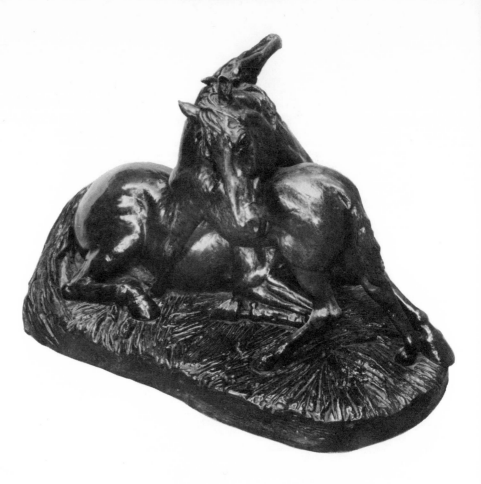

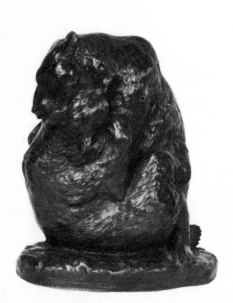

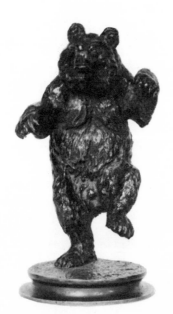

Christophe Fratin
Bears wrestling 6¾″

Christophe Fratin
Dancing Bear

Christophe Fratin
Dancing Monkey 6¾″

Christophe Fratin
Horse attacked by Wolves
$17\frac{1}{2}''$

Christophe Fratin
Mare and Foal $16\frac{1}{2}''$

63

Christophe Fratin
Equestrian group,
signed 12½″

Christophe Fratin
Arab Stallion prancing,
base signed Fratin 11¼″
Christophe Fratin
Stag, signed 23″

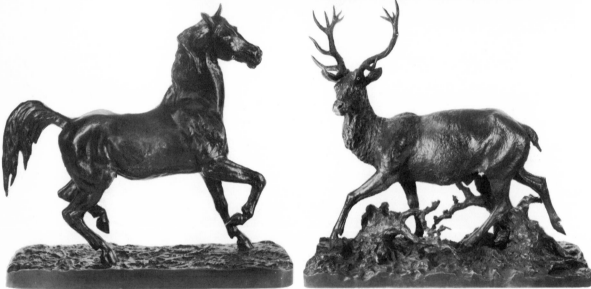

Bulldogs fighting over a Hare. Two years later he showed a plaster study of a hare, a chained dog and a bronze of an *ecorché* horse (i.e. one in which the anatomical detail is clearly delineated). From then until 1863 he was a regular exhibitor at the Salon, winning many medals and receiving several important State commissions. In the latter category come his Wild Horse attacked by a Tiger which is in the square of Petit-Montrouge in Paris, a Thoroughbred Horse (for the Ministry of the Interior, 1850) and the Horse attacked by a Lion (Ministry of State, 1853). His more important works, exhibited at the Salon, were Canadian Deer hunted down by Dogs, the Thoroughbred 'Felix', Panther seizing a Gazelle and a Dead Cow being eaten by Wolves (1834), Vulture devouring a Gazelle, Tiger throwing down a young Camel, Lion devouring a Zebra, Elephant killing a Tiger, Lioness carrying its prey to its Cubs, Reclining Deer, Dead Horse, the Stallion 'Rainbow' (commissioned by M. Rieussec), Bull fighting with Dogs and Three Stud-Horses (1835). Lion overpowering its Prey and Tiger holding its Prey (1836), Mare and Foal (1837),

Eagle and Vulture quarrelling over their Prey (1839). From then until after the Revolution Fratin did not exhibit at the Salon, but in 1850 he re-entered the arena with his Thoroughbred in bronze and various figures and studies in plaster or terra cotta. These were followed by the Triumph of the Eagle (1852), Horse attacked by a Lion (1853), Resting Stag listening to the Trumpet (1861), and Arab Horse (1863). Fratin died at Raincy (Seine-et-Oise) in August 1864.

The city of Metz possesses a fine collection of Fratin's works while important holdings of his bronzes are in the Wallace Collection (London), the Eisler Collection (Vienna), in Potsdam, and the Peabody Institute (Baltimore). A fine example of one of his larger sculptures is Two Eagles guarding their Prey (1850) now in New York Central Park. Fratin's early work in plaster was edited in bronze for him by Susse Frères, but subsequently he superintended the casting of his bronzes in the workshops of E. Quesnel or A. Daubré. See Appendix for a more detailed list of Fratin's bronzes.

GARDET, Georges (1863–1939)
Born in Paris on 11th October 1863, Gardet was a pupil of Aime Millet and Frémiet (qv), and became one of the more outstanding Animalier sculptors of the late nineteenth century. Both his father (Joseph) and brother (Antoine) were sculptors of note, though never approaching him in quality or brilliance. Gardet exhibited regularly at the Salon from 1883 and won many prizes and honours, including third and second class medals (1887 and 1888) a medal of the *Exposition Universelle* (1889) and a *grand prix* at the Exposition of 1900. He was a member of the Society of French Artists and of the Academy of Fine Arts, being appointed Chevalier (1896) and Officer (1900) of the *Legion d'Honneur*. Gardet enjoyed tremendous popularity with his animal statuary and although he mainly worked in marble, his works were produced in bronze reductions or were reproduced in Sèvres porcelain and many of his sculptures are preserved in museums all over the world. Among the more notable may be cited Two Panthers (Simu Museum, Bucharest), *Le Précurseur* (Hamburg), Lion and Lioness (Limoges), Chantilly Dogs (Limoges), Panthers and Parrots (Musee d'Art Moderne, Paris), Great Dane (Petit Palais, Paris), *Mézence blessé* (Roanne) and Fallow Deer (Port Dauphine, Paris). Among the more monumental works are the Tiger and the Bison which decorate the entrance to the Laval Museum and the group of a Panther and Python in the Parc Mountsouris which won him a third class medal at the Salon of 1887. Among his smaller works may be mentioned Tiger and Tortoise, Seated Bear, Two Mice investigating a Snail, and Lioness looking at a Snake over her dead Cubs.

GAYRARD, Raymond (1777–1858)
Born at Rodez (Aveyron) on 25th October 1777, Gayrard studied sculpture under Boizot, Taunay and Geoffroy. He was of a generation before Barye and Fratin, to whom credit for founding and popularising the Animalier movement must be given. The majority of Gayrard's works consisted of portrait busts and medals or statues of saints and classical figures in the best academic traditions. Apart from several marble groups of children with dogs or pet rabbits there is little to suggest that Gayrard was particularly interested in animals as fit subjects for sculpture. More significant perhaps are the equestrian statues of Henry IV (1814) and the memorial to General Tarayre (1857) which demonstrate an ability to model horses. The Sladmore Gallery exhibition 'The Horse in Bronze' (1969) featured a bronze of a Harness Horse bearing the signatures of Gayrard and Emile Boyer. It is assumed that these sculptors collaborated since their signatures have been found together on other work.

GECHTER, Jean-Francois-Theodore (1796–1844)
Born in Paris, Gechter was a pupil of Bosio and a contemporary of Barye, but unlike him chose to follow closely the prevailing academic climate. Thus the vast majority of his works are in the classical tradition – gladiators, medieval

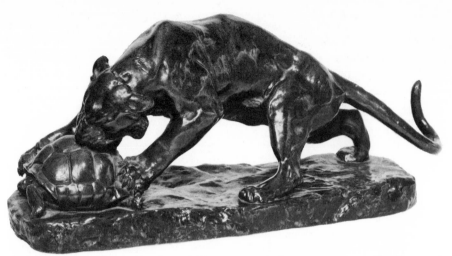

Georges Gardet
Tiger and tortoise 7½″

knights, figures from Greek and Roman mythology, statuettes of saints and kings of France. He made his début at the Salon in 1827 with a group of Pirithous overpowering a Centaur. Nevertheless Gechter came under the influence of the Animaliers to some extent in his later years and had he lived longer it is likely that he would have produced more in this *genre*. His English Thoroughbred, cast in iron and exhibited at the Salon of 1838, is certainly characteristic of the Animalier school and one of his last works, sculpted shortly before his death, was a group showing a Stag and a Lion. He is also known to have produced bronzes of greyhounds, while many of his equestrian groups demonstrate sensitive modelling of the horses. His group showing the medieval hero Charles Martel in combat with Abderame, king of the Saracens, was exhibited at the Salon of 1833 and was the subject of many *bronzes d'edition*. Under the description of "crusading knight attacking infidel" this bronze was featured in a Sotheby's sale in 1970.

HINGRE, Louis-Theophile (c. 1835–1911)
Born about the year 1835 at Ecouen (Seine-et-Oise), Hingre was a pupil of Gervois and Posset, making his début at the Salon in 1863 with a Marsh Heron. In subsequent years he showed a silvered-bronze Chicken (1868), an English Cat (1869), a Dromedary (1872), plaster bas-reliefs of fruit and flowers (1876), a Family of Partridges (1877) and plaster bas-reliefs of fish and vegetables. A small bronze of a Fox, signed 'T. Hingre' was exhibited at the Sladmore Gallery (Barye to Bugatti) in 1968.

ILLIERS, Gaston d' (1876–)
Born on 26th June 1876 at Boulogne-sur-Seine, he was a pupil of the Comte de Ruillé and G. Busson and first exhibited at the Salon in 1899. D'Illiers specialised in horse sculpture with such subjects as Plough-horse, the Departure for the Fair, group of Hunters in the time of Louis XV, and especially his studies of horses in action during the First World War. Of the latter the best known are Artillery Team, Wounded Cavalry Horse, Dead Mule, and the group sculpted as a memorial to the horses killed in the war. He was equally versatile in modelling racehorses, many of which were edited in bronze. An Arab pony by d'Illiers was sold at Sotheby's in 1970.

JACQUEMART, Henri-Alfred-Marie (1824–96)
Born in Paris on 22nd February 1824, he was a pupil of Delaroche and Klagman and attended the *École des Beaux Arts* from 1845 onwards.

66

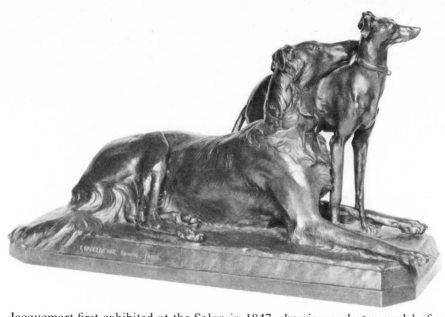

Georges Gardet
Borzoi and Whippet 11¼"

Jacquemart first exhibited at the Salon in 1847, showing a plaster model of a heron. Between that date and 1879 he was a regular contributor to the Salon, specialising in Animalier subjects. His principal works in this field, shown at the Salon, were Tunisian Horse (1848), Watching Tiger (1851), a Hare, a bas-relief of the German Basset Hound 'Sir Erdman' (1853), Lion (1855), Menagerie Lion (1857), equestrian statue of the general commanding the French Army in Italy in 1796 (plaster) and 'Moloch', a hound belonging to the pack of M.B. of Chantilly (marble) (1863), bronze version of the equestrian statue (1864), Prisoner delivered up to the Beasts (1865), Dog-handler (1866), equestrian statue of Louis XII for the Compiegne town hall (1869), Camel-driver of Asia Minor (1877) and Nubian Dromedary (1879). Jacquemart won several medals for his figures and received the *Legion d'Honneur* in 1870. He was commissioned by the State and various public bodies to execute sculptures, many of which may be seen to this day. They include the sphinxes on the fountain of the Chatelet de la Victoire (1858), the two winged griffons on the fountain of St Michel (1860–61), the eight bronze lions on the Place Lobau facade of the town hall, two eagles on the west facade of the Opera and the Rhinoceros on the fountain in front of the Trocadero. His sojourn in Turkey and Egypt, which resulted in the figures of camels and dromedaries, also produced commissions to sculpt the four lions for the Kars-et-Nil bridge in Cairo, and the colossal statue of Mehemet Ali for Alexandria. To the last years of his life belong several statues of important personalities, such as the Egyptologist Mariette and the bust of Maire Nethien in the graveyard at Rouen (1884). Jacquemart also supplied designs used by the goldsmith Christophle, including the decoration on the great Vatican 'Bull-shrine' for Pope Pius IX. Bronzes by Jacquemart are featured in various museum collections and include Antelope and Snake (Aix-les-Bains), Lioness (Bergues), Stag (Chambéry) and Camel (Nantes). Other small bronzes by Jacquemart which may be encountered are Greyhound, Staghound and Tortoise, Bull and Stable Companions (a stallion and long-haired terrier). Bronzes by Jacquemart may be found signed A-J or 'A Jacquemart.'

LECOURTIER, Prosper (1855–1924)
Born at Gremilly in 1855, Lecourtier was a pupil of Frémiet (qv) and Coutant and exhibited at the Salon in the later years of the nineteenth century, gaining a third class medal in 1880, a second class medal in 1879 and a first class medal

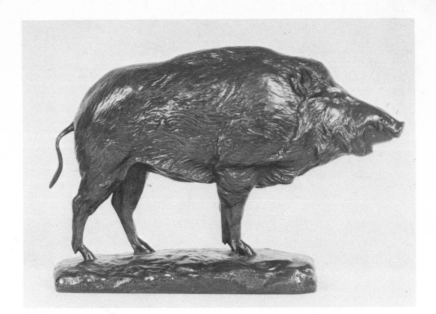

Georges Gardet Boar 7″

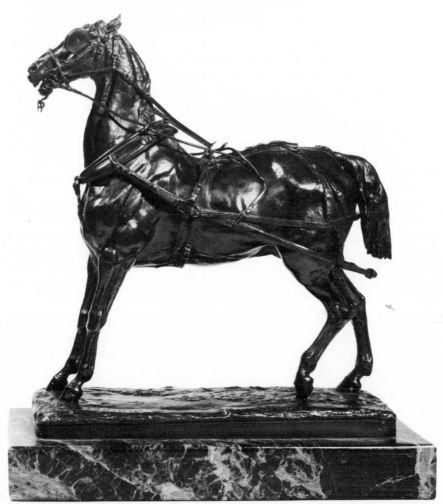

Raymond Gayrard
Harness Horse 13″

Raymond Gayrard
Deerhound, silvered bronze
dated 1848

in 1902. At the *Exposition Universelle* of 1900 he was awarded a bronze medal.
The museum at Provins contains a bronze group by him entitled Great Dane
suckling her Young, while the Tourcoing museum has The Forgotten One
(*L'Oublie*) – a sensitive study of a braying donkey. A bronze of his Stalking
Lion, exhibited at the Salon of 1898, was sold at Sotheby's in 1970.

LENORDEZ, Pierre (flourished 19th century)
Little is known about Lenordez other than that he was born in Vaast (Manche)
and subsequently worked in Caen. He exhibited at the Salon between 1855
and 1877, making his debut with a wax model of 'The Baron', a horse of the
imperial stud in the Bois de Boulogne. In later years he showed Stallion and
Brood-mare (1861), Half-breed Mare (1867), Episode from the Surrender of
Sedan (1874), Huntsman sounding his Horn (1876) and Slave and Sultan on
Horseback (1877). Lenordez specialised in racehorses and among his other
works may be noted the bronzes of the stallions 'Royal' and 'Ibrahim', a group
of a Stallion and Terrier, and the matched pair of bronzes featuring a racehorse
and jockey in the saddling enclosure and cantering to the start.

The Sladmore Gallery's exhibition of 1969 entitled The Horse in Bronze
included a Welsh Pony by Lenordez, signed and dated 1860. Another bronze
depicts a blacksmith shoeing a pony.

LEONARD, Lambert-Alexandre (1821–)
Born in Paris on 18th March 1821, Leonard studied sculpture under Jacquot,
Rouillard and Barye (qv), imbibing from the last-named a love of animals.
He was an exhibitor at the Salon from 1851 to 1873, confining his work
entirely to Animalier sculpture. The works exhibited were a Heron (1851),
Fox and Partridge – in wax with a silvered finish (1853), Thrushes fighting
(1859), a group of Sparrows and Watching Thrushes (1861), Foraging Chickens
(1863), Wild Ducks surprised by a Fox (1863), Wounded Bittern (1865), Eagle
guarding its prey, The Wolf and the Swan (1866), Heron surprised by Spaniels
(1867), Male and Female Turkey and After the Hunt (1868), Arab surprised by
Lions (1869) combat of Eagles (1870), Waterhens (1873). Sculptures by
Leonard may be found in plaster, wax or wax with a silver finish, but they
were also edited in bronze more or less simultaneously. Bronzes by him bear
the signature 'A. Leonard'.

Henri-Alfred-Marie
Jacquemart Stable
companions, signed 13½″

Pierre Lenordez
Arab Stallion, signed 14″

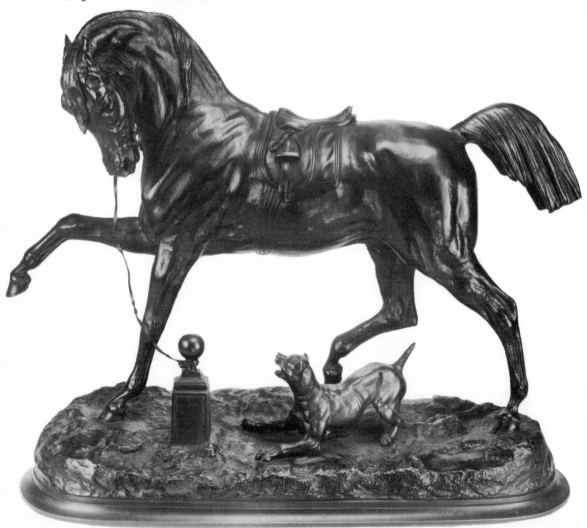

70

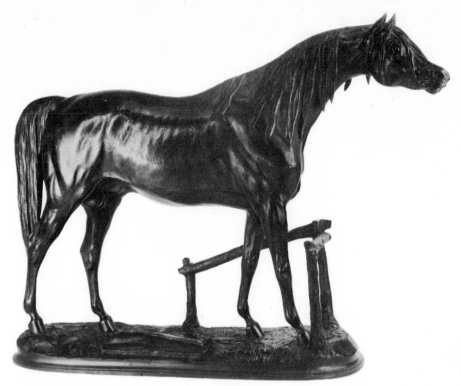

Pierre Lenordez
Arab Stallion, signed
18½″ long

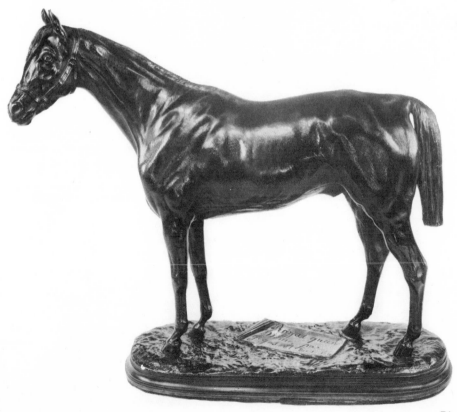

Pierre Lenordez
Horse, signed 15″

LOISEAU-ROUSSEAU, Paul-Louis-Emile (1861–1927)
Born in Paris on 20th April 1861, Loiseau-Rousseau was a pupil of Barrau. He exhibited at the Salon around the turn of the century, winning a third class medal in 1892 and a second class medal three years later. He was awarded a gold medal at the *Exposition Universelle* of 1900 and created a Chevalier of the *Legion d'Honneur* a year later. He won a travelling scholarship in 1892 and spent some time in Africa, as a result of which he made a speciality of African subjects, both animals and human figures. His best known works in the Animalier field are Picador and Bull and Panther Hunt, both of which are represented in the museum at Nice. A cold-painted spelter figure of a racehorse and jockey, sold at Sotheby's in May 1970, bore the signature 'E. Loiseau' and may have come from his hand.

MAILLARD, Charles (1876–)
Born on 29th June 1876, Maillard studied under Barrias and Coutan. Little is known of him, though he exhibited at the Salon in 1901 and received an honourable mention. Many of his models of animals were reproduced in porcelain as well as bronze. A figure of a Hare, signed by Maillard, was sold at Sotheby's in March 1970.

MALISSARD, Georges (1877–)
Born at Anzin on 3rd October 1877 Malissard specialised in equestrian subjects, receiving important State commissions after the First World War to produce statues of Marshals Foch, Lyautey and Petain. He also sculpted

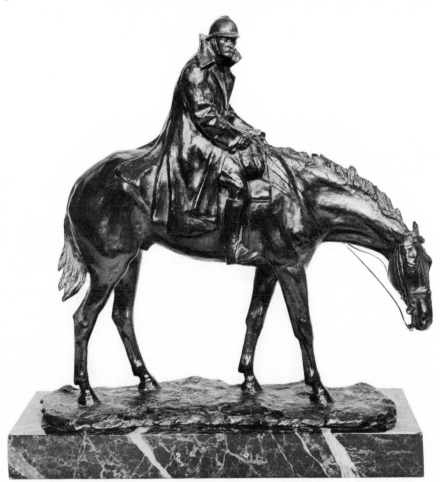

Georges Malissard
French Cavalry Officer 19½″.

equestrian statues of Albert I, King of the Belgians, and King Alfonso XIII of Spain. His small bronzes were edited for him by Valsuani using the *cire perdue* process. The Sladmore Gallery exhibition of The Horse in Bronze featured a French Cavalryman, signed by Malissard and dated 1922.

MARCHAND, Désiré (flourished 19th century)

Beyond the fact that he exhibited at the Salon between 1843 and 1846 nothing is known of this artist. Both Bénézit and Bellier-Auvray mention him as an animal painter, the latter listing several works featuring horses. Whether his horse studies were also produced in the three-dimensional medium (as Rosa Bonheur did with her animals) and whether, if that is the case, he also took wild animals as his subjects, is a matter for conjecture unsupported by concrete evidence. A figure of a Lioness on a Rock, sold at Sotheby's in May 1970, bears the signature 'Marchand'. The only nineteenth century sculptor with this surname was Paul-Emile-Alexandre Marchand, but he is only recorded as having produced marble busts and allegorical subjects in neo-classical styles and it is therefore highly unlikely that he would have dabbled in Animalier subjects.

MÉNE, Pierre-Jules (1810–1877)

Born in Paris on 25th March 1810, Mêne was the son of a metal-turner. Unlike the majority of the Animaliers, Mêne usually edited his own work, and undoubtedly his family background helped to give his the necessary technical training. As a sculptor he was largely self-taught, although he received some tuition from the sculptor, Réné Compaire. Mêne became one of the most fashionable of the Animaliers and received the *Legion d'Honneur* in 1861. His work was popular in Britain as well as France and this explains in some measure the comparative abundance of his bronzes in Britain, where he exhibited at the Great Exhibitions of 1851 and 1862. In 1838 he established his own foundry in order to cast his work in bronze, and in the same year he

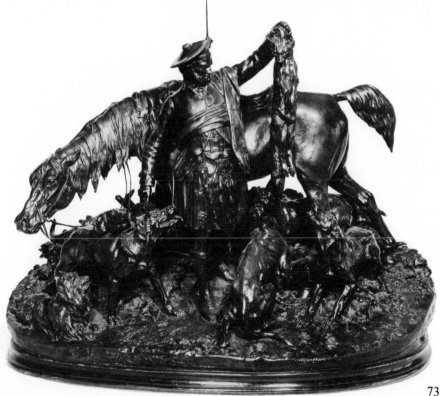

Pierre Jules Mêne
After the Hunt in Scotland
$20\frac{1}{2}'' \times 26''$

73

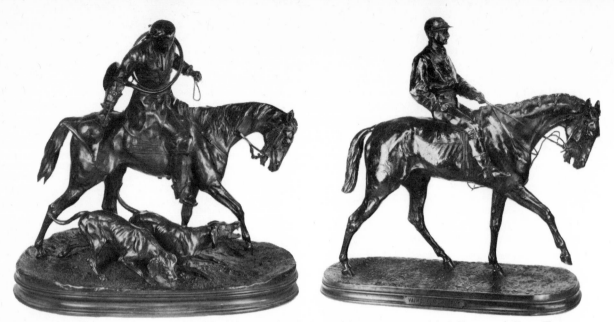

Pierre Jules Mêne
Horse and Jockey, signed
and dated 1868 15½"
Pierre Jules Mêne
Hunting group, signed 17½"

made his début at the Salon with a group entitled Dog and Fox. Two years later he showed Horse attacked by a Wolf, as well as various small animal figures in bronze or terra cotta, the most notable being a Stag and a Merino Ram. From then until his death he was a regular exhibitor at the Salon and received awards as well as State commissions. At the celebrated Salon of 1848, in which he exhibited three wax models entitled Partridge Hunt, Boar Hunt and Fox with Young, as well as a bronze of a Half-bred Ram and a plaster group of Two Hares, he was awarded a second class medal. First class medals came to him in 1852 and 1861 for figures of the Arab horses 'Tachiani' and 'Nadjebé', Roe-deer and Heron and Dog with Game (1852) and *Chasse en Ecosse* (usually known in English as After the Hunt in Scotland), Roe-deer and a still-life group of Hare and Fish (1861). A wax group of Terriers won him a third class medal in 1855. Many of his figures, apart from *Chasse en Ecosse,* were designed specifically for the British market, the best known being his Derby Winner, exhibited at the Salon of 1863 in wax and in bronze the following year. Mêne is perhaps, after Barye, the most widely known of the Animaliers and the sculptor whose work, more than any others, set the standard for the Animalier school. While his work shows great originality and an astounding versatility in subject, much of the work in this *genre* produced by his son-in-law Cain (qv) and the later Animaliers was derived from him and seldom attained the same level of brilliance or individuality. Examples of his work are preserved in museums all over the world, from Marseilles to Melbourne, including the Louvre and the Ashmolean at Oxford.

Like Barye, Mêne studied animals as closely as possible, but he ranged more widely in his choice of subject, including domestic animals such as cows, bulls, dogs, sheep and horses as well as the more exotic caymans, jaguars, panthers and gazelles. He was equally at home in the sculpture of race-horses and game-birds, while his equestrian statuettes from the period of Louis XV compare favourably with the historical bronzes of Frémiet. The best of Mêne's bronzes are those which he edited himself between 1838 and 1877 and his autograph work is outstanding for the delicacy and sensitivity of the modelling and the extremely meticulous afterwork. This is evident in the amount of fine detail and the skill with which finely chiselled lines may be seen in Mêne's autograph bronzes. After his death many of Mêne's bronzes were edited by Cain and these are also generally of a high technical standard. Subsequently

74

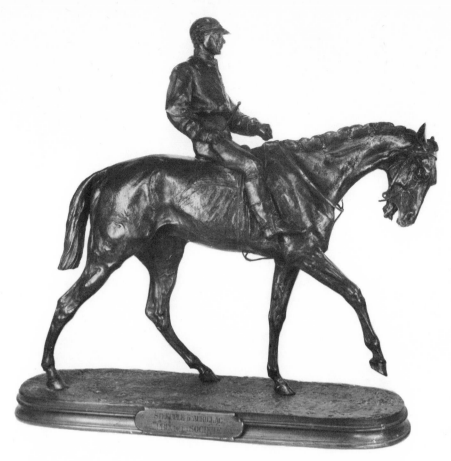

Pierre Jules Mêne
Horse and Jockey, signed 16″

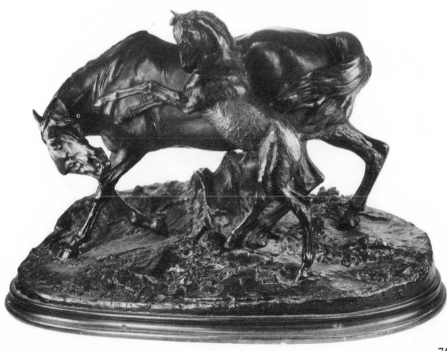

Pierre Jules Mêne
Mare and her Foal, signed
and dated 1850 19″ long

75

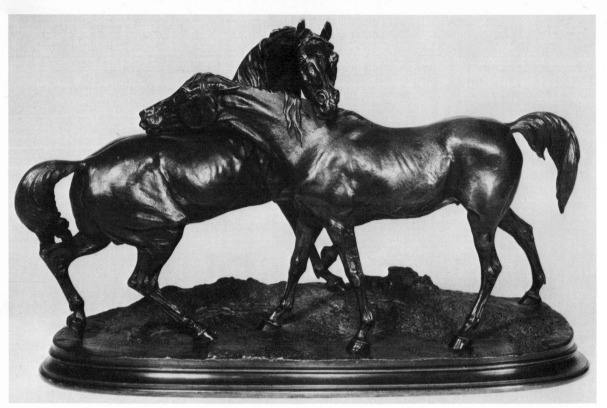

Pierre Jules Mêne
L'Accolade, signed 20″

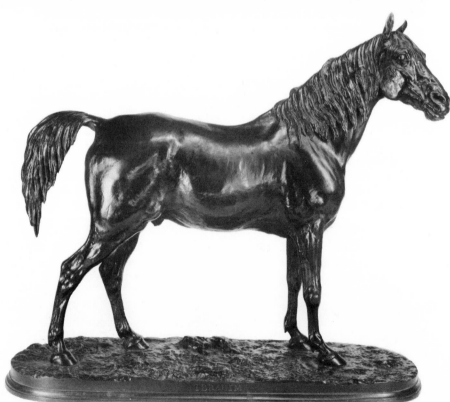

Pierre Jules Mêne
'Ibrahim', signed 13″

76

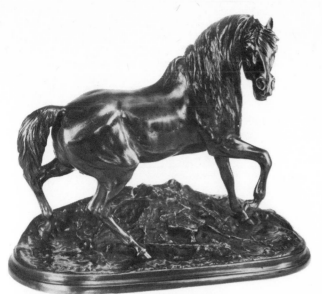

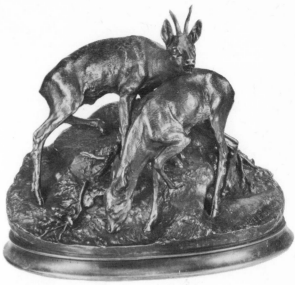

about 200 of Mêne's models were acquired by Susse Frères who produced casts of them in the latter years of the nineteenth century. Bronzes from their workshops bear Mêne's signature but also have the Susse foundry mark. Although not as finely finished as Mêne's own work, these bronzes are technically excellent and fetch correspondingly high prices. Barbédienne also acquired some of the Mêne models which, of course, may be recognised by the stamp of that foundry. The Coalbrookdale Company of England made copies of several of Mêne's works and signed them 'Coalbrookdale-Bronze'. Though not as highly prized as the French versions these bronzes are not without some merit. Indeed, it seems to have been a point of honour for the Coalbrookdale Company to pay a great deal of attention to the afterwork of these bronzes in order to demonstrate their mastery of this medium. Some of them are of exceptional quality and it is known that they were produced as exhibition pieces for the Great Exhibition of 1862. Though strictly outside the scope of this work it is interesting to note that several of Mêne's figures were reproduced by Copeland's in the white unglazed porcelain known as Parian ware, about 1860. Unfortunately the work of Mêne, like Barye, was subject to later 'recasts' and these are in many instances quite inferior to the editions of Susse and Barbédienne. It is not known who produced these bronzes, though it is assumed that some of the original models fell into the wrong hands in the early 1900s, but the majority of these late casts were made from actual bronzes and not from the original plaster models. This may be demonstrated from the fact that the pirated editions are somewhat smaller in their dimensions than the genuine bronzes, the new piece-moulds taken in plaster from the bronzes have shrunk on drying out. The difference in size may be marginal and not always an infallible guide to detection, but detail and patina are much better indications. Rich black and deep shades of brown are typical of Mêne's work; bronzes purporting to be by Mêne but possessing a dull, lifeless green patina are highly suspect. Inevitably the amount of detail in the minor points of the bronze is the best pointer to a bronze being autographed Mêne, a later Barbédienne, Susse or Coalbrookdale edition, or a comparatively worthless twentieth century copy. A catalogue of Mêne's bronzes, available from the atelier which he operated in conjunction with Cain, was published by them and lists over 130 figures, groups, bas-reliefs and plaques. This is by no means the total figure for bronzes produced by Mêne and a tentative list, based on his catalogue together with

Jules Moigniez
Cavalier King Charles
Spaniel 14½″
Jules Moigniez
Wading Bird 21¼″

those exhibited at the Salon in his lifetime, featured in more recent exhibitions or sold at auctions in the past few years, is given in the Appendix.

MOIGNIEZ, Jules (1835–1894)

Born at Senlis in 1835, Moigniez was a pupil of Comolèra (qv) and made his debut at the Salon in 1855 with a plaster group of a Setter seizing a Pheasant and a plaster group of a Hobby (small hawk) quarrelling with a Weasel over a Sky-lark. Four years later he exhibited his Setter hovering over a Pheasant, now preserved in the Chateau of Compiègne. From then until 1881 he exhibited regularly at the Salon. Among his best known works were Heron, King Charles Spaniel, Merino Ram from the Farm of Wideville, Scottish Dog, Reclining Dog (1861), silvered bronze figure of a Tiercel (1863), Pheasant and Weasel (1864), Partridge Family (1865), Egret, group of Gazelles (1866), Buck and Doe, Sparrows Fighting (1867), Cock defending his Family (*Exposition Universelle*, 1867), Trotting-horse 'Bayard', Quarrel between the Greyhounds 'Mina' and 'Jacquot' (1876), Basset-hound 'Belot', Scottish Greyhound and Havana Dog (1877), Stallion 'Chief-Baron' (1878), 'Thio', pure-bred New-foundland Dog, and 'Sultane', half-bred Newfoundland Dog – a group in painted plaster commissioned by M. Götzer (1879), plaster bas-reliefs and plaques (1881). Moigniez was fortunate in that his father was a metal gilder, from whom he learned much regarding the technical aspects of bronzes. Moigniez *père* established a bronze foundry in 1857 in order to cast his son's work and several other sculptors are known to have had their bronzes edited there. After the death of his father Moigniez had his bronzes edited by A. Gouge. Like Mêne, Moigniez was fashionable in Britain and paid a great deal of attention to his export market, as the number of English and Scottish subjects he sculpted testifies. He received a medal at the Great Exhibition of 1862. It has been estimated that more than half of Moigniez's total output was exported and this accounts for the large number of his bronzes which are to be found in collections in Britain and America. A list of bronzes by Moigniez is given in the Appendex.

MONARD, Louis de

Born at Autun (Saône et Loire) on 21st January 1873, Monard exhibited regularly at the Salon in the years around the turn of the century, where he showed busts and animal groups. His group entitled Young Bucks in Combat

Jules Moigniez
Irish Setter 8½″

Jules Moigniez
Mare and Stallion 13″ × 17″

79

Jules Moigniez
Racehorse and Greyhound
at Chantilly 16″

stands on the terrace of the Luxembourg while other animal groups are to be found at Sèvres, the Paris town hall and at Cahors. He was also responsible for the monument to the airmen killed in the First World War which stands in the *Chapelle des Invalides*. Monard specialised in horses and dogs, though he also produced occasional bird subjects. Among his bronzes may be mentioned Hunting Terrier, Snarling Terrier, Terrier gnawing a Bone, Riding Cob, Groom restraining a Stallion, Two Stallions Fighting, Horse with rear foreleg raised and a Swan.

PARIS, Réné
Born in Paris on 26th November 1881, he was a pupil of Thomas, Gardet (qv) and Peter (qv). Paris made his début at the Salon in 1906, receiving an honourable mention the following year and subsequently winning bronze (1912), silver (1944) and gold (1920) medals for his animal sculptures. He specialised in figures of horses. The Sladmore exhibition The Horse in Bronze, featured his bronze of 'Pearl Diver', the 1947 Derby winner.

PASSAGE, Arthur-Marie-Gabriel, Comte du (1838–1909)
Born at Frohen (Somme) on 24th June 1838, the Comte du Passage was a pupil of both Barye and Mêne (qqv). Although he had a town house on the Avenue des Champs-Elysées most of his life was spent at his country seat at Frohen where he died in February 1909. He exhibited at the Salon from 1865 onwards, making his début with a wax model of a Dying Roe-deer. Subsequently he exhibited the Steeple-chaser 'Franc-Picard' (1866), Steeplechaser jumping a fence (1867), Mare being harnessed by a Groom (1873), Gallic Huntsman bringing back a Wild Boar (1874), Gallic Hunter returning to the Chase (1875), Jeanne d'Arc (1876), Jeanne d'Arc dedicating her Standard to God (1877), The Relay (a wax group of fresh horses) (1878), The Last Effort (1880) and Hunter at the Trot (1881). The Sladmore Gallery (Barye to Bugatti) record two bronzes bearing the signature 'Ct. du Passage'– Trotting Horse and Groom at Exercise and Setter with Game. A small bronze of a Hare in Flight was sold at Sotheby's in 1969. The Comte du Passage is better known,

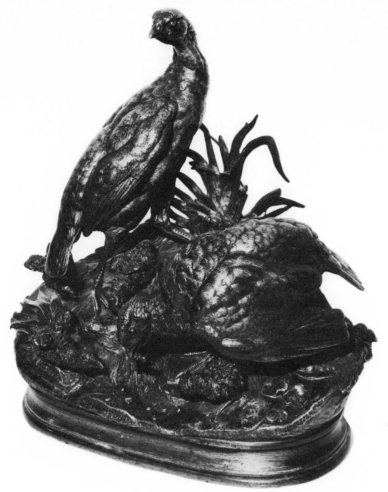

Jules Moigniez
Pair of Partridges with
Young 15″

Louis St. Monard
Two bronze Terriers 12½″

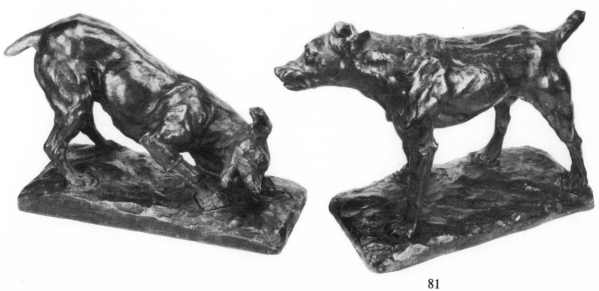

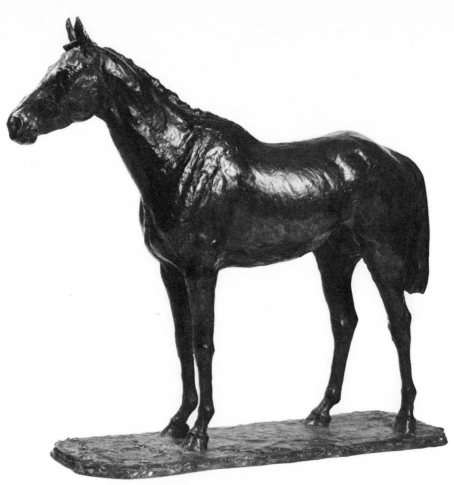

René Paris
Thoroughbred Colt
'Pearl Diver' 16½″

however, as a painter of animal subjects and examples of his pictures are preserved in the museums at Amiens and Orleans.

PASSAGE, Charles-Marie, Vicomte du (1843–?)

Younger brother of the above, the Vicomte du Passage was also an animal painter who produced a number of sculptures and, indeed, it was with a bronze group of Woodcocks that he made his début at the Salon in 1874. From then until the end of the century he exhibited regularly and among his sculptures should be noted Bull Terrier tormenting a Martin trapped in a Snare (1875), Falcon and Hare, Falcon attacking a Homing Pigeon (1876), Cat and Dog (1877), Goshawk seizing a Heron, Falcon in Flight (1878), Rabbit Hunt, The Poacher (1879), Fox strangling a Cock (1881) and Boars Fighting (1882).

PAUTROT, Ferdinand (flourished 19th century)

Little is known of this sculptor other than the fact that he was born in Poitiers and exhibited at the Salon between 1861 and 1870. At the Salon of 1861 he exhibited plaster groups of a Cross-bred Spaniel, Setter and Teal, and Setter and Partridge. The Spaniel and Teal group was subsequently shown, in bronze, at the Salon of 1863, along with Setter and Hare, and Fox caught in a Trap. In later years he exhibited Pheasant hunted by two Pointers (1864), Dog and Rabbit by a Warren, and Dog (1865), Partridges and Weasel, and Setter and Fox (1866), Snipe and Thrushes (1867), Horse and Roe-deer (1868), Silver Pheasant and Group of Teal (1869), and Cat and Kitten and Chinese Pheasant (1870). The Sladmore Gallery exhibition 'Barye to Bugatti' featured

ten different bronzes by Pautrot – two different Partridge groups, Wading Bird with Frog, Fox, Partridge with Chicks, Finch, Seated Setter, Seated Pointer and Humming Bird. The Seated Setter was exhibited in two sizes, $18\frac{3}{4}'' \times 12\frac{1}{2}''$ and $12'' \times 9''$ respectively. Other bronzes by Ferdinand Pautrot which have come on the market in recent years include a fine group of Two Stags Fighting and a Hare. Bronzes by this artist bear the signature 'F. Pautrot.'

PAUTROT, Jules (flourished 19th century)

The identity of this sculptor is something of a mystery. He was a pupil of Ferdinand Pautrot but whether he was a son or a younger brother is not known and he maintained a separate studio at 13, Boulevard du Temple, whereas Ferdinand Pautrot worked at 65 Rue de Saintonge. It is known, however, that Jules Pautrot was born at Vernon (Eure) and exhibited at the Salon in 1874–5. He made his début with Struggling Falcons, a plaster model which was subsequently edited in bronze and shown at the Salon the following year. In 1875 he also showed Heron and Snake. Bronzes by this artist are signed 'J. Pautrot'.

PETER, Victor (1840–1918)

Born in Paris on 20th December 1840, Peter was a pupil of Cornu and Devaulx. He is best known as a painter of landscapes and portraits but he also practised the medallic art and dabbled in sculpture, showing a preference for animal subjects. His début at the Salon, in 1868, was made with a drawing entitled The Lesson of Love, but when he next returned to the Salon five years later it was with a bronze bas-relief of a Dog and Bitch. From then until shortly before his death he was a regular exhibitor, winning third class (1869), second class (1898) and first class (1905) medals, as well as a bronze at the Exposition of 1889 and a gold medal at the *Exposition* of 1900, being appointed a Chevalier of the *Legion d'Honneur* in the same year. Most of his exhibits at the Salon and elsewhere consisted of portraits, although at the Salon of 1881 he showed nine bas-reliefs in bronze: Goat, Lion, Bull, Percheron Horse, Hind, Horse, Bitch, She-goat and Bulldog. In previous years he showed Lion of Zanzibar (1875) and Bulldog (1878). Bronzes by Peter were cast for him by Hébrard. With the exception of the Zanzibar Lion most of Peter's animal

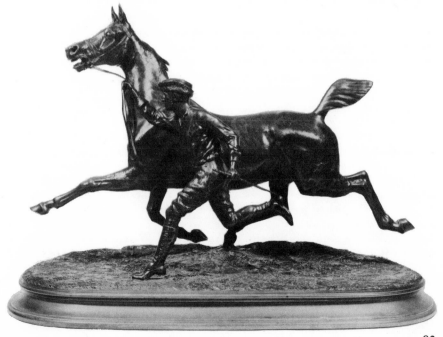

Comte du Passage
Trotting Horse and Groom
at exercise 17"

83

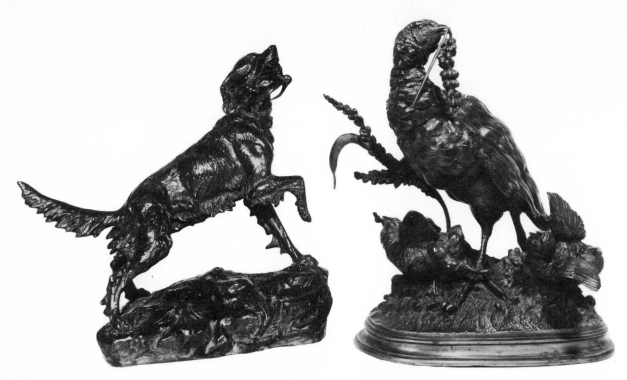

Ferdinand Peutrot
Partridge with Chicks 10½″
Comte du Passage
Setter with Game 15″

bronzes had a two-dimensional character, strongly influenced by his work as a medallist, and consisted of plaques and roundels. At the Sladmore exhibition, Barye to Bugatti, plaques of Duck, Cockerel, Grazing Sheep, Sow and a Cow were shown. These bronzes bore the signature 'V. Peter' and sometimes had the Hébrard foundry mark in addition. Animal sculpture by Peter is preserved in the museum of Caen, which has various groups, and Cahors which contains a fine group of a Lioness and Cubs.

PETERSEN, Armand

Born in Bâle on 25th November 1891, Petersen studied in Switzerland before settling in Paris where he worked between the world wars in the best traditions of the French Animalier school. Petersen was a regular exhibitor at the *Salons d'Automne* and of the Tuileries and also exhibited his work in Bâle, Brussels, Berlin, Budapest and New York. A Hare signed by Petersen was sold at Sotheby's in 1970.

ROUILLARD, Pierre-Louis (1820–1881)

Born in Paris on 16th January 1820, Rouillard was a pupil of Cortot and studied at the *École des Beaux Arts* in 1837, making his début at the Salon in the same year with a plaster model of a Lioness. Rouillard eventually became Professor of Drawing and Mathematics at the *École Imperiale Speciale* but throughout his career worked as a sculptor of animal figures, though in a style which is regarded as rather more academic than that adopted by the Animaliers in general. The list of sculptures exhibited at the Salon is impressive and in 1842 he won a third class medal and received the *Legion d'Honneur* in 1866. Among his more notable works in the Animalier field were Dromedary (1838), Mastiff, Bulldog Bitch, Ewe and Lamb, Horse, Merino Ram, Cow (1839), Pug Dog and Cat Somersaulting, Buck (1840), Lion (1841), Boar Hunt (1842), Buffalo, Bull (1843), Dromedary lying down, Buffalo lying down, Newfoundland Dog (1844), Greyhound (1845), Hind and Kid (1847), Algerian Lion, head of a Moroccan Lion (1848), Lion, Lioness, head of Lion (1849), Scottish Dog (1851), Group of Foxes and Rabbits (1852) Setter 'Medor' (1853), Mastiff

84

and Young (1859), Eagle (1861), head of Ajax, the horse ridden by the Emperor at the battle of Solferino (1863), Greyhound (1864), Stag (1864), bas-reliefs of a Lion and Tiger of Gujerat Fighting and Bulgarian Bulls Fighting – the latter being a model for a frieze in the Belerbey Palace of the Ottoman Sultan (1865), Cow (1866), Lion, Skeleton of an Arab Horse (1868), Cow (1869), Bulls fighting, Tiger (1870), bas-relief of a Tiger (1872), Horse and Jaguar (1873), Bulls fighting (1874), Berkshire Pigs from the Grignon School (1875), two versions of Hind and Fawn (1876), American Stag, European Stag (1877), Stallion 'Dollar' from the Viroflay Stud, Stallion 'Royal' from the Lamballe Stud (1879), head of a Panther, Durham Bull (1880), Sheep-fold, Swine-herd and Pigs (1881).

Rouillard sometimes collaborated with other artists in the production of his sculptures. Thus a fine cup in gold and silver donated by the Ministry of Agriculture and Commerce in a public competition in 1861, was produced in collaboration with Eugène Capy and Auguste Madroux, while the Swine-herd and Pigs group was sculpted with the assistance of Mathurin Moreau. Rouillard was not content to have his works cast in bronze alone, but experimented with other materials. His sculptures may be found in plaster with a bronze finish, in zinc, plaster with a galvanised zinc finish, oxydised silver, or in iron with a bronze finish. Rouillard was also given numerous State commissions and examples of his larger work may be seen to this day. The old Louvre had a monumental group of Diana, nymphs and animals, while two dogs and the head of a huntress grace the Richelieu pavilion in the new Louvre. Other bas-reliefs by Rouillard, designed to ornament the windows in the Louvre included two lions and a shield (clock room), a horse accompanied by two tritons (stable courtyard), the Genii of the Fine Arts with their animal attributes (the library passageway), a Wolf clutching a Young Dog by the Head (on the approach to the Emperor's stable). The same site also has a Combat between Wolf and Mastiff and Boar seized by a Dog. The gateway of the former Imperial Riding-School at the Louvre bears a group of three horses by Rouillard, executed in bronze in 1863. Rouillard sculpted the pair of stone lions which stand in the vestibule of the Commerce Tribunal in Paris, while the Chateau of Eclimont has an equestrian statue of Francois de Larochefoucault (marshal of France under Francis I), which Rouillard sculpted for the Duke of Larochefoucault-Bisaccia. This statue was subsequently cast as a *bronze d'edition*.

SALLÉ, André-Augustin
Born at Langenueau in 1891, Sallé exhibited at the Salon from 1923 onwards. Bronzes by Sallé were edited by A. Planquette by the *cire perdue* process. An elephant attributed to this sculptor was sold at Sotheby's in March 1970.

SALMON, Émile-Frédéric (1840–1913)
Born at Paris, Salmon was a pupil of Barye, Hedouin, Gaucherel and Theodore Salmon. Though trained as an engraver he also produced a considerable amount of sculpture, much of it in the animalier idiom. He made his début at the Salon in 1859 with a plaster model of a Cow Lying Down. Five years later he exhibited a bronze of a Greyhound and from then onwards was a regular contributor to the annual exhibitions at the Salon. In later years his works included Terrier (1865), and Head of a Mule (based on an antique sculpture) (1882). The majority of his sculptures in later years were allegorical subjects. Sotheby's sold a group of Two Turkeys signed by Salmon in 1970.

SANTA COLOMA, Emmanuel de
Little is known of the personal life of this sculptor, beyond the fact that he was born in Bordeaux and exhibited at the Salon between 1863 and 1870. In 1863 he showed a bronze of a Team-Horse and the following year was awarded a medal for his wax groups of Spaniel and Horse, and The Old Friends. His

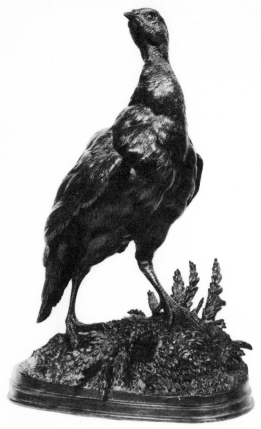

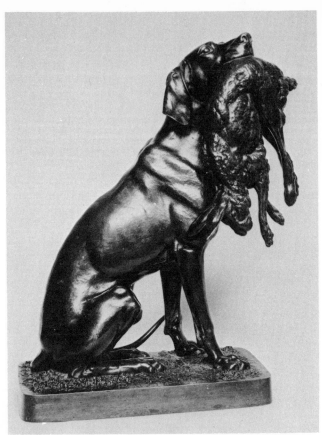

Ferdinand Pautrot
Seated Setter 18¾″
Ferdinand Pautrot
Partridge 13″

other works shown at the Salon were Artillery Horse Team, Hunting Pony (1865), Cavalier, Lion (1866), Irish Horse (1867), Napoleon III at Solferino (1868), Lady on horseback, Percheron Horse (1869) and the Commander of the 800 Grenadiers of the *Garde Consulaire,* at the battle of Marengo (1870). A bronze group of Horse and Groom signed 'Sta Coloma' was sold by Sotheby's in February 1970.

VALTON, Charles (1851–1918)

Born at Pau, Valton was a pupil of Barye (qv) and Lebasseur. He made his début at the Salon in 1868 and 1875 became a member of the Society of French Artists. He received third class (1875) and second class (1885) medals, as well as medals from the *Expositions* of 1889 and 1900. Among his works may be noted the following, exhibited at the Salon: Senegal Lioness (1868), Fox strangling a Rabbit (1869), Lioness seizing a Monkey (1870), Jaguar (1870), French Stag (1873), Senegal Lion (1874), Lioness and Cubs in the presence of their Enemy (1875), Python of Seba swallowing a Hare (1876), Buzzard seizing a Rabbit (1877), Tigers playing (1878), Two Quails quarrelling over a Wasp (1878), Roaring Lion and Yawning Lioness (1880), St. Bernard Dogs (1881), and Sleeping Lion and Lioness (1882). Several of his works are preserved in museum collections: Mammoth and Polar Bear (Natural History Museum, Paris), Head of a Lion (Castres), Lion (Constantine), Tiger and Tigress (Musée Galliera, Paris). The Sladmore exhibition 'Barye to Bugatti' featured Valton's Pointing Griffon 'Marco', while Sotheby's have sold in recent years Dying Lioness, Boxer, Two Labradors and Arab Stallion. Bronzes by this artist bear the signature 'C. Valton'.

VIDAL-NATAVEL, Louis (1831–1892)

Born at Nimes on 6th December 1831, Vidal, as he is usually known, was a

pupil of Barye and Rouillard (qqv). Despite his blindness he became a sculptor of some note, winning a third class medal in 1861 and an honourable mention two years later. He made his début at the Salon in 1855 with A Crouching Panther (now in the Orleans museum). Subsequently he exhibited Hind lying down (1859), Lioness (now in the Nantes Museum), American Stag (1859), Hind giving suck to her Fawn, Bull (1861), bronze of a Bull (now in the Museum of Nimes), Dying Stag (1863), Cow giving suck to her Calf (1864), Wild Horse (1865), Roe-deer, Bull (1866), Royal Tiger (1867), Lion (1868), Roe-buck (1870), bas-relief of a Lion (1870), Greyhound (1872), Great Lion of Senegal (1875), Arab Horse (1876), Stag (1877), Algerian Gazelle, Javanese Tiger (1879), Female African Gazelle (1880), English racehorse 'Traveller' (1881), English horse 'Kob' (1882). A bronze of the Lion (exhibited in plaster in 1868) was sold at Sotheby's in March 1970.

I do not claim that this list is complete by any means and inevitably there are other Animalier sculptors of the nineteenth and early twentieth centuries, about whom nothing is recorded, but whose work occasionally turns up in the sale-rooms. In this context it should be noted that Sotheby's alone, in the season of 1960–70, handled bronzes by Xavier Baccoua (Hound 24″), Georges

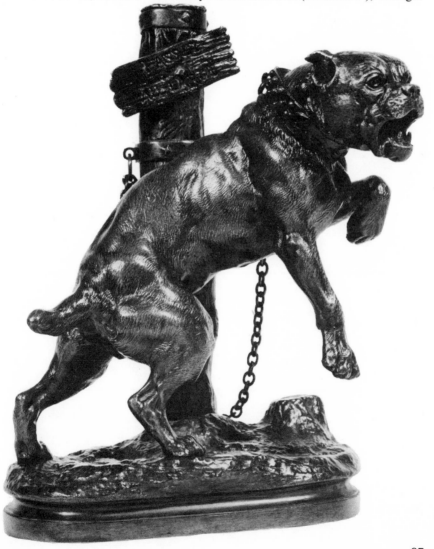

Charles Valton
Mastiff 10½″

Bommer (Horse 9½″), Couci (Ram guarding sleeping Ewe), R. Guillaume (Spaniel and Child 9½″), Kristesko (Horse jumping two-bar Fence 19″), Laddroux (Tiger 10″), Landez (Terrier Puppy), Lustagh (Beagle 8″), A. Mayenc (Arab Stallion 8½″), Muntini (Prancing Horse 8½″), A. Nille (Charging Bull 12″), Natide (two groups of Dogs – one drinking, the other urinating – both 4¾″), W. Roche (two different groups featuring Jockey and Racehorse, both 11″), H. R. de Vains (Horse 13½″) and Vinard (Cob and Bull Terrier 16½″). Others such as Pompon, Degas and Bugatti, are treated in a separate chapter since their work may be regarded as tending more towards the Impressionist than the purely Realist style of main-stream Animalier sculpture.

Chapter VI

The French Impressionist School

To the average art-lover Edgar Degas is remembered for his paintings of the ballet – and at first sight this seems to be far removed from the subject of this book. Yet Degas deserves to be regarded as one of the great Animaliers, even if it is quite by chance that his work in the three-dimensional field has been preserved. The stature of Degas the painter is so great that the importance of Degas the sculptor is often overlooked. The *Encyclopaedia Britannica,* for example, in an admittedly cursory article on Degas, merely states in passing that "he attempted modelling in a Dancer in wax". From this one would hardly deduce that he had a role (far less a major one) to play in the development of modern sculpture in general, and in animal sculpture in particular.

Hilaire-Germain-Edgar Degas was born in Paris on 19th July 1834 and died there on 27th September 1917. His life thus spanned the period of the heyday of the Animaliers. At the time of his birth Barye had just begun to win acceptance; by the time of his death every aspect of art in Western Europe had been subject to sweeping changes. The classicism which Barye and his Barbizon colleagues had fought against had been overthrown and in its place successive waves of artistic styles – realism, expressionism, impressionism, cubism and surrealism, not to mention *Art Nouveau* and *Art Decoratif,* had eroded the traditional concepts of art.

Degas had a fairly conventional art training. He studied painting under Lamothe and Ingres at the *École des Beaux Arts* and first exhibited at the Salon in 1865 where he showed a pastel entitled *War in the Middle Ages.* The only resemblance between this work and his later pictures was the material used, and he soon turned to other subjects. Significantly he exhibited a picture called *Steeplechase* at the Salon of 1866, and this established his penchant for horses and racing subjects. *Family Portraits* followed in 1867 and in the year after he exhibited a painting of a dancer in the ballet *La Source.* In 1869 and 1870 he restricted himself to portraits but thenceforward he boycotted the Salon and attached himself to the Impressionists, taking the lead, with Manet and Monet, in the new school at its first exhibition in 1874. Over the ensuing forty years Degas produced pastels, paintings, drawings and watercolours of ballet-dancers, cafe-singers, criminal types, working women, nudes and every conceivable subject connected with night-life. Horses and jockeys also featured prominently in his two dimensional work and he achieved a reputation as the artist of the sporting world, equalled only by his reputation as a painter of the ballet.

We have seen how Rosa Bonheur, at an early stage in her career, modelled figures as an aid to her painting. Comparatively few painters have seemed to realise that unless one models its forms one can never fully understand the mass of a body, especially since the human eye can only take in one aspect of an object at a time. There is a world of difference between seeing something and seeing it while modelling it. Only then can one grasp the mechanism of the movements of the body, the relationship of proportions to equilibrium. Only then can one conceive the body in its entirety. This truth was recognised by Rosa Bonheur, by Honore Daumier who used models as the basis for his political caricatures, by the Comte du Passage in France and Frederic Remington in America. At the present day the American Animalier, Harry Jackson, produces paintings and sculpture of the same subject which are mutually interacting.

As a painter or draughtsman, working in two dimensions, Degas could conveniently forget the invisible parts of the subject, whereas the sculptor has no such choice and must visualise his subject in he round. This is a fundamental problem which relatively few artists have been able to overcome satisfactorily. Yet it appears that Degas experienced no difficulty in learning the rudiments of sculpture, thanks to his inborn sense of the exigencies of form. It has been suggested that modelling would have taxed his patience sorely. For a painter, and especially for an Impressionist intent on capturing the fleeting suggestion, there could have been no process more exasperatingly slow than modelling. This exercise was not merely a question of physical effort; it also demanded attention to such practical details as the armature, the dampness of the clay, the consistency of the wax and the limitations of the material. One must presume that Degas endured this for the satisfaction given by the work and the feeling that his ability to paint a subject was enhanced by having modelled it.

It is equally obvious, however, that Degas never regarded himself seriously as a sculptor *per se*. To a large extent he was self-taught in sculpture and preferred to stumble along rather than take the advice of those who could have helped him. Instead of using armatures prepared by experienced technicians, for example, Degas was content to improvise them for himself. The result was that his more or less balanced models often collapsed or cracked; but it would seem that Degas was prepared to pay this price to preserve his freedom.

In almost half a century Degas must have produced a considerable number

Rembrandt Bugatti
Two Panthers 15¼″

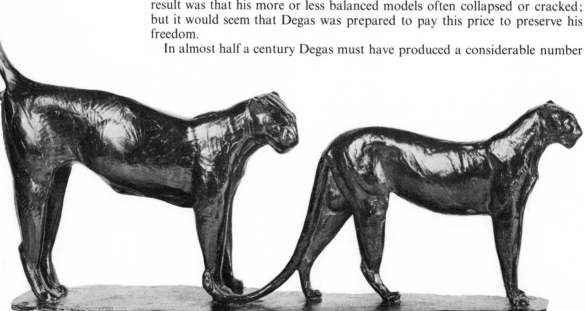

90

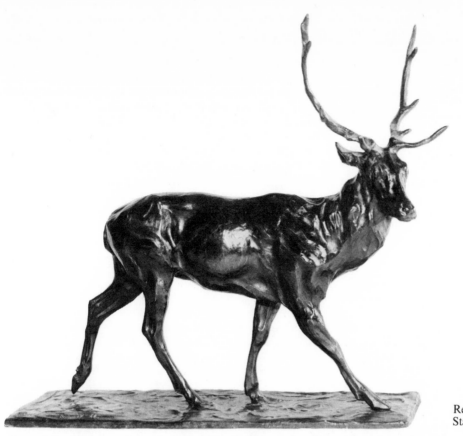

Rembrandt Bugatti
Stag 19″

of models. Many collapsed under his fingers and others must have been ephemeral in nature, but so long as they served their purpose in assisting his painting Degas could not have cared less. He felt diffidently about himself as a sculptor, and exhibited his three-dimensional work on only one occasion. In 1881 he exhibited his little wax figure of a Dancer Aged Fourteen Years dressed in a real lace tutu, but this excited little curiosity other than vulgar comment at the time. Subsequently Degas ceased even to exhibit his paintings, feeling no longer any desire to communicate with the world.

As a result there were very few who were even aware that Degas practised modelling on an extensive scale, especially in his later years when failing eyesight prevented him from painting and drawing. He drew comfort from the fact that his skilful fingers were still capable of giving expression to his art. In 1903 he wrote to a friend, "Here in this studio I'm always working with wax. Without work, what a dismal old age!" When the young Aristide Maillol once ventured to ask him if it were true that he was doing sculptures, Degas indignantly queried who had told him this. When Maillol replied that he had got the information from an intimate friend of Degas, the ageing artist commented solemnly, "Yes, I model, and perhaps one of these days I shall be cast in bronze!"

Although he may have considered it Degas never got around to editing his models in bronze. At the time of his death some 150 models were found in his studio. A few had been cast in plaster and had survived the ravages of time, while certain others were preserved in glass cases in his studio. But at least half of them were in a sorry state; the clay had dried up and cracked badly, or the wax had partially melted. Many were broken or damaged beyond repair. Yet the models discovered in his workshop must have represented only a

91

fraction of his total output in sculpture, since presumably many others were destroyed in 1912 when Degas had last moved house, not to mention the unknown number which had perished over the years.

For obvious reasons the models which were in existence in 1917 must have represented the work of Degas in his latter years, and thus little is known of his earliest sculpture; nor can his surviving sculptures he dated with any degree of certainty. From the hazy recollections of his few intimates and contemporaries, however, it has been possible to deduce that his Animalier sculpture belongs to the relatively early period. In an article in *Art et Decoration* (September–October 1919) P. A. Lemoisne relates that Degas had been on close terms with Cuvelier whose equestrian studies had been exhibited at the Salon between 1865 and 1870. Cuvelier's work was regarded as something of a novelty at the time and it would have been surprising had they not exerted some influence on the young Degas, who was then still in the formative stage of his artistic career. Remembering that Degas had shown a marked predilection for horses as suitable subjects for pictures it seems inevitable that when he first turned to modelling he should have chosen equestrian subjects.

When he switched from such historical compositions as *Semiramis Building a Town* to scenes from contemporary life (about 1866–68) Degas was faced with the problem of having to introduce into his composition a horse not as he might have imagined it for the occasion but as it actually appeared in the scene he was depicting. Wishing to create a realistic work, and no doubt inspired by his friend Cuvelier's example, Degas then had the idea of modelling a horse in the same attitude as he had observed in the ballet *La Source*. By placing the wax horse in the appropriate stance he could later make use of it as a model for his painting of *Mademoiselle Fiocre in the Ballet La Source*. Of course this is no more than a supposition, but the similarity between the modelled horse and the horse shown in this painting make this deduction inevitable. Furthermore the pose of this animal indicates that it was a relatively early work; it seems logical to suppose that Degas first modelled standing horses before attempting more complicated poses.

From standing horses Degas quickly progressed to figures of horses and their riders modelled in motion. It was in the late 1860s that he began frequenting the race courses, making numerous sketches which later served as the raw material for some of his best known paintings. In passing Degas also produced numerous models of horses, which were shown walking, then galloping, then rearing, jumping over obstacles and finally culminating in the technically ambitious groups which show horses with all four feet off the ground.

According to Lemoisne, Degas ceased modelling horses after the death of Cuvelier during the Siege of Paris, and merely made use of existing models for

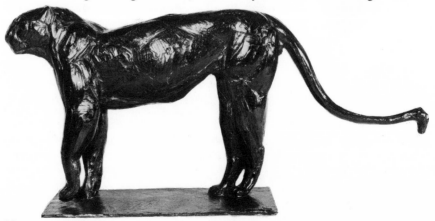

Rembrandt Bugatti
Panther $7\frac{1}{2}'' \times 19''$

92

his sporting pictures painted years later. John Rewald, in *Degas: Works in Sculpture,* disputes this statement on the grounds that it would not have been possible for the artist to have modified existing models and altered their poses without materially destroying them. Those statuettes of horses which have survived show such a real knowledge of the anatomy and characteristics of the animals that it is difficult to envisage how Degas could have made the slightest alteration without destroying their harmony and being obliged to do the whole animal again. Rewald moreover dismisses the idea that Degas needed models of horses for his later pictures anyway. It is not easy to believe that the man who could impregnate his mind with the attitudes of horses at Longchamp so vividly as to be able to model them later in his studio, had need of models in order to draw or paint these same horses. It seems unlikely that there was between his models and his paintings any other bond than that same passionate search for movement.

At the time of his death, in his eighty-eighth year, Degas lived in an apartment in the Boulevard de Clichy. It was here that his friend Paul Durand-Ruel discovered his models, mouldering under a thick layer of dust, on a long table at one end of his studio. Of about 150 models still in existence, only some 73 were in a sufficiently good state of repair to be cast in bronze. Those were subsequently removed and stored in the cellar of the bronze-founder Hébrard for safe-keeping until the end of the war. Towards the end of 1919 Hébrard commenced the difficult work of editing Degas' sculptures. Fortunately the *cire perdue* process was adopted for the casting of 22 bronzes from each of the models. Between 1919 and 1921, 72 sculptures were cast in this way and the 73rd was edited some time later. Of the 22 bronze copies cast from each model, 20 were lettered from A to T and destined for sale, while of the remaining two one was reserved for the founder and the other for the sculptor's heirs. Hébrard's copy was unlettered, while that handed over to the heirs was marked HER (*heritier*). To each sculpture was also assigned a serial number from 1 to 72. The 73rd model was unnumbered and marked by neither figures or letter. Each bronze also shows the incised signature of Degas and the mark in relief of the founder (*cire perdue, A. A. Hébrard*).

When the work of casting was completed Hébrard organised an exhibition held in their galleries in Paris in May–June 1921. In the catalogue of the 72 bronzes exhibited the horses were listed together and numbered from 38 to 54, and this order has been preserved in most of the Degas exhibitions held since then. However in the Appendix to this book the seventeen horse bronzes of Degas are listed in numerical order according to the serial numbers marked on them.

Compared with the Animaliers of the traditional school Degas demon-

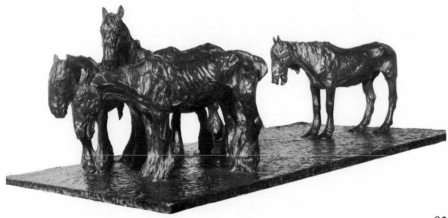

Rembrandt Bugatti
The Old Horse

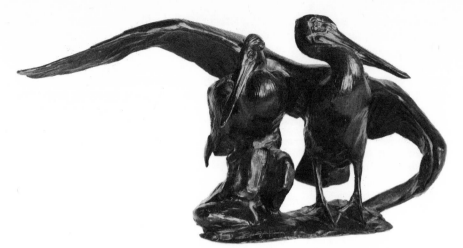

Rembrandt Bugatti
Two Pelicans 11¾″

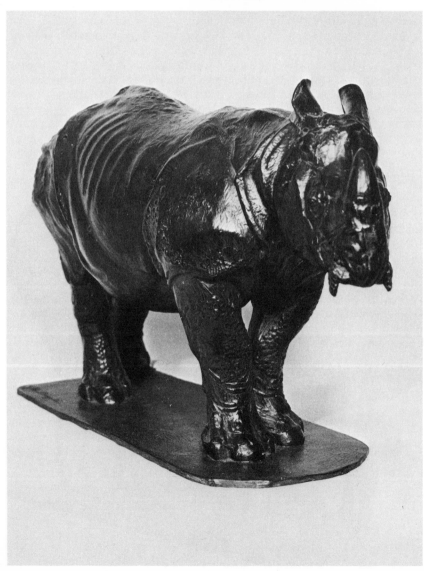

Rembrandt Bugatti
Rhinoceros 16½″

94

strated his originality of talent and independence of spirit in not slavishly imitating the work of Barye or Frémiet. In the true spirit of the Impressionists Degas was a master of the art of suggestion and this quality is inherent in his sculpture. Thus there is often a rough, vigorous character in his work, compared with the meticulous mannered quality of the early Animaliers, and there is a world of difference between the equestrian groups of Degas and such sculptors as Lenordez and Malissard. Degas did not attempt to delineate minor detail with painstaking clarity, but concentrated instead of conveying a sense of movement and capturing the feeling of a split second in time.

It can be argued that Degas qualifies as an Animalier quite fortuitously and only the prompt action of his friends preserved his models of horses for posterity. With François Pompon, however, there is no argument since his whole artistic career was devoted to sculpture and the major part of that was in the Animalier tradition. Pompon was born at Saulieu (Côte d'Or) on 9th May 1855 and at the age of fourteen was apprenticed to a marble-cutter in Dijon where he learned the rudiments of stone-carving and also attended classes at the *École des Beaux Arts* in that town. In 1875 Pompon moved to Paris where he established himself as a *marbrier*. In his twenties Pompon gained the friendship of the painter Charbonnel and the sculptor Caille who assisted him in the furtherance of his career and helped him to get admission to the *École des Arts Decoratifs*. For a while (1880) he was an assistant to Mercie and subsequently, about 1889 worked with Rodin whose impressionistic approach to sculpture influenced him greatly.

In his early years Pompon modelled the human figure and a measure of his success in this direction was his award of a third class medal at the Salon of 1888 for a statuette of a little girl Cosette. Two years later, however, came the turning point in Pompon's career and from then onward he specialised in animal sculpture. Pompon showed tremendous courage and single-mindedness in pursuing this course. By the 1890s the work of the Animaliers had become unfashionable in France and only those sculptors who produced equestrian statuettes of actual personages were able to make a precarious living. In clinging uncompromisingly to the sculpture of animals for their own sakes Pompon pursued a largely solitary course. Moreover, by adopting an impressionistic style which was at variance with the naturalistic style familiar to the mainstream Animaliers and their devotees, Pompon cannot be accused of seeking the favour of the masses. For years he laboured in conditions of obscurity and extreme poverty. Recognition did not come his way until he was in his sixty-seventh year. In 1921 the sculptor Bernard yielded his place at the *Salon d'Automne* in favour of Pompon whose marble sculpture of a Polar Bear was shown instead. In this way was revealed to the public one of the greatest Animaliers of this century and Pompon immediately won wide acclaim. From then until his death in 1933 Pompon exhibited regularly at the *Salon d'Automne* and among the honours which belatedly came his way was the *Legion d'Honneur*.

Pompon claimed that his interest in animal sculpture stemmed from his childhood, when he used to contemplate the figures of boars and other wild animals which were carved on the pillars of the church of Saint-Andoche. Oddly enough Pompon always felt an affinity with bears, based on childhood memories of pictures of performing animals in the fairs of the Middle Ages, and it is perhaps significant that it was with one of these animals, albeit the polar variety, that he eventually found fame. His father was a carpenter and he was determined that the young François should follow a trade. Celestin Nanteuil, the curator of the local Museum and a teacher at the *École des Beaux Arts,* was quick to spot the artistic aptitude in young Pompon, though originally it was thought that he would ply his craft as a stone-cutter and monumental

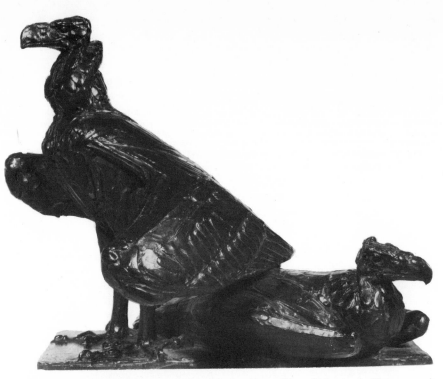

Rembrandt Bugatti
Two Vultures

mason. Undoubtedly his apprenticeship in the atelier of François Dameron in Dijon was to stand him in good stead and though, in later years, he did a certain amount of modelling, carving was always his main medium of artistic expression. On the other hand he obtained valuable experience in modelling while working with Rodin. Pompon was responsible for a number of the small figures on Rodin's *Porte de l'Enfer*. As a mark of his appreciation Rodin gave Pompon a small sketch-model of The Kiss which Pompon subsequently presented to the Dijon Museum.

Between 1879 and 1890 Pompon was mainly concerned in carving portrait heads and busts, and even after that date he continued to produce a few examples, such as the head of Theophile Mangey sculpted in 1893. Conversely, although 1890 is regarded as the turning-point in his career, Pompon had shown some evidence of his growing interest in animal sculpture prior to that year. As long ago as 1874 he had produced a sketch model of a Lucane in terra cotta; ten years later he sculpted a Quacking Duck. After 1905, however, he abandoned the human form completely and concentrated entirely on animal sculpture.

Stylistically Pompon's sculpture possesses a solidity and mass which is to be found in the work of no other Animalier except the German, August Gaul. His predilection for carving led Pompon to show his birds and animals in static poses and this impression of repose was further heightened by his use of such devices as cubes out of which the animal or bird took shape. An excellent example in this *genre* is his Turtle-dove, now in the Luxembourg, while it was taken to its extreme in the carving of a mole emerging from the soil which Pompon executed in 1912. In this carving only the snout and fore-paws of the animal were delineated in the mass of rough stone; the similarity between this work of Pompon and Rodin's *Puvis de Chavamne* is very striking.

Above all, it is in the sleek, streamlined surfaces of his sculpture that Pompon evolved his own highly individualistic style, imparting to his tigers and panthers, his bears and bulls, his owls, pelicans and geese that quality of dignity and

96

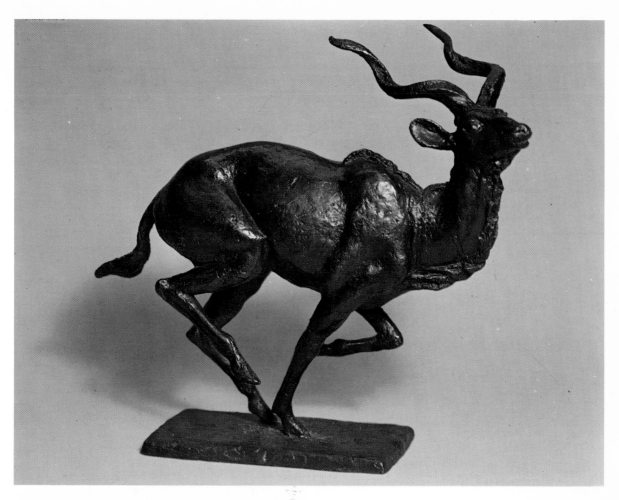

Lorne McKean Gazelle

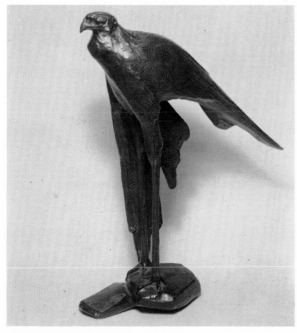

Rembrandt Bugatti
Secretary Bird 13″ × 11″

Jonathan Kenworthy
Cheetah chasing three
Grant's Gazelles

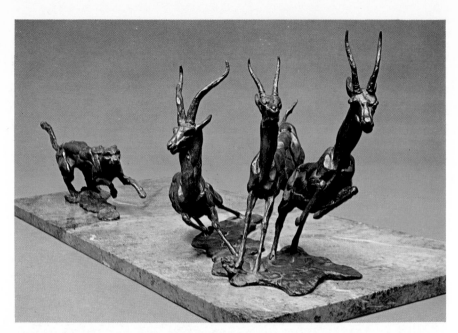

Harry Jackson
Pony Express (painted
bronze)

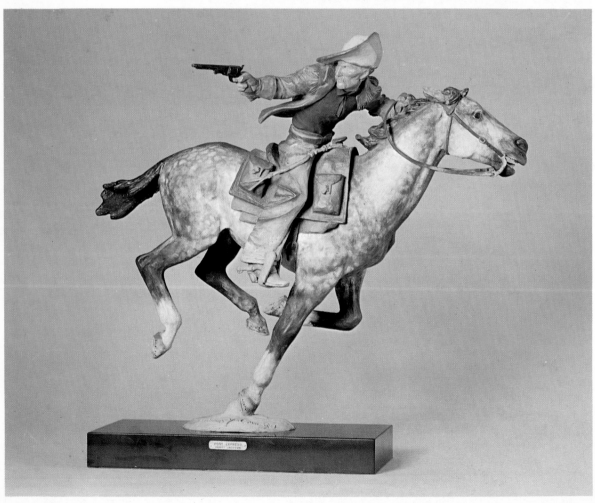

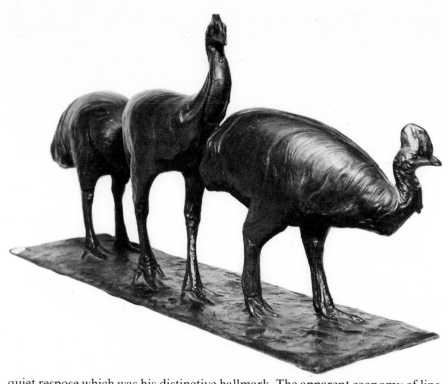

quiet respose which was his distinctive hallmark. The apparent economy of line and detail in Pompon's work is quite deceptive. He used the subtle expression in the eyes, or perhaps the tilt of the head or the flick of the tail to convey exactly what he wanted to show, without expending unnecessary detail which might have detracted from the impression he wished to suggest. His modelling was perfectly executed nonetheless and his carving attained a high quality of finish. His stone carvings invariably have a rounded smoothness while many of his bronzes were highly polished.

Pompon covered an astounding range of animals and birds, from the wild and exotic to the purely domestic, from hippopotami and giraffes to stallions, rams and piglets. His birds were equally far-ranging, from ducks, chickens and geese to golden pheasants, condors, marabout storks and parrokeets. In the Appendix are listed the sculptures of Pompon known to have been edited in bronze, as well as figures in wax, terra cotta or plaster which may also have been cast in bronze. The sculpture of this artist is preserved in many museums throughout the world but the finest collection of his work is in the *Musée des Beaux-Arts* in Dijon.

The third of the great Impressionist Animaliers discussed in this chapter poses the problem of what might have been, for Rembrandt Bugatti died in tragic circumstances at the untimely age of 31. Bugatti came of a long line of artists who could trace their lineage from Zanetto Bugatti, the fifteenth century Milanese portrait painter. His ancestors included Giovanni Francesco Bugatti, the seventeenth century engraver while his father was Carlo Bugatti, the painter, silversmith and furniture designer. One of his uncles was Giovanni Segantini the painter and his elder brother was Ettore Bugatti, designer of the racing cars. It may seem ironic that the name of Bugatti is best known today on account of the last of this illustrious family, but it has been said with a great deal of justification that Ettore designed cars "in much the same way as a court clock-maker of the eighteenth century would design and build a time-piece for a royal patron".

97

Rembrandt Bugatti was born in Milan in 1885. With a name like his and four centuries of artistic breeding it was axiomatic that he should follow in the footsteps of his father and elder brother. He received a general art training in painting and sculpture but at a comparatively early age decided on the latter as his *metier*. At the age of seventeen he came to Paris where he came in contact with Prince Troubetzkoy, (see Chapter 8). Troubetzkoy, though of Russian parentage, was born in Italy and spent much of his career as an Animalier in France, and one can understand the bond of similar background and interests between the two men. Bugatti spent five happy years in Paris studying and modelling animals and then, in 1906, he moved to Antwerp.

At first sight this seems a curious move, since Paris was the lodestone which drew artists from all over the world at the turn of the century. But Antwerp had a long tradition as the artistic centre of the Low Countries and one is tempted to suggest that, in bearing the name of one of the most illustrious artists of the Netherlands, Bugatti was drawn to that part of the world by some sort of romantic association. From a purely practical point of view, however, Antwerp boasted an excellent zoological garden and it was there that Bugatti spent most of the next ten years, commuting between the Antwerp Zoo and the *Jardin des Plantes* in Paris. Bugatti never received any formal art training and though one may see hints of impressionism in the sculpture of Prince Troubetzkoy the suggestion that Bugatti derived anything of his style or inspiration from Troubetzkoy could hardly be farther from the truth. Bugatti's empathy with animals, however, was only equalled by his amazing technical skill and power of expressing their essential individuality of movement and character. It was not surprising that, at a time when enthusiasm for Animalier sculpture in general was on the wane, Bugatti should be acclaimed by public and art critics alike. Recognition of his merits came in the

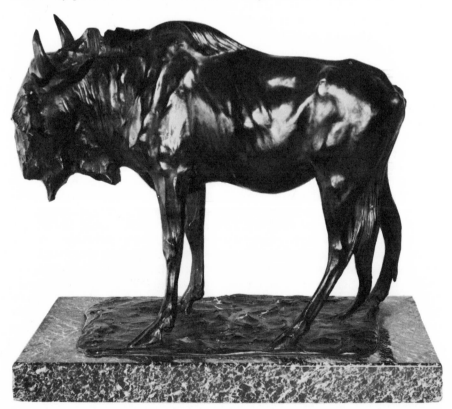

Rembrandt Bugatti
Gnu 13½″

98

form of state purchases of his work in both Belgium and France while the latter country paid him the singular honour of conferring on him the *Legion d'Honneur* at the early age of twenty-six.

At the outbreak of the First World War Bugatti was living in Antwerp and very soon he was caught up in the terrible events which overtook Belgium in the winter of 1914. Bugatti and his friend, the painter Walter Vaes, volunteered for Red Cross work. Night and day they tended the sick and wounded and gave assistance to the crowds of refugees. Physically and mentally the war had a profound effect on Bugatti. Eventually the French consul-general persuaded him to return to France to recuperate from the severe headaches and fits of depression which overwork had brought on. The last year of his life, spent in Paris, was a fruitful one for Bugatti. The experience of war had matured him, and in his art this was reflected in the evolution of stronger and more vigorous modelling. This boldness and vigour is seen at its best in his last work, a Lioness about to trample a Snake, symbolising the ultimate triumph of good over evil.

During the winter of 1915–16, however, his attacks of migraine became intensified and were accompanied by longer bouts of depression. On the morning of 10th January 1916 he left his studio at 3 Rue Joseph Bara in Montparnasse, went to the Madeleine to pray and then, on the way back, purchased a small bunch of violets which he left on a table, with a note for his mother. Carefully he dressed and attended to his toilet. Beside the letter and the flowers he placed his photograph and the Chevalier's cross of the *Legion d'Honneur*. He closed the doors and windows, meticulously sealed all the chinks, then turned on the gas jets and lay down on his couch. Bugatti died at the age of thirty-one, having left a work which was vast and splendid, but incomplete. In what way his genius might have developed can only be conjectured. It is difficult to imagine that he could ever have greatly improved upon his best work, and today he is regarded as the finest Animalier sculptor of the early twentieth century.

Several retrospective exhibitions of his animal sculpture were held in Paris and Antwerp shortly after the First World War and a major exhibition of his work was held in London in 1929. Thereafter he suffered the fate meted out to most sculptors of the Animalier school whether naturalistic or impressionistic, but in the past decade there has been a marked re-appraisal of his work. The *Institute National Superieur des Beaux Arts* in Antwerp instituted the Bugatti Prize for Sculpture as a memorial to him. Bronzes of his Lion Cub and Greyhound and Panthers are preserved in the *Musée des Beaux-Arts* in Brussels, an Elephant and the figure of a Woman are in the *Musée Royale des Beaux-Arts* in Antwerp, while the Belgian Royal Zoological Society have an Elephant and an Old Horse. His Crouching Panther and White Elephant were acquired by the *Direction des Beaux-Arts*, Paris and the latter was subsequently sent to the French embassy in Berlin where, unfortunately, it was destroyed during the bombing in the Second World War. Animal bronzes by Bugatti are scattered all over the world in museum and private collections, but the finest assemblage of his work was preserved at Molsheim in Alsace where his brother Ettore established a shrine to his memory. A tentative list of Animalier bronzes by Bugatti is given in the Appendix.

Bugatti forms an important link between the faithful and sensitive representation of animal life which the nineteenth century Animaliers aimed at, and the sculptors of the twentieth century who used animal subjects to create an increasingly formalised and intensified reality. Bugatti's work belongs to neither, or perhaps to both, of these categories for he achieved, at his best, something far subtler and more difficult – a purely abstract beauty of plastic harmony and rhythm without ever sacrificing the literal structure and vitality of the animals he portrayed.

François Pompon
Dove (plaster) 9½"

99

Six months before Bugatti took his life a young French artist of great promise was killed in action during the attack on Neuville St Vaast. Henri Gaudier-Brzeska was barely 23 at the time of his death and his work as a sculptor had scarcely begun. Yet the work he produced in the period from 1912 to 1915 was of such a calibre as to set him apart from the run-of-the-mill young artists struggling to make a living in Britain and France at that time.

Henri Gaudier was born at St Jean de Braye near Orleans on 4th October 1891, the son of a carpenter from whom he inherited an instinctive love of materials. There was a family legend that one of his ancestors had worked on the cathedral at Chartres. He was a very sensitive child, delicate and frail in appearance, yet possessed of a deep assurance and strength of will. At the age of six he would draw incessantly, mainly birds and insects, entranced by the patterns and shapes of their bodies. At school he was well above average, winning several scholarships including one which took him to London for two months in 1906. Two years later he won another scholarship, worth 3,000 francs, which enabled him to study at University College, Bristol. But by this time he had begun to realise that a career in business was not for him. Although he subsequently obtained employment with a firm of coal contractors in Cardiff he spent all his free time sketching and drawing at the docks. In 1909 he spent some time in Nürnberg before moving to Paris where he worked in an office by day and studied art in the St. Genevieve Library in the evenings.

It was here that he met Sophie Brzeska, a Polish woman twenty years his senior, who had led a strange, nomadic existence in Europe and America and whose health, both physical and mental, had been impaired by years of poverty and privation. Theirs was a curious, platonic relationship, at once both passionate and asexual. In 1910 they moved to England where they lived together as brother and sister (though surviving correspondence suggests that it was more of a mother and son relationship). They adopted each other's surname in hyphenated form though this was never more than a personal arrangement. Henri Gaudier-Brzeska found employment in the City of London as a typist and foreign correspondent with a Norwegian company, while Sophie occasionally augmented his minuscule salary by teaching French. Both had artistic aspirations, he as a painter and she as a poet and author. In 1912 they made the acquaintance of Major Haldane McFall whom Henri impressed immensely and who was instrumental in gaining for him an introduction to artistic circles in London, finding buyers for his work. Although his earliest work consisted of drawings and posters he soon turned to sculpture, experimenting both with stone carving and modelling in clay. His more commercial work consisted of portrait busts, but he also produced figures and bas-reliefs and a number of semi-allegorical groups.

At the time of his death he had not yet arrived at a complete development, or, at least, had not evolved the style best suited to his particular talent. The quasi-abstract style that he was exploiting at the time of his death can scarcely be regarded as his final method. Bearing in mind his youth, it is ridiculous to assert (as did his earliest biographer, Ezra Pound) that he had found his *metier* in geometrical shapes. His flirtation with the abstract was a natural reaction against 'prettiness' in sculpture. He was, more significantly, a great admirer of Chinese sculpture, especially animal pieces, and the abstract phase through which he was passing when war broke out, was in many respects merely an exercise in sculpture. He was interested in form for its own sake and was continually experimenting, rejecting and destroying. The art critic John Cournos has written of him that "'He had the confidence of youth, but also its doubts, and in his moments of despair he put the new art to question and spoke of

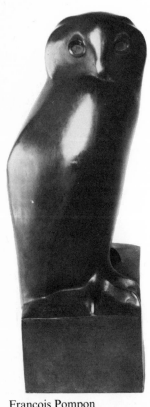

François Pompon
Owl 19¾″

100

François Pompon
Stag 23″

Degas Horse galloping
on right foot 11$\frac{1}{8}$″

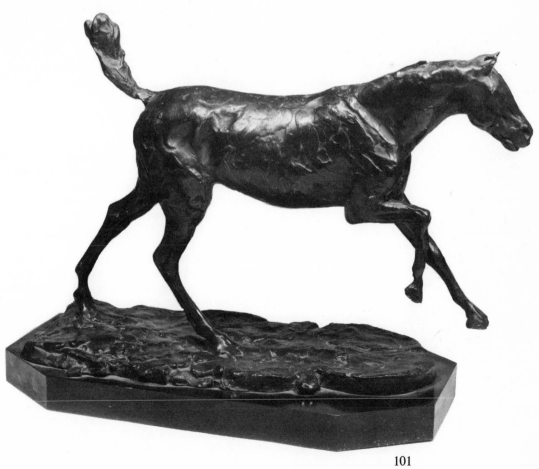

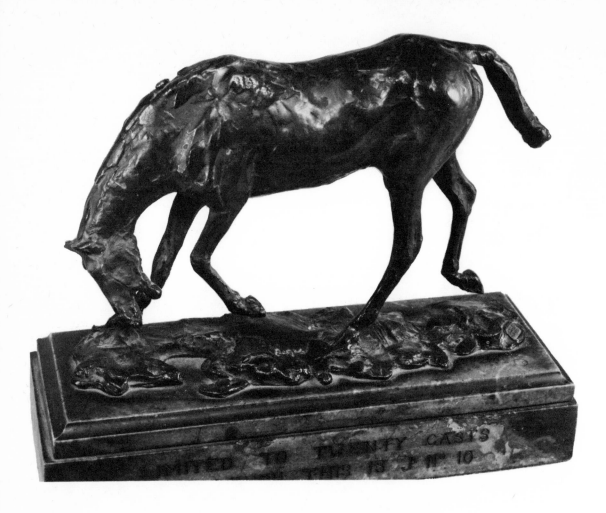

Degas Horse with head lowered 7⅛″

'going back to the Greeks'."

Gaudier-Brzeska dabbled in abstract forms and produced much that was bizarre and wilfully absurd. He was labelled a Barbarian and became the darling of the avant-garde Rebel Art Centre. By the time of his death he was being labelled a Vorticist, a term which had only ephemeral significance. But in truth he was addicted to no kind of 'ism'. Admittedly he was not a realist in the academic sense, but a naturalist sculptor he certainly was–moreover, with a big dash of the romantic and at times sentimental. From the trenches of Flanders he wrote "If I ever return I am sure that I shall not work like Conder (an abstract contemporary). But I believe I shall develop a style which, like the Chinese will embody both the grotesque and the non-grotesque. Anyway, much will be changed after we have come through the blood bath of idealism." His correspondence with various friends about this time confirms that he had abandoned the abstract in favour of a more realistic approach to sculpture.

Although he came temporarily under the influence of Brancusi his main source of inspiration was the ancient art of Egypt and China which he studied assiduously at the British Museum. His extraordinary love for animals and birds was in close sympathy with the Egyptian sculptors of the Saite period who modelled their enigmatic cats, or the Chinese artists who painted or sculpted deer. He was a frequent visitor to the London Zoo and studied the deer in Richmond Park. Although his art was in an unformed, indecisive

state at the time of his death, his interest in animals as a subject for sculpture is obvious. At the Autumn Exhibition of the International Society of Sculptors, Painters and Gravers, held at the Grosvenor Gallery in 1913, he exhibited a Golden Figure in gilt plaster while the majority of the works shown at the London Salon in the Albert Hall in July of that year consisted of portrait busts. But in January 1914 he contributed a marble Cat and a stone Fawn to the Grafton Group exhibition at the Alpine Gallery. The Fawn, one of Gaudier-Brzeska's favourite themes, was purchased by Princess Lichnowsky for £15. At the London Salon in July 1914 he exhibited Insect, Bird and Boy with a Coney.

In May-June 1918 a memorial exhibition was held at the Leicester Galleries and constituted the most comprehensive display of his sculpture. In the Animalier *genre* there were several variations on the Fawn theme, Serval, Monkey, Fish, Gorilla, Sea-bird and a Group of Stags. Like Pompon, Gaudier-Brzeska preferred smooth, simplified lines, reducing lumps of stone to achieve the desired result rather than building up his figures with modelling clay. Nevertheless, several of his animal studies were modelled in clay and subsequently cast by the lost wax process in bronze. As with Bugatti, one can but speculate on Gaudier-Brzeska and in what directions his talents might have developed. One thing seems certain, however and that is that his sculpture would have taken a more naturalistic turn, in which the Animalier idiom is likely to have been strong.

Chapter VII

The American School

The United States in the early part of the nineteenth century was exposed to the cultural influence of France in many respects and in the arts the developments in style and techniques may be said to parallel those in France to a certain extent. In sculpture, for example Augustus Saint-Gaudens, the doyen of American artists, had a Paris training, being the son of a Frenchman. For much of his career he was a corresponding member of the French *Académie des Beaux Arts* and exhibited regularly in France. Thus he came under the influence of the best academic traditions as well as the more modern naturalistic movement, and imbibed them both to the degree that his own temperament and the conditions of his inspiration demanded. His statue of General Sherman has been compared with the Jeanne d'Arc of Dubois – both equestrian statues on a monumental scale, tracing their descent to some degree from an original classic type. But whereas the Jeanne d'Arc is noble in every particular, it is at once mannered, more consciously correct and has an air of hauteur and aloofness, as becomes its aristocratic descent from Verrocchio's Colleoni. The statue of Sherman, on the other hand, may be described as of collateral descent from the Renaissance sculpture, modified by a larger environment and a fresher inspiration. The typal form has yielded to the individual, abstract dignity to the force of character, the fundamental suggestion to that of vivid, immediate actuality.

It is this freer spirit which marks out American sculpture of the nineteenth century from its French contemporaries, and the same remarks hold good for a comparison of the American and French Animaliers. Animalier sculpture was somewhat later in being established in the United States, becoming fashionable after the Civil War (1865) and attaining its heyday in the closing decades of the century. Prior to the 1860s such animal sculpture as was practised in America consisted mainly in equestrian statues of famous personages, such as the Washington monuments by Thomas Crawford and Thomas Ball, the Jackson of Clark Mills or the General Thomas of John Ward, and this style of sculpture remained paramount to the end of the century. Indeed, the United States would be a far poorer place had George Washington never mounted a horse.

Nevertheless, in a vast country with such a rich native fauna it would have been surprising if a certain number of sculptors had not arisen to combine the instincts of the hunter with some form of artistic expression. In addition the romance and glamour which surrounded the development of the American

104

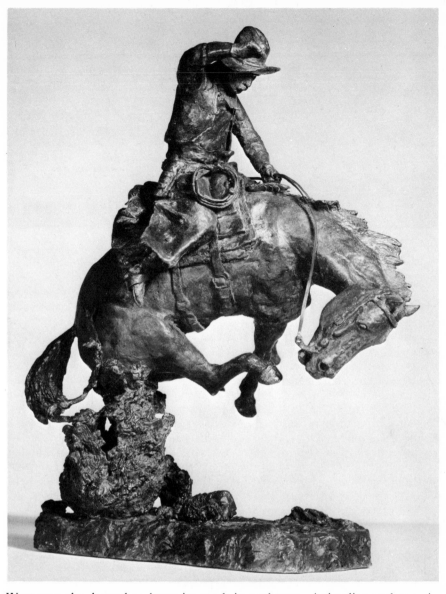

Farrington Elwell
Bronco Buster

West was also bound to leave its mark in sculpture. Animalier sculpture in America thus divides into two main streams – the sculpture of animals, mostly wild and in their natural habitat, or Western sculpture (cowboys, Indians and cattle).

Although several sculptors had been working in the Animalier field for at least two decades it was not until the Columbian Exposition of 1893 that they came to prominence. At the Exposition three artists in particular were distinguished for their animal sculptures; these were Edward Kemeys, Edward Potter and Phimister Proctor. Both chronologically and in terms of achievement Kemeys heads the list of American Animaliers and no other artist since his time has done more to record for posterity the wild-life of the great American plains or popularise animal sculpture with the collecting public. At the Columbian Exposition Kemeys was responsible for two figures of wild cats which stood at the end of two of the ornamental bridges. These figures are quite extraordinary examples of animal sculpture and excited a great deal

105

Farrington Elwell
Indian in a Canoe (plaster)
13¾″

of favourable comment at the time they were exhibited. Their stealthy, supple movement "as, bellies low to the ground, they advanced with that slow, cling-step which precedes the spring", represented the closest study of the subject by an artist who was also a competent naturalist, while the treatment of the lines and masses was altogether the work of a sculptor who had acquired an intimate mastery of his subject.

Edward Kemeys was born in Savannah, Georgia in 1843, but his parents, who were Northerners, removed shortly afterwards back to New York City where young Edward received his education. Although he showed great aptitude for art from a very early age, he was not allowed to develop his talent and, in fact, went to work in the iron industry on leaving school. At the outbreak of the Civil War he enlisted in the Federal Army, eventually attaining the rank of captain in the Artillery and seeing action in the engagements before Richmond in 1862. At the end of the war he was employed by the civil engineering corps of Central Park, New York and there made his début as a sculptor. In the 1870s he spent much of his time travelling over the West, studying the Indians and the wild-life of the plains. This period provided him with the material for Bison and Wolves, a group which he exhibited at the Salon of 1878, during a prolonged visit to France.

He returned to the United States the following year and subsequently produced several of his best known works – the Still Hunt (Central Park, New York), Wolves (Fairmount Park, Philadelphia), Panther and Deer and Raven and Coyote. In 1882 he modelled the colossal head of a Bison for the Omaha Bridge of the Union Pacific Railroad. Ten years later he went to Chicago to begin work on the sculptures which he showed at the Exposition the following year and stayed in Chicago for eight years, working on the bronze Lions which stand in front of the Chicago Art Institute building, an Indian figure for Champaign, Illinois and numerous small animal bronzes for private collections. Kemeys died in Washington in May 1907. In addition to the Paris Salon of 1878 Kemeys exhibited his work at the Centennial Exposition held in Philadelphia in 1876 and at the Royal Academy in London the following year. About fifty of his small animal bronzes are preserved in the National Gallery in Washington.

Kemeys was very largely self-taught and had a healthy disregard for the work of his predecessors. As a result his sculpture departed quite radically from the academic traditions which even Barye could never escape. One would look in vain at a sculpture by Kemeys for those passages of beautiful modelling which are part of the charm of Barye's little masterpieces. On the contrary Kemeys was content to give the bare facts, stopping abruptly when the story

106

was told. He thus belongs to the Impressionists and was a master at the art of conveying the idea of movement, strength or tenderness in turn, rather than concerned with meticulous delineation of hair and muscle.

In many respects Kemeys was too radical in his approach for many of his contemporaries. Lorado Taft, himself an outstanding sculptor as well as an art historian, wrote of Kemeys in 1903, "He loses much thereby, since his interpretations of nature do not always win one back in search of new discoveries; but, on the other hand, this summary, impressionistic treatment has its own particular appeal". Yet Kemeys' powerful modelling conveyed with an element of rugged forcefulness a sense of movement which none but a master could express by means of careful modelling. The appearance of his bronzes can be quite deceptive. In the best Animalier traditions Kemeys had studied his animals intimately, both alive and dead, and his knowledge of them was thorough – one might almost say instinctive. He avoided that danger which Ruskin voiced, of "substituting in our thoughts the neatness of mechanical contrivance for the pleasure of the animal". Ruskin once stated that "the moment we reduce enjoyment to ingenuity and volition to leverage, that instant all sense of beauty ceases". Kemeys never made this mistake and it would be true to say that no other American sculptor ever more truly epitomised the spirit of the animal. In particular his studies of the cat family and his figures of bears are irresistible, whether pictured in the serious occupations of their existence or enlivened with that "touch of terrific comedy" which they assume so readily.

Writing in *Century* (1884) the art critic Julian Hawthorne admirably summed up the significance of Kemeys' art, in which one finds "not merely, nor chiefly, the accurate representation of the animal's external aspect, but what is vastly more difficult to seize and portray – the essential animal character or temperament which controls and actuates the animal's movement and behaviour. Each one of Mr Kemeys' figures gives not only the form and proportions of the animal according to the nicest anatomical studies and measurements, but is the speaking embodiment of profound hindsight into that animal's nature, and knowledge of its habits... Here is an artist who understands how to translate pose into meaning, and action into utterance, and to select those poses and actions which convey the broadest and most comprehensive idea of the subject's prevailing traits".

The importance of Kemeys in the development of American sculpture may be realised when it is remembered that, prior to the late 1860s when he began his career as a sculptor, only two sculptures had been produced of American wild animals, Indian and Panther by Henry K. Brown, and a figure of a Dog modelled by Brown's pupil, John Quincy Adams Ward. It is perhaps ominous that Kemeys saw his role, among other things, as the recorder in permanent form of American wild-life which advancing "civilisation" would eventually destroy for ever. His figures of panthers, cougars, wolves, buffalo and wild horses are not only works of art but a record for posterity, preserving the spirit and character of the old West. Americans of the present day owe a great debt to Kemeys for appreciating the immediate world about him and recognising the artistic possibilities of his own land and time.

Kemeys was largely self-taught and his work had a refreshingly home-spun quality about it. By contrast, Edward C. Potter (1857–1923) received a formal art training under Mercie and Frémiet and the latter in particular had a strong influence upon the development of Potter's art. Potter's early career as a sculptor was spent as an assistant to Daniel Chester French who was, himself, a notable exponent of the old style of equestrian statue. Potter first came to prominence in 1893 at the Columbian Exposition, for collaborating with French in the great Columbus quadriga. This great quadriga, titled The Apotheosis

of Columbus, crowned the great colonnade misnamed the Peristyle. The noble horses were led two by two by maidens whose flying draperies contributed movement and colour, while the decorative effect, as well as the originality of the work, was accentuated by youthful standard-bearers, who served as outriders. It is difficult to assess to what extent Potter was personally responsible for the sculpture in this colossal group, but the modelling of the horses was certainly characteristic of his later work, in which he showed a particular predilection for these animals. He was also responsible for the great animals which, with their attendant figures, formed the decorations of the lagoon within the Court of Honor. The figures consisted of draught horses of massive build and oxen of tremendous girth, sculptured as such animals never were in America before. French was responsible for the accompanying human figures, of a farmer, a Negro teamster, an Indian woman and a female allegorical figure of America.

In subsequent years the partnership of French and Potter resulted in a number of fine equestrian groups, in which Potter was responsible for the horses. These included General Grant (Fairmount Park, Philadelphia), the statues of Washington in Paris and Chicago and General Hooker (Boston). Potter produced a certain amount of non-Animalier sculpture, of which his classical nude of a Sleeping Faun (in the Art Institute of Chicago) is the best-known example. He showed his versatility by sculpting portrait busts, of which his Fulton (Library of Congress) and Governor Blair (Lansing, Michigan) are good examples. One equestrian statue in which he sculpted both horse and rider was his General Slocum for the Gettysburg battlefield memorial park. Around the turn of the century, however, Potter modelled numerous other animal groups, mainly horses, which were cast in bronze and may be found decorating the parks, squares and open places of many towns all over the United States. Some of these were also cast as bronze reductions for interior decoration and are occasionally met with.

The third of the animal sculptors to come to notice as a result of the Columbian Exposition was Alexander Phimister Proctor who shared with Kemeys the honours for executing the figures of American wild animals which decorated several of the pavilions of the Exposition. Proctor was born in Ontario in 1862 of a Scottish father and a New York mother. At the end of the American Civil War, when he was five years old, the family moved to Des Moines, Iowa where they remained for several years. During these early formative years Proctor showed a tremendous aptitude for drawing and modelling and as far back as he could remember it was his ambition to become an artist. While still a boy, Proctor and his family moved to Denver in Colorado where he found the atmosphere and background more conducive to his artistic development. Here he had the opportunity for exploring the hills and mountains and seeing the animals in their rocky fastnesses. Art and hunting were the two great passions of his life, and both developed during his years in Denver. At the age of thirteen he shot his first deer, while three years later, when hunting on his own, he shot his first grizzly bear and bull elk. He was both a keen marksman and an intuitive artist and all his spare time was spent, with rifle and sketch-pad, in the hills of Colorado. His hunting gave him the opportunity to stalk his prey and observe it closely. He studied the natural movements of animals as meticulously as Barye and likewise paid a great deal of attention to detail in the animals he hunted down and shot. The years spent in the Rockies paid off in his subsequent career as an animal sculptor, but at the age of 25 he realised that he had to acquire a more formal art education if he was to progress any farther. In 1887 he sold the family ranch and an interest in a mine, and used the proceeds to enrol at the National Academy of Design in New York. Here, and later in the Art Students' League, he applied himself

with enthusiasm and a diligence which won the respect of students and teachers alike. His training had just been completed when plans for the Columbian Exposition were being projected and, as a young sculptor of great promise, Proctor was entrusted with some of the animal groups.

After the Exposition Proctor moved to New York where he collaborated with Saint Gaudens in the equestrian statue of General Logan. To this period, however belongs the fascinating small bronze figures of native American animals – bears, pumas, elk, wolves and buffalo. He was awarded a Rinehart scholarship which included a year's study in Paris. In 1895 he set off for Europe and actually stayed there for five years, studying sculpture, not as one might have expected, under one of the Animaliers, but under Puech and Injalbert. Proctor felt that he had mastered the techniques of animal sculpture as he saw it, and that the study of animal structure and comparative anatomy at the *Jardin des Plantes* would be a wasted exercise. At this stage he was more concerned to observe the techniques of sculptors in other fields, to see in what way these could be applied to his own speciality. It is also likely that Proctor did not like to be labelled as an Animalier and strove, with only varying degree of success, to break free from his early training and inclinations. Many of his small bronzes incorporate human figures, but it was only after many years that he succeeded in mastering the techniques of sculpting the human figure.

Proctor's best known works in the period before 1900 include his Bison – a figure giving the impression of tremendous energy and strength, a Timid Fawn and a group of Bear-cub and Rabbit. The last-named in particular, demonstrates Proctor's expressive craftsmanship – the underlying humour of the little bear frightened by the sudden appearance of a tiny, long-eared rabbit. The Striding Panther, which also belongs to this period, is a powerful work, which reveals throughout its sinuous length the intimate knowledge and painstaking research of its creator. Although most of his work at this time consisted of wild animal figures, he dabbled with the Wild West theme and produced a fine equestrian statuette of an Indian warrior.

In 1900 he returned to the United States in order to undertake an important commission for the American pavilion at the Paris *Exposition Universelle* of that year. This was the colossal quadriga entitled The Goddess of Liberty on the Chariot of Progress. Allegorical figures in quadrigas were rather hackneyed subjects in the late-nineteenth century and it is to his credit that Proctor managed somehow to imbue his Goddess of Liberty with a fresh approach. The horses were especially picturesque and fiery, and the addition of running youths on either side of the rampant steeds imparted the element of life and motion. This quadriga was subsequently shipped back to America and employed in various exhibitions there. Proctor's pair of panthers from Prospect Park in Brooklyn were also installed at the 1900 Exposition.

In the first decade of the present century Proctor continued to develop his style in monumental animal sculpture. At the Pan-American Exposition at Buffalo in 1901, for example, he sculpted a group embodying the concept of Agriculture and showing a man at the plough-tail while a boy urged on the team, a horse and an ox. It was a very remarkable example of the force of realism, when governed by the sculptural intention. The mass was most imposing and full of variety of movement through the contrast afforded by the figures; the horse vigorously straining at the traces, the ox exerting his slow lumbering weight, the boy in free action, while the man's was concentrated and checked. Moreover, it told its story so simply and directly, with such complete recognition of the essential points. As a piece of artistic realism, it was alive with the spirit of Millet – altogether a most remarkable work in the best traditions of the Barbizon school.

Other large animal groups which Proctor produced in the early years of this

109

century included the massive lions on the McKinley monument in Buffalo and the superb Princeton Tiger. His equestrian subjects included an incredibly active Bronco Buster and the complementary study of an Indian on the War-path, both executed for the Denver Civic Center, while his splendid statue of Roosevelt the Roughrider may be seen in Portland, Oregon. Towards the end of his career, however, he tended to prefer human figures and dispensed with the animal element. In this category come his Indian Drinking (Saratoga Springs) and the Pioneer (University of Oregon) in which animals are conspicuous by their absence. Undoubtedly Proctor's reputation as an American Animalier rests on the period from 1887 to 1900 when most of his small animal bronzes were edited by the foundry of J. N. O. Williams. Small bronzes by Proctor are now rising in popularity; a fine bronze of a Pacing Lioness was sold at Sotheby's in October 1970.

If Kemeys pioneered animal sculpture in America and Potter and Proctor consolidated its position in the United States, the artist who did most to perpetuate it was Solon Hannibal Borglum, who founded the American School of Sculpture for practical instruction. Born in Ogden, Utah in 1868, the son of a Danish immigrant wood-carver who later became a physician, Solon Hannibal Borglum spent his youth in the neighbourhood of Fremont, Nebraska where his father's medical practice encompassed a vast area of prairie country of white homesteads and Indian villages. Young Borglum often accompanied his father on his rounds and must have imbibed much of the lore of the plains which he later translated into sculpture. As a youngster he was at home on the back of a pony as most boys of his age would be on their feet and he could throw a lasso with great skill. He has been described as "an integral part of the rough life around him", yet he was an artist at heart and was inspired to follow in the footsteps of his elder brother Gutzon who made a name for himself as a painter.

Their father had been unable to ply his trade as a wood-carver, when he emigrated from Denmark to the United States in the early 1860s, but if heredity has any significance it was undoubtedly from his father that young Solon acquired his skill as an artist in a three-dimensional field. A more immediate influence, however, was his father's sideline occupation as a horse-breeder. Solon showed little academic aptitude and preferred the schooling of "the great outdoors". He grew up among horses and as soon as he was permitted to leave school he became a cowboy. The formative years of his teens and early twenties were spent on cattle ranches and it was not until he was 26 that he decided to take up art seriously. Prior to that he had done a little sketching, mainly of horses and cattle, but in 1894 he sold his ranch and went to live with another brother in the Sierra Madre Mountains of California. At this time he dabbled with portrait painting and even opened an art school at Santa Ana near Los Angeles where he taught painting one day a week and roamed the mountains and the countryside on the other six days.

He realised that his art was drifting in no fixed direction and it occurred to him to seek instruction for himself. In the autumn of 1895 he drifted eastward to Cincinnati where he enrolled for art classes at the Museum school. Near his lodgings was a livery stable where he spent all his spare time sketching and modelling the horses. Here he modelled a group of a horse pawing a dead companion, supposedly lying on the plains, and this statuette won for him a special prize. The following year he exhibited no fewer than seventeen different studies of horses as a result of which he was awarded a travelling scholarship. In 1897 therefore he went to Paris to pursue his studies further and here he produced his spirited study entitled Lassoing Wild Horses which, with another horse formed his exhibit at the Salon of 1898. The following year he produced his most ambitious group, the large and complex Stampede of Wild Horses

110

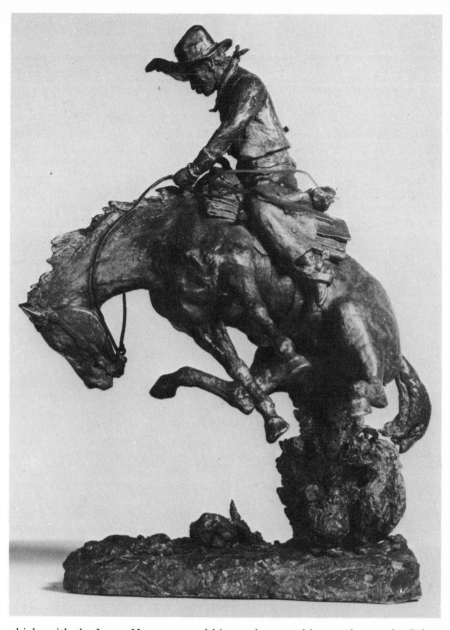

Farrington Elwell
The Sunfisher

which, with the Lame Horse, earned him an honourable mention at the Salon of 1899 and was subsequently placed in the centre of the United States pavilion at the 1900 *Exposition Universelle* where his work brought him a silver medal. He also received a silver medal at the Pan-American Exposition in 1901, with a remarkable exhibit of twelve small bronzes and marble groups which included his evocative group entitled On the Border of the White Man's Land – a study of a stalking Indian and his bare-back pony.

After the Pan-American Exposition the Keppel Gallery in New York held an exhibition of his work and from then onwards his reputation was established in art circles in America. Borglum died in 1922, before his art had become fully developed, and it is interesting to speculate in what way he might have progressed. Curiously enough, his elder brother, Gutzon, who had worked mainly as a painter, subsequently turned to sculpture and produced numerous monu-

111

mental pieces on a heroic scale, the culmination of which was his project for an extraordinary relief 700 by 100 feet across the face of Stone Mountain near Atlanta, Georgia, involving several hundred figures, as a memorial to the Confederate Army. Solon Hannibal Borglum's greatest legacy to modern American art, however, was the foundation of the American School of Sculpture.

In Paris Borglum studied figure sculpture at Julien's Academy and frequented the Louvre and the Luxembourg. But apart from having the critical advice of Frémiet now and again he did not study under any of the French Animaliers. As regards his animal sculpture Borglum was largely self-taught, drawing inspiration from the memory of his own experiences and working out for himself a technique that should give substance to his ideas. His sculpture therefore occupies a transitional position between the meticulous attention to detail of the traditional Animalier school and the Impressionism of Pompon and Bugatti.

In its disregard for symmetrical composition, in the frequent appearances of passages left suggestively in the rough and in the vivid naturalness that characterises it, we may for a moment fancy that we detect the influence of Rodin. Nevertheless it shows none of the latter's feeling for subtlety of modelling, and by comparison is crude; moreover, the viewpoint of each was widely different. Rodin's was profoundly analytical and introspective at the same time; Borglum's was more spontaneous and instinctive, aiming to interpret in a vigorous ensemble the vivid impression of an objective fact. Similarly, in breadth of handling and in knowledge of animal structure and movement we might compare him with Barye; only to find, however, that the latter far excels him in nobility of line and mass and falls as far behind him in the expression of sentiment.

For Borglum's work reveals in a remarkable degree the sentiment which comes of intimate, habitual companionship. He did not, on the one hand, invest his animals with any quasi-human sentimentality, or, on the other, look at them from the outside standpoint of the hunter or otherwise observant student. He succeeded in entering into the actual sentient part which animals play in the life they share with mankind. Hence the sentiment which his work reveals is poignantly affecting. In this sense Borglum broke new ground. No other Animalier up to that time had managed to represent with such fidelity and conviction the intelligence and emotions of animals. This quality is seen at its best in his sculpture of wild horses. One shows a young bronco, fully-grown though still untamed but quiet as a lamb, resting its muzzle on its dam's back; it has not yet come in contact with the disciplining force of man. Another sculpture depicts the animal confronted with a saddle lying on the ground, and it is shown recoiling with a mixture of trembling and curiosity. Now it has been rounded up and thrown, at first struggling with impotent fury then stretched in utter exhaustion. Later the saddle is on its back, and it is pitting its strength and cunning against the knowledge and endurance of man. Subsequent sculptures depicted the bronco, finally tamed, co-operating with man in the taming of other horses, or sharing the night watch, or enduring with him the dangers of a blizzard.

Coupled with this ability to convey animal feelings was Borglum's mastery of movement. Impetuous dash, sudden arrest of action, alert repose, the vicious fling of body and heels as the beast prepares to turn a somersault, the limp of pain, the submission of exhaustion, the supple step to music in the circus, the pause of doubt and the spasm of baffled rage were all represented with an intimacy of knowledge and an instinctive certainty of method.

An Animalier artist of a very different kind was Frederic Remington (1861–1909) who set out to place on record the life of the American West and achieved this equally in oils, pastels, watercolours and bronze. It is fortunate that an artist of Remington's stature should have been at work at that time, in the

112

Pierre Jules Mêne
Two Greyhounds playing
with a ball 6½″

Pierre Jules Mêne
Family of Goats 5″ × 8½″

Pierre Jules Mêne
Stag browsing at a branch
15¼″

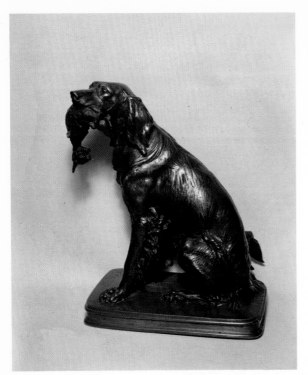

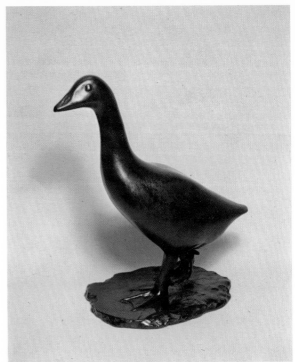

Ferdinand Pautrot
Pointer 18″ × 12½″

François Pompon
Young Goose Walking 10½″

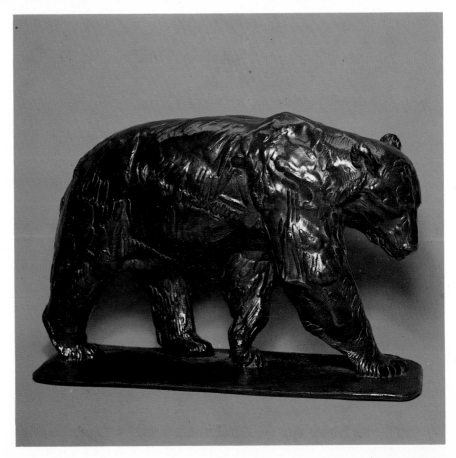

Rembrandt Bugatti
Bear 8″ × 12″

closing decades of the nineteenth century, and was able to record the wildlife, the Indians, the cowboys and the cavalrymen of the plains and prairies before the frontier way of life vanished for ever. Moreover it is significant that Remington's staunchest admirers were those people who knew the Old West intimately and would therefore be in the best position to evaluate his work critically.

Frederic Sackrider Remington was born in Canton, New York on 1st October 1861, the son of old New York families. At first sight therefore it seems strange that the greatest exponent of the art of the Old West should have been an Easterner born and bred, but during his earliest years his father was serving in the American Civil War and attained the rank of lieutenant-colonel in the elite Eleventh New York Cavalry, seeing active service in Tennessee and Mississippi. Canton was a small town in a rural district and this afforded the young Remington every opportunity for fishing, hunting, riding, hiking and swimming. As a small boy he showed tremendous aptitude for athletics and little enthusiasm for academic learning. Horses fascinated him immensely and he spent much of his time hanging around the local fire brigade. At the age of ten he was made official mascot of Engine House Number One. His schoolbooks were defaced with numerous drawings of horses, soldiers and Indians – the three subjects which he was to paint and sculpt in later life. He was educated at the Highland Military Academy in Worcester, Mass. and in 1878 enrolled at Yale. The two years spent at college proved that he was unfitted for a business career, but apart from earning a considerable reputation on the football field he enrolled as a part-time art student and began to make his mark as an illustrator of the college magazine. His father's death in 1880 left him with a modest inheritance and a sense of independence which enabled him to follow his own bent. In the summer of that year he was refused permission to marry Eva Caten, her father having doubts as to his abilities to maintain a wife. Frederic Remington was determined to prove his worth, and in the manner which had become established in America he decided to 'go West'. The next four years were spent in the pioneer country to the west of the Mississippi and it was not until 1884 that he settled down in Kansas City and married his childhood sweetheart.

The period of Remington's first sojourn in the West was an eventful one, coming in the middle of the era when the Sioux nation was fighting its last-ditch battle against the encroachments of the white man. Renegade redskins, train robbers, fur trappers, buffalo-hunters, squaw-owning frontiersmen, cowboys and homesteaders still made up the bulk of the population which roamed the vast wilderness of the plains into which civilisation had, as yet, made little inroads. The West was still the land of the open cattle range and the war-trail, and it was this scene which he set out to record, to illustrate the newspapers and magazines back East, where a growing volume of literature was catering to the insatiable demand for information on the frontiers of the United States. Apart from his magazine work Remington also produced paintings which an astute businessman in Kansas City, William W. Findlay, purchased. Findlay paid as much as $100 for a painting by Remington in the early 1880s; sixty years later his grandson was to pay almost a thousand times that sum for a Remington picture.

Remington's career was comparatively short, spanning a period of only 23 years. He died of cancer at the age of 48 and, in fact, produced relatively little work in the last seven years of his life. The culmination of his artistic career was his depiction of scenes from the Spanish–American War of 1898–99 in which he served as a war artist with his friend Theodore Roosevelt. Nevertheless his output in this period was quite prolific, amounting to at least 2,700 drawings and paintings reproduced in 41 periodicals and 142 books. Many of

113

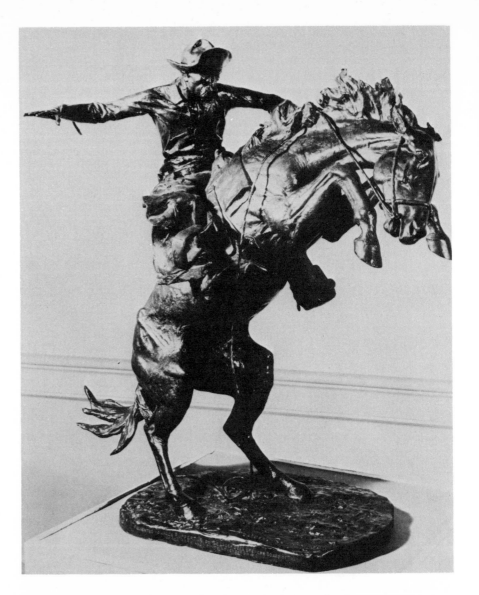

F. Remington
The Bronco Buster

them were subsequently reproduced as prints for calendars, posters or art portfolios. Eight of the books were from Remington's own pen, while the magazines for which he worked had a combined circulation running into hundreds of thousands. In addition, however, he produced some 25 works of sculpture which were subsequently cast in bronze in limited editions.

Remington turned to sculpture at a comparatively late date. It was in the summer of 1895, when he was 33 years old, that he first experimented in the three-dimensional field. The eminent sculptor Frederick Ruckstull was responsible for his conversion to sculpture. A tent had been pitched on a vacant lot near Remington's house in New Rochelle and in it Ruckstull worked on the half life-size clay model of his equestrian statue of Brigadier John F. Hartranft (now standing on Capitol Hill in Harrisburg, Pennsylvania). Remington was a frequent visitor to Ruckstull's tent that summer. The horse in particular caught his interest. Ruckstull's unpublished memoirs contain a vivid account of Remington's attraction to sculpture and are worth quoting at some length:

"He [Remington] became very much intrigued by the Hartranft model I was

114

making. One Sunday morning I was loafing with him in his studio. 'Ruck', he said suddenly, 'do you think I could model? [Augustus] Thomas has suggested that I could'. 'Certainly you can'. 'What makes you say certainly?' he asked. 'Because you *see*, in your mind, so very clearly anything you want to draw. You will be able to draw just as clearly in wax as you do on paper'. 'But how about the technique of it?' he queried with a quizzical look. 'Technique be hanged', I replied. 'Forget it and it will take care of itself. Then you will have an individual technique, or surface modelling, personal and peculiar to you, and in this epoch of a craze for individuality that will be an added quality. All you need to think of is a popular subject, a fine composition, correct movement and expressive form. Begin right away. You can do it. Take that drawing of yours of a bronco buster–you can start with that. I'll get a modelling stand, and tools and modelling wax for you, and show you how to make a wire skeleton for supporting the wax, and all that'. He jumped up eagerly. 'By God!' he exclaimed boyishly, 'I can try anyhow, can't I?' 'And you can't fail', I replied."

The bronco buster which he selected for his first attempt at modelling was a subject of great complexity and fraught with many problems which would have daunted a far more experienced sculptor. The difficult pose, showing the bucking horse on his hind legs with a rider on his back, was almost too much for Remington but with characteristic determination he persevered with it until the model was completed. On the eve of his thirty-fourth birthday Remington put the finishing touches to the model. Few sculptors can have achieved the instant success which came Remington's way.

Some 250 copies of The Bronco Buster were sand-cast in bronze and retailed for a total of $62,500. Such is the enduring popularity of Remington's work that these bronzes, which originally sold for $25 each, fetched up to $200 fifty years later, at a time when interest in small Animalier bronzes was at a low ebb on both sides of the Atlantic. Flushed with the success of The Bronco Buster Remington shortly afterwards began work on a second model and this eventually became the group known as The Wounded Bunkie–a Western equestrian subject showing two horses at full gallop, with only a single hoof of each animal actually touching the ground. Each horse bore a frontier cavalryman, one of whom was wounded and was supported in the saddle by

F. Remington
The Stampede, 8″, Courtesy
Amon Carter Museum,
Fort Worth, Texas

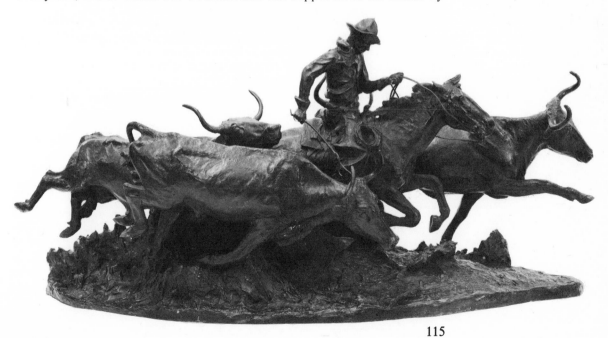

115

the other trooper who had come along just in time to save his wounded 'bunkie' (comrade) from falling from the saddle. Only fourteen copies were made of this sculpture and today it is one of Remington's most highly sought after bronzes. In 1898 Remington produced The Fallen Rider and The Scalp (the latter showing an Indian warrior holding aloft the scalp which he has just taken from an enemy).

Up to the end of 1900 Remington had produced only five works of sculpture; in the last nine years of his life, however, when he drew and painted comparatively little, he produced seventeen entirely new works and three variations of existing works, making a total of 25 bronzes altogether. Whereas other sculptor-painters had modelled merely as an aid to their painting or, like Degas, had found modelling more congenial at a time when their ability to paint was diminished, Remington seems to have turned increasingly to sculpture for its own sake, and one wonders in what direction his art would have led him, had he lived longer. Prior to 1901 Remington's bronzes were sand-cast but from then onward he had them edited by Riccardo Bertelli who established the Roman Bronze Works in New York and used the *cire perdue* process. There is a marked difference in the quality of the post-1901 bronzes which exhibit a far higher degree of perfection than the earliest bronzes. The outstanding hallmark of all Remington's bronzes, however, is the realism with which they were modelled. Remington was uncompromising in this matter and did not believe in 'artistic licence' at the expense of accuracy. He knew and loved horses and would never consider altering the slightest anatomical detail to achieve a more artistic pose.

Examples of Remington's bronzes are to be found in many museums and art galleries in the United States as well as numerous private collections, though it is only within recent years that his bronzes have caught the attention of the collecting public on the other side of the Atlantic. The bronzes of Frederick Remington are listed in the Appendix.

Charles Marion Russell is well-known in the United States as a great painter, in both oils and watercolours, of the frontier life and animals of Montana. However what is not so well known is that he was also a prolific sculptor. He was born in 1864 in Missouri and lived there until he was 17. From a very early age, he was modelling in clay using only one small lump; he used to make a model of a Red Indian or an animal; even then he was fascinated by the native peoples and animals; and when it was perfect he would destroy it and begin again.

In 1880, he moved to Great Falls in Montana, a small mining town on the banks of the Missouri, where he lived until his death. He married a girl called Nancy, but to their great regret the marriage was childless and so, in 1916, they adopted a small boy. During his life he produced nearly 250 different sculptures of animals, cowboys and indians apart from his many paintings. Most of these were cast only in very small editions; very few of them were cast in a larger edition than 24 and many were not cast until after his death. Among his sculptures are all the native animals of the Montana frontier and many different types of Red Indian from various tribes; he was, however, particularly fond of the buffalo, the bears and the wolves which he modelled over and over again. He was modelling up to a few days before his death which occurred in 1926. His reputation as one of the greatest portrayers of the old 'wild west' is fully justified as he has the rare ability to show wild animals in an intrinsically humorous or tragic pose without becoming sentimental. His statues of the Red Indians also show his awareness of the tragedy of their fate as well as the value of their culture, which was being eroded by the white man even as he modelled; his contribution to recording the frontier life can never be overestimated.

116

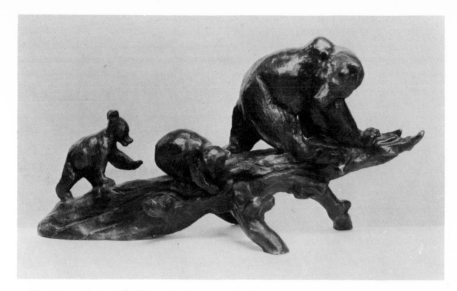

Charles Russell
Mountain Mother 14½″

The last of the Old West artists was Robert Farrington Elwell (1874–1962) whose career in many respects duplicated that of Remington. Like Remington, Elwell was an Easterner, having been born in Boston, Massachusetts. He had a conventional grade school education in urban surroundings, but as a small boy he was captivated by the romance of the Old West and was forever drawing cowboys and Indians. His father, a building contractor, did marine paintings as a hobby while his mother also sketched in her leisure time. Apart from the precept and example of his parents, however, Elwell was largely self-taught. Shortly before he left school at the age of fifteen Elwell paid a visit to the Wild West Show of Buffalo Bill Cody which was then being staged in Boston. Young Elwell was so entranced by the sight of real-life cowboys and Indians that he paid numerous visits to the show and spent many afternoons sketching them. After a while Cody noticed the boy who came so regularly and sketched so diligently. One day he came up behind the boy unobserved and watched him sketch. Cody was so impressed by Elwell and his work that he asked him if he would like to spend the summer at his large range in Wyoming where he could draw horses and cowboys and Indians in their natural setting. The boy accepted the invitation and, after persuading his parents to let him go, he set off for Wyoming where he spent the summer and the autumn painting and drawing. This was only the first of several extended visits to Wyoming during which Elwell laid the foundation of his artistic career.

On his return to Boston after that first summer vacation his parents felt that he should seriously consider a career in art and they took advice on what training would be required. Elwell was told that he would require years of academic training before his work would be of a sufficiently high quality for him to earn a living from it. This pronouncement infuriated him and on impulse he walked into the Lothrop Publishing Company's offices in Boston and sought an interview with the president of the company. The result of this was his first assignment, to illustrate two novels–*Oscar Peterson, Ranchman and Ranger,* by Henry W. French, and *Archie of Athabasca* by J. Macdonald Oxley. Both Westerns were published in 1893 and in this way Elwell made his modest beginning as an illustrator. For almost a decade he worked exclusively in black and white, producing drawings and pen-and-wash sketches for book and magazine illustration. In 1902, however, he was commissioned to paint landscapes in full colour, but continued to use the same subjects–cowboys, Indians, cattle, horses and wild animals. Comparatively late in life he began

117

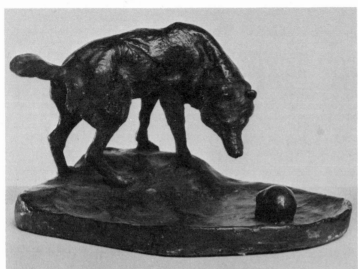

Charles Russell
The Last Laugh 8½"

Unknown
A mounted Red Indian
Chief, signed Roman
Bronze Works N.Y., 19¾"

using pastels and watercolours and worked in these media to the end of his very long life.

At first art was regarded as a spare-time activity, albeit a lucrative one. Elwell trained as an engineer and for some years spent the winter months in the East engaged in engineering work. Subsequently he accepted Cody's invitation to become manager for one of the Cody ranches in Wyoming and for many years he lived there with his wife and two daughters. When the girls reached school age, however, the Elwells moved back to Massachusetts and bought an estate near Dover. After his daughters had grown up Elwell and his wife returned to the West, exploring the Rockies before settling at Wickenburg, Arizona. Apart from the years of the Second World War, when he worked on picture drawings from blueprints of aircraft assemblies to enable semi-skilled workers to assemble the parts assigned to them, Elwell continued to paint Western scenes, many of which were subsequently featured in exhibitions in New York, Boston, Columbus and other American cities.

Like Remington, Elwell looked for other media in which to express his art, but he was well on in middle age before he turned to sculpture and then only as a form of relaxation from painting. Eventually modelling became his chief occupation during the last years of his life and in that period, in the 1950s and early 1960s, he produced between twenty and thirty studies of Indians, cowboys, horses and cattle. Very few of these were cast in his lifetime and, as with Degas, the majority of the models were not discovered till after his death. These are now being edited in limited editions using the lost wax process under the supervision of the Sladmore Gallery in London. R. Farrington Elwell's artistic career conveniently bridges the gap between the *fin de siècle* sculpture of Remington and the work of Harry Jackson at the present time. Jackson (born 1924) has been producing sculptures of horses and cattle since 1958 and a discussion of his work in this field is therefore more appropriate to the final chapter.

Chapter VIII

The Animaliers of other Countries

Outside France and the United States the greatest attention to animal sculpture was paid by artists in Germany, although, as in America, interest in this field did not develop until the latter years of the nineteenth century. Connoisseurs and collectors of animal bronzes in Germany and Austria were content to import sculpture from France. When native Animalier sculptors began to appear it was significant that they were artists who had received much of their training, or who had worked extensively, abroad. Foremost in this field was Louis Tuaillon, born in Berlin of French descent in 1862. Tuaillon was a pupil of the Berlin Academy and received his training as a sculptor from Karl Bégas. Thus his background was academic and inevitably he produced sculpture in the heroic tradition fashionable in Germany at the end of the nineteenth century. Nevertheless the work for which he is now best remembered was almost wholly Animalier. Work in this *genre* which is preserved in German museums and art galleries includes his Amazon on Horseback (Berlin), Amazon (Bremen), Bulls (Krefeld) and Hungarian Bull (Leipzig). Tuaillon also sculpted a number of small animal figures which are known in bronze, while bronze reductions were made of some of his larger groups. Tuaillon died in Berlin in 1919.

A close friend of Tuaillon, and seven years his junior, was August Gaul (1869–1921) who came to sculpture comparatively later in life. Born in Bross-Auheim near Hanau, he attended the School of Arts and Crafts and later the Berlin Academy, where he received a thorough artistic training. At Hanau he studied drawing but later worked with a gold and silversmith and only gradually turned from designing jewellery to modelling. In 1894 he went to work as assistant to Reinhold Bégas and was entrusted with modelling the lions for the monument to the Emperor William I. He was awarded the Prix de Rome by the Berlin Academy and this enabled him to spend a year there (1897–98). About this time he became friendly with Tuaillon and his career reached its turning point. Not only did he concentrate from then onwards on the sculpture of animals and birds, but he joined the artistic movement known as the Secession.

In 1899 he sent his Lions to the exhibition held by the Berlin Secession, where they drew considerable comment and aroused the attention of the art world. Gaul's chief merit as an Animalier was in having found a means, still novel at that time, of freeing himself from the stereotyped attitudes adopted

119

by the later Animaliers in France. He showed great originality not only in turning his attention to animals which had hitherto been neglected by the Animaliers but also in his treatment of the subjects. In comparison with the exact realism of Barye and Frémiet his work showed a deliberate simplification, parallel to Pompon, though somewhat more naturalistic. Above all else, he succeeded in capturing the attitude and character of the animal and also experimented with groups of animals in order to make a satisfactory sculptural composition which he circumscribed by a strongly marked contour. He sought the natural cube form and the simple silhouette, as Pompon did, usually by depicting the bird or animal at rest. There is, for example, a curious affinity between the owls sculpted by Gaul and Pompon.

In spite of his high reputation he received few official commissions. He sculpted the ducks on a fountain in Charlottenburg, a bear balancing on a ball for the Wertheim Stores, a fountain with a bison for Königsberg (now Kaliningrad), and the penguins on a fountain for the grounds of a private villa at Wannsee, near Berlin. Examples of his work preserved in museums include Two Pelicans, Lion and Sheep in Repose (Berlin), Bear Amusing Itself, Ostrich and Geese (Bremen), while eleven of his small animal bronzes are in the Hamburg Museum.

Johann Vierthaler, born at Munich in the same year as Gaul, studied at the Munich Academy and subsequently trained as a sculptor under Eberle, an artist in the academic tradition. His work consisted principally of statuettes of the human figure (three of which are preserved in the Leipzig Museum) but he also dabbled in animal subjects. A Bull about to Charge sculpted by Vierthaler was sold at Sotheby's in 1970.

Several Austrian sculptors also worked in the Animalier field. Friedrich Gornik was born in Carinthia and studied at the Vienna School of Arts and Crafts, subsequently setting up his studio where he modelled animals for ceramic reproduction (plaques, plates, cups, vases etc) but also produced numerous plaster models and groups for casting in bronze. The best-known work from this period, at the beginning of the present century, was Troika, a group of horses drawing a sledge, which he sculpted for Artur Rubinstein. This group was cast in bronze in a limited edition and one of these bronzes was later purchased by the Emperor Franz Josef. An excellent group of three Cock Pheasants in Fright by Gornik was sold at Sotheby's in March 1970. In the latter part of his career, however, Gornik turned away from the Animalier style and concentrated almost entirely on human figures, such as his Wounded Soldier and other military subjects dating from the First World War. Nevertheless in his spirited Group of Dragoons one can see something of the old Animalier magic in the sensitive modelling of the horses.

Michael Six, born at Weng, near Braunau in 1874, studied art in Salzburg and Vienna and became a medallist of note. While most of his work consists of commemorative medals and plaquettes, he also sculpted statuettes mainly allegorical in composition. An Eagle signed by him and sold in London in 1970, has a less naturalistic, more heraldic quality about it.

In general the German school of Animaliers broke free from the more naturalistic concepts of the nineteenth century French school. The ideas expressed by Tuaillon and developed by Gaul culminated in the work of Renée Sintenis who kept alive the spirit of the Animaliers in the years after the First World War when the majority of sculptors everywhere were abandoning impressionism in favour of cubism and surrealism. Renée Sintenis was born in 1888 at Glatz, then part of Prussia and now in Poland. She spent her early years at Neuruppin and then went to Stuttgart where she studied drawing at the Art School. Between 1908 and 1911 she continued her training at the Berlin School of Arts and Crafts under L. von König and Haverkamp. After the First

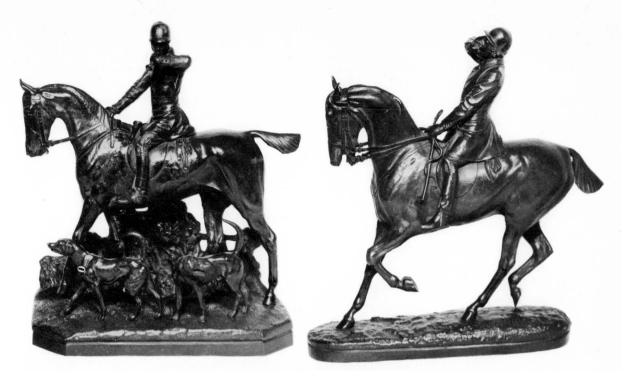

World War she married the engraver, Emil Rudolf Weiss. In 1929 she became a member of the Prussian Academy of Fine Arts but was later expelled by the Nazis. In 1944 she lost her private collection in the bombing. After the Second World War she was appointed to the staff of the Berlin Art School. Her seventieth birthday was the occasion of a large retrospective exhibition organised by the Haus am Waldsee of Berlin in 1958.

Miss Sintenis has produced a number of fine portrait sculptures, both self-portraits and portraits of her husband, André Gide and Joachim Ringelnatz (the latter returning the compliment by dedicating his poem *Farewell to Renée* to her). Above all, however, she is regarded as the finest Animalier sculptor to have appeared in Germany this century, a worthy successor to Gaul. Her animal figures differ radically from those of Gaul; whereas he preferred his masses compact and static, she was always concerned to depict movement and action. In her earliest work the surfaces of her sculptures were relatively solid, but later she adopted greater freedom in modelling (a technique which may be observed, for example, in some of the more recent work of Gillian Wiles and Jonathan Kenworthy). Her later work is almost impressionist although carefully controlled in its smallest detail.

Although Miss Sintenis has sculpted animals of all kinds she always had a *penchant* for young animals – foals, puppies, bear cubs, baby camels and infant deer, all of which have an innocent, leggy quality which provides a refreshing contrast to the work of most other Animalier sculptors. Similarly most of her human figures tend to be of young children and this love of youth is often combined, especially in the various studies of little boys carrying new-born lambs which she modelled between 1949 and 1953. Few of her sculptures are of more exotic subjects, although she has produced Secretary Bird (1946), Reclining Llama (1947), Walking Elephant (1926) and Kneeling Elephant (1936).

Walter Schott, born at Ilsenburg in 1861, was a pupil of Dopmeyer and Schaper, subsequently becoming a *genre* painter and sculptor. His characteristic work is exemplified by the statues of Frederick-William I and William II

121

in Berlin, and his monument to William of Orange. On a less heroic scale is his charming Girl playing Bowls, versions of which are in the Berlin National Gallery and the Dusseldorf Museum. He also dabbled to some extent, however, with animal subjects and a bronze Bulldog sculpted by him appeared in the saleroom not long ago. Christian Schmidt, both in Halle in 1869 studied at the Dresden Academy and became a sculptor of animal and human figures. The Halle zoological gardens have a statue of an Archer by him. He also produced small bronzes of horses, but whether the Stallion sold at Sotheby's in March 1970 was by him or an unknown artist bearing the same (all too common) surname, can only be conjectured. Since the growth of popularity of Animalier bronzes developed dramatically, and the leading auctioneers have begun to hold regular sales devoted to them, quite a number of excellent bronzes have turned up which are the work of artists about whom little or nothing can now be gleaned. At Sotheby's sale of October 1970, for example, there was an attractive little Dormouse bearing the monogram S.W. I have not been able to identify this artist, nor the sculptor named Schmidt-Felling who signed a figure of a Nude Horseman which was also sold at Sotheby's. Both of these bronzes bore the foundry-mark of Gladenbeck and would seem to date around the beginning of the present century.

Little is known of Albert Hinrich-Hussmann, beyond the bare facts of his birth in 1874 and that he exhibited three works in Berlin in 1909, but he sculpted a Young Stag which turned up in the sale-rooms in 1970. Other bronzes which have been featured in Animalier sales since 1969 include a Bull Elephant signed by G. Hickholtz, an equestrian statue of Don Quixote on Rosinante by A. Hupmann, a group of a Lion and Lioness by J. Haehnel, Cow and Calf by J. Kabende, and The Stallion 'Morgenstrahl' by Reinhold Kübart. Another sculptor of the German school about whom little is known is the artist who signed his bronzes 'Waagen'. Bénézit merely records that Waagen was working in 1869 and that his bronze of Shepherds, Dogs and Dead Wolf is preserved in the Sheffield Museum. A hunting group, inscribed *Kabyle au Retour de la Chasse*, in gilt-bronze signed by this sculptor, was sold

Willis Good
Equestrian Group, signed
and dated 1875 11½″
Willis Good
Jockey and Racehorse
(silvered bronze) 10″

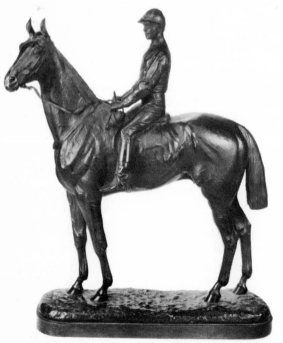

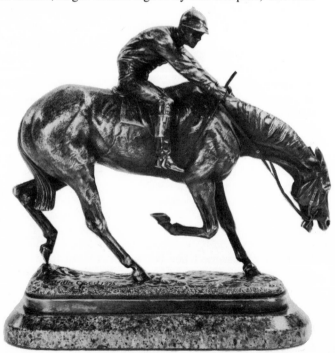

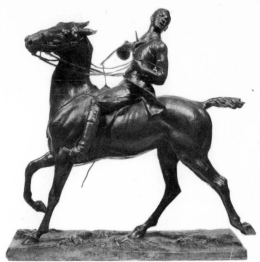

at Sotheby's in 1970. The Sladmore Gallery have a lively group showing a Greyhound and a Cat sculpted by Waagen.

There was a small, but relatively important, Animalier movement in nineteenth century Russia, founded by Baron P. K. von Jurgensburg Klodt (1805–67). He came under the influence of the French Animaliers who supplied so many of the Russian aristocracy with small animal bronzes, and executed several monumental pieces for the Imperial family. Baron Klodt produced monumental statuary himself, including a magnificent equestrian statue of Tsar Nicholas I and the allegorical group on the Anichkov Bridge in St. Petersburg (now Leningrad), but most of his surviving work consists of small bronzes. The Russian Museum in Leningrad includes his study of a Horse, which was subsequently used for the group on the Anichkov Bridge, Horseman attacked by a Panther, equestrian statuettes of Nicholas I and Mihail Federovich, a study of Horses, Horseman Resting and Mare and Foal, while the Tretiakoff Museum had another version of his Mare and Foal. After him came Ievgenni Alexandrovich Lanceray (sometimes rendered as Lanceré) who also had a *penchant* for equestrian subjects and produced several fine bronzes in this *genre*. Lanceray (1848–1886) spent much of his life in France, and is thus sometimes regarded as one of the French Animalier school, but his bronzes were invariably of Russian subjects and his modelling and composition were quite distinct from those of his French contemporaries. His best-known bronzes include Peasant on a Mule, Tribesman on a Donkey, Cossack on Pony with Packhorse, and Boy with three Donkeys. Bronzes by Lanceray are found with the mark of the Chopin foundry and bear his signature in Cyrillic.

Another Russian Animalier who is known mainly for his sculpture of horses was Nikolai Ivanovich Liberich (1828–1883). Born at St. Petersburg, he studied at the Academy in that city and was admitted to membership in 1861. Apart from his numerous small bronzes of horses he executed dogs and deer. Bronzes by Liberich were cast by the Werffel foundry and a few statuettes by him have also been recorded in silver. At Sotheby's sale in June 1970 a bronze by an unknown artist named Grachev was sold; this group featured the Czar's Falconer on a trotting Stallion.

Undoubtedly the best-known of the Russian Animaliers, however, was Prince Paul Petrovich Troubetzkoy. Born at Intra in Italy in February 1866, he studied art under Ernest Bazzaro and spent much of his working life in Italy

123

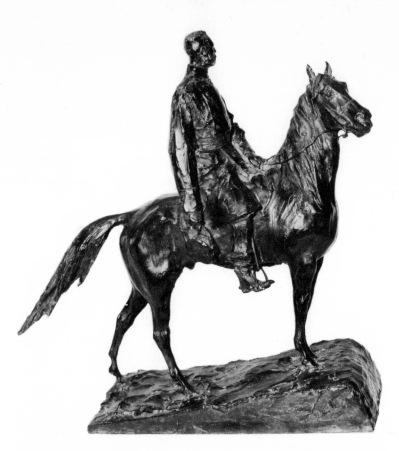

Prince Troubetzkoy
Tsar Nicholas II on
horseback

and France as well as Russia. Thus he came under the influence of the
Impressionists in each country, particularly Rodin and Medardo Rosso, from
whom he learned the techniques of capturing the fleeting attitudes of the
moment. His elder brother, Prince Peter, became a portrait painter of some
note and Paul also worked in the two-dimensional field, though mainly as an
engraver. Prince Paul Troubetzkoy produced a number of portrait-statuettes
but his forte was animal sculpture and he travelled extensively studying nature
for the basis of his groups. At the *Exposition Universelle* of 1900 he was
awarded a *Grand Prix* and four years later he exhibited a collection of important
bronzes at the *Salon d'Automne*. Appropriately for such a cosmopolitan, Prince
Troubetzkoy's work was always better known abroad than in his ancestral
country and he frequently exhibited his bronzes in New York, Chicago,
Washington, Detroit, San Francisco and Los Angeles in America, as well as in
London, Berlin, Vienna, Dresden, Rome and Paris. Among his portraits in
bronze may be mentioned the painter Segantini (uncle of Rembrandt Bugatti)
and the busts of Tolstoi and Boborikin in the Tretiakoff Museum in Moscow.
Among his monumental work may be cited the equestrian statues of Tsar
Alexander III and the Italian General Cardona. Troubetzkoy sculpted horses,
dogs and cattle mainly. A fine figure of a Cow is in the Berlin Museum, while
a figure of a young girl (Marrinecca) with a dog is preserved in the Dusseldorf
Museum. A French Bulldog dated 1915 and signed 'P. Troubetzkoy' was
featured in the Sladmore Gallery exhibition Barye to Bugatti.

Apart from Troubetzkoy, who spent so much of his time in Italy and was
born and died there (February 1938), or Bugatti whose working life was spent
in France and Belgium, there were few indigenous Italian Animaliers. Of these
the only one who was in any way outstanding was Count Stanislas del Poggetto

124

Grimaldi, a cavalry officer in the Sardinian Army who was a talented painter and sculptor. His first important artistic commission came in 1850 when he was charged by the Minister of War, La Marmora, to produce a series of prints illustrating the principal events of the recent War of Independence which led to the partial unity of Italy under the House of Savoy. These lithographs were subsequently published between 1851 and 1855. Later he was commissioned by King Victor Emmanuel II to paint horses, including the *Review of the Sardinian Troops in the Crimea*, the equestrian portrait of Victor Emmanuel, *Crown Prince Umberto at the Battle of Custozza* (1866) and the *Cavalry Charge at Montebello* (1859). Of his sculpture little is known, though he executed the splendid equestrian figure of General La Marmora which stands in the Plaza Bodoni in Turin. A group of A Trotting Horse, signed by him and dated 1883, was sold at Sotheby's in July 1969.

The same sale featured a bronze group of a Cow and Calf inscribed 'A Monsieur G. Mondou In Omaggio di Ricognoscenza Pina' and dated 'Paris 1915'. This group has been ascribed to Alfredo Pina, a pupil of Rodin who exhibited at the Salon from 1911 onward. Pina was born in Milan in 1883 and like Bugatti came to Paris about the turn of the century where he soon came under the influence of Rodin. He began exhibiting at the Salons of French Artists and d'Automne in 1911 and exhibited at the *Salon des Independents* in the 1920. Most of his work seems to have consisted of portrait busts and beyond the fact that the Cow and Calf are impressionistic there is not much to connect this group with Alfredo Pina, though it is not improbable that he also produced animal groups.

Considering that the British have long been regarded as a nation of animal-lovers it is somewhat surprising that comparatively little Animalier sculpture was produced in the United Kingdom. For the most part the upper and middle classes were content to import their animal bronzes from France and it has already been noted that Barye, Bratin and Mêne in particular operated a con-siderable and highly lucrative trade in their bronzes to Britain, while many of the other French Animaliers also pandered to the British market by sculpting Derby winners and Scottish cattle. Nevertheless there are a few examples of British Animalier sculptors who were at work in the nineteenth century. Out-standing among them is the enigmatic figure of John Willis Good who exhibited at the Royal Academy between 1870 and 1878. Nothing is known about him, save that he specialised in equestrian subjects and portrait busts. During the nine year period in which he exhibited at the Royal Academy he showed some sixteen statuettes in bronze or terra cotta of racehorses and jockeys. Most of his bronzes seem to have been produced in pairs. There are, for example, the pair of hunting subjects, both approximately $11\frac{1}{2}$ inches high, depicting the View Halloo and the Whipper-in. These bronzes bear the signature 'J. Willis Good' and the date 1874, and are numbered 1 and 2 respectively. Two figures of hunters show them before and after the hunt, in characteristic poses. Another pair of hunters show them after the hunt, with the fox's mask tied to their saddles; the main difference in this pair is that one is shown resting its off

Prince Troubetzkoy
Husky

125

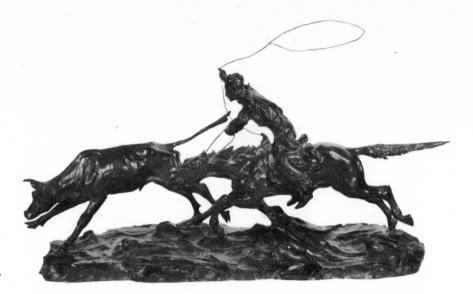

Prince Troubetzkoy
Cowboy, signed and dated,
13″

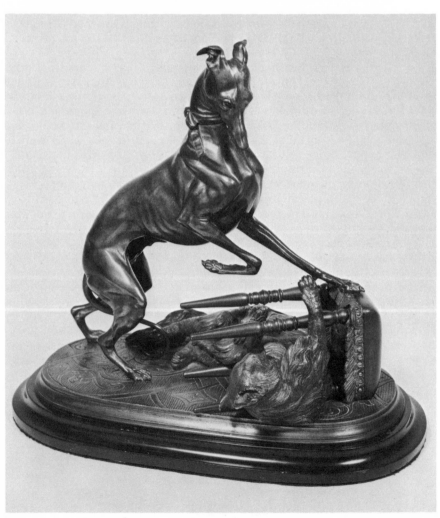

Waagen
Greyhound and Cat

hind-leg. Another pair, dated 1875, featured jockeys before and after the race. An equestrian statue of F. L. Floersheim is also known to have been modelled by Good.

In the last year that Good exhibited at the Royal Academy John Macallan Swan (1847–1910) made his debut as a painter. Born in Old Brentford, Swan began his studies in Worcester and subsequently worked with John Sparkes at the Lambert Art School. Eventually he went to Paris where he studied painting under Gerome and sculpture under Frémiet. During the latter years of the nineteenth century Swan exhibited regularly at the Royal Academy (A. R. A. 1894, R. A. 1905), but also showed his work on numerous occasions in France. At the Salon of 1885, for example, he received an honourable mention, while his exhibits at the *Expositions* of 1889 and 1900 earned him silver and gold medals respectively. The bulk of his work consisted of watercolours, drawings, pastels and oils, but he also produced a considerable amount of sculpture which faithfully reflects the derivation of his art from Barye and Frémiet. Although he carved a fine Wounded Leopard in marble and the head of a Lion in black and white stone, he preferred modelling to carving. Examples of his work are preserved in several British museums and art galleries (Aberdeen, Glasgow, Edinburgh, Nottingham and Preston as well as the Victoria and Albert Museum and the Tate Gallery in London) and are also featured in European museums (Amsterdam, Groningen, Rotterdam and Stuttgart) and galleries in Melbourne and Sydney. A small bronze Lioness by Swan was exhibited at the Sladmore Wildlife Exhibition in November 1970. Swan was also an accomplished medallist and produced several excellent portrait medals of J. Zarify, A. C. Ionides and Matthew Maris.

Possibly the best-known sculptor of the nineteenth century English school was Sir Joseph Edgar Boehm (1834–1890). As his name implies he was not a native Englishman, but was born in Austria and did not come to Britain until he was fourteen years old. Nevertheless all his art training and working life were in England and he enjoyed the patronage of the Royal Family and the nobility, being given a baronetcy in 1889. Boehm is best remembered for his portrait busts and statues, many of them on a monumental scale, but it is inevitable that he should also have experimented with animal studies. Among his monumental pieces may be mentioned the colossal equestrian statues of the Prince of Wales and Lord Napier, destined for erection in Bombay and Calcutta respectively; these large works showed his skill in depicting horses, a subject to which he returned in the form of small bronzes, such as The End of the Day, a fine study of a tired hunter. Boehm also sculpted cattle, and demonstrated the range of his talents by engraving coins and medals.

Apart from these artists the nineteenth century produced no other British Animaliers, though a number of sculptors, such as Sir John Steell (1804–91) and Thomas Thornycroft (1815–85) produced one or two isolated examples of equestrian statuettes or models of horses and cattle. By contrast British sculptors are in the vanguard of the modern Animalier movement which has been manifest in the return to naturalism and impressionism in the past decade and which is discussed at greater length in the last chapter.

Chapter IX
Contemporary Animaliers

Sculpture in the twentieth century has largely been non-figurative or abstract, moving rapidly from the impressionism and expressionism of Rodin and Bourdelle to the cubism of Picasso and the surrealism of Lipchitz or Zadkine. From a perusal of most general works on contemporary sculpture one would form the impression that naturalism and realism were totally defunct and that impressionism was virtually non-existant. Of course there are numerous sculptors who have drawn on the animal world for some of their inspiration but the resulting works are so far removed from what we would describe as Animalier that they can scarcely be considered in the context of this book. Constantin Brancusi (1876–1956) produced numerous works with such names as Bird in Space, Three Penguins, the Gosling or the Cock, but these streamlined abstracts bear absolutely no relation to the bird studies of Comolèra or Moigniez. Nor are the dogs sculpted by Alexander Calder, Alberto Giacometti or Lynn Chadwick to be compared with the pointers and setters of Mêne, or the equestrian figures of Marino Marini in the same *genre* as the hunters and race-horses of Fratin, Leonordez or Willis Good. It is true that in his early years as a sculptor Picasso produced a few works, such as his Goat, which is almost impressionistic and dates from the period when he was most strongly influenced by Rodin, but his surrealist arrangement of a bicycle saddle and handle-bars to form a bull's head would not qualify as a work in the pure Animalier tradition.

Although the years between the world wars provided a lean time for the sculptor in the modern idiom, let alone those who continued to cling to the more traditional modes of expression, it would be wrong to dismiss this period entirely as one in which naturalism and realism did not survive to some extent. The most outstanding example of an Animalier sculptor whose best work was produced in this period is provided by Herbert Haseltine (1877–1962). Haseltine was born in Rome, the son of the American painter William Stanley Haseltine who spent much of his career in Europe. Herbert himself had a very cosmopolitan education and upbringing. His formal education was gained at the Collegio Romano and Harvard University (class of 1899), but he studied art in Munich, Paris and Rome. He first exhibited at the Salon in 1906 and subsequently showed sculpture at the Royal Academy and the international exhibitions in Vienna, Liverpool, Venice, Rome, Brussels and Ghent. Over a period of fifty years Haseltine modelled and carved domestic animals – horses, cattle, pigs and sheep – and produced equestrian statues ranging from small

table bronzes to large monumental pieces.

In 1908 he sculpted for King Edward VII a bronze of his charger 'Kildare' and from then onwards he received many royal commissions. One of his best known works is The Meadowbrook Team, showing Dev Millburn on 'The Roan Mare', Larry Waterbury on 'Little Mary', Harry Whitney on 'Cotton Tail' and Monte Waterbury on 'Cobnut'. This splendid group, cast in *cire perdue* by Valsuani, was commissioned by Harry Payne Whitney in 1909 and subsequently presented to the Hurlingham Club.

Following the outbreak of the First World War Haseltine was attached to the American Embassy in Paris but following the entry of the United States into the war he was commissioned in the Engineer Corps where he headed the Camouflage Section. Military techniques of camouflage owe a great deal to Haseltine's pioneer work in this field. After the war he returned to his sculpture and had numerous one-man shows in France, Britain and the United States. In the summer of 1921 he began work on a series of champion domestic animals of Great Britain destined for preservation in the Field Museum of Natural History in Chicago. The models were carved in stone of various types and hue chosen specially for their suitability to reproduce the colours and characteristics of the different animals, or were cast in bronze, often partially plated with gold to give them additional highlights. The first of these models was of the Champion Shire Stallion 'Field Marshal V', from the stables of King George V. Altogether there were nineteen figures, made between 1921 and 1924 in various parts of England, Scotland and Ireland; the series on completion was exhibited in Paris and London. The other models in this collection consisted of the Shire Stallion 'Harboro Nulli Secundus', the Suffolk Punch Stallion 'Sudbourne Premier', the Percheron Stallion 'Rhum' and Mare 'Messaline' with Foal, a composite type of Thoroughbred Horse, the Thoroughbred Horse 'Polymelus', the Chaser 'Sergeant Murphy' and the Polo Pony 'Perfection'. Three bulls and a cow were included: the Aberdeen-Angus 'Black Knight of Auchterarder', the Shorthorn 'Bridgebank Paymaster', the Hereford 'Twyford Fairy Boy' and the Dairy Shorthorn 'Lily Charter II'. The remaining animals consisted of the two Lincoln Rams 'Conqueror' and 'Challenger', the Southdown Ewe 'Sandringham Ewe No. 10 of 1921', the Middle White Boar and Sow 'Wharfedale Deliverance' and 'Wharfedale Royal Lady', and the Berkshire Boar 'Highland Royal Pygmalion'. Subsequently six other models were added to the series including the Thoroughbred Mare 'Mumtaz Mahal', 'Easter Hero', 'Bois Roussel' and a group of Lady Wentworth's Arab horses.

In an appreciation of Haseltine's work written in the Twenties, Georges Bénédite of the *Académie Française*, summed up his accomplishments in this field:

"In the course of his close study of these wonderful examples of British breeding, Haseltine has been brought into contact with all those interested in their welfare, from owners to stud-grooms and herdsmen, and has been able to draw upon the knowledge accumulated by them from day to day to supplement his own powers of observation. His chief merit lies in his having realized that the pursuit of their utilitarian ideal of the best furnishes the artist with the essentials for his own pursuit of the beautiful. To give to the line the simplest expression, to reconstruct nature's handiwork in accordance with man's directions, to feel in it and to give to it its due proportion and to endow it with the technical detail which every aspect demands, can alone satisfy the true artist and constitute a true work of art."

In the 1920s Haseltine modelled a number of figures for Indian princes. He visited Nawanagar where he sculpted figures of state bullocks in Burgundy stone for the Maharajah. Later the famous Kathiawar Stallion 'Ashwani Kumar'

was sent from Jamnagar to Paris in order that Haseltine could see it as the basis of the fine equestrian statue of Jam Rawalji, the sixteenth century warrior who conquered that part of Kathiawar which became the state of Nawanagar and founded the dynasty of the present Maharajah. Other equestrian groups which he produced was the statue of Field Marshal Sir John Dill which now stands in the Arlington Cemetery in Washington (1950), the statue of George Washington for Washington (1959) and Prince Ranjitsinjhi in India (1934). Bronze reductions of these monumental pieces were also produced. Figures of horses on their own include The Empty Saddle, the Cavalry Club War Memorial (1921–24) and Auriole commissioned by Queen Elizabeth and now in Buckingham Palace. One of his finest and most ambitious works was *Les Revenants* (Returning Spectres) which represented the wounded, gassed and worn-out horses returning from the Meuse-Argonne front during the First World War. In connection with this work, modelled in 1920, Haseltine worked in the Vanguard slaughter-house in Paris, under much the same conditions that faced Rosa Bonheur many years before. This group, comprising twelve horses and two riders, won for Haseltine a gold *Medaille d'Honneur* at the Paris *Exposition Universelle* in 1937. Examples of this group, cast by Valsuani, are in the Imperial War Museum, London and the *Musée de l'Art Moderne,* Paris.

In addition to models of entire animals Haseltine also produced several heads of horses. Two of these, the Horse 'Indra' and the Mare 'Lakshmi' were modelled in plasticine at Jamnagar in 1938, cast in plaster in Venice later the same year and taken to the United States in 1940. During the ensuing eight years they were recarved a number of times and brought to a highly stylized finish, with detailed designs for the jewels and other ornaments, inspired by Indian miniatures of the seventeenth and eighteenth centuries. The plaster heads were then cast in 24 carat gold and ornamented with diamonds, pearls, rubies, sapphires, emeralds, garnets and jade – all selected to carry out the original conception. The casting and chasing of the gold heads and the jewellery work were done by Joseph Ternback in New York. The cosmopolitan nature of these works was rounded off by mounting them on rock crystal bases carved in Germany.

Haseltine's work is represented in numerous museum collections in the United States including the Metropolitan Museum of Art and the Smithsonian Institution, while the Tate Gallery and the Victoria and Albert Museum in London contain his work.

Ewald Mataré, born in 1887 at Aix-la-Chapelle, worked originally as a painter and it is only since 1920 that he has turned increasingly to sculpture, working in wood at first. He lived in Berlin until 1931 and then took up a teaching appointment at the Dusseldorf Academy but was dismissed from his post by the Nazis. He was reinstated in 1946 and it is from that year that his best work in the Animalier tradition dates. The Museum of Arts and Crafts in Hamburg held a large retrospective exhibition of his work in 1953 and the following year he was awarded a gold medal at the Mainz Triennial Exhibition. Since then his sculpture has been represented in almost every major exhibition in Germany and in many other countries. The bulk of his work is still done in fine woods such as mahogany and kingwood in which the carved shapes of the animals follow the natural grain of the wood. His love of smooth rounded masses, which were completely satisfying in shape and amplitude, have limited him to a particular kind of subject, particularly to cows shown in standing or lying positions. His attempts at horses have been confined to depicting the animals in repose. In recent years, however he has also carried out a certain amount of work in cast bronze, including the doors for Cologne Cathedral and a church in Hiroshima.

Chana Orloff, born in 1888 in Russia of Jewish parentage, went to Paris in

1910 and enrolled at the *Ecole des Arts Décoratifs* and also trained as a sculptor at the *Académie Russe*. She first exhibited at the *Salon d'Automne* in 1913 and was a member of Fauvist and Cubist movements in Paris during and after the First World War. After flirting with Cubism in the 1920s she returned to a more direct and naturalistic style of sculpture. At first she preferred to work in wood but between 1919 and 1945 she usually worked in marble. During this period she specialised in portrait busts and female nudes. Since the Second World War, however, she has given up working in stone and radical changes in her technique have led her to modelling figures for ultimate casting in bronze. She has shown a marked predilection for the bird as a subject which she studied, develops and returns to without ever repeating herself. Her birds are impressionist in style, presenting an unusual synthesis of emotional and intellectual elements.

Gerhard Marcks, born in Berlin in 1889, began his artistic training in 1907 with Richard Scheibe who was then still working as a painter. Marcks subsequently studied sculpture under August Gaul though many years elapsed before he turned to Animalier sculpture. In 1918 he was appointed to the staff of the Berlin School of Arts and Crafts and two years later he went to Weimar where he spent five years working with Gropius at the Bauhaus. From 1925 to 1933 he taught in Halle until he was summarily dismissed by the Nazis. Four years later his works were suppressed and he was forbidden to exhibit any. After the Second World War he was appointed to the Central Art School in Hamburg where he taught for five years before moving to Cologne where he has lived ever since. In the prewar period his sculpture consisted mainly of the human figure, strongly influenced by ancient Greek sculpture. After the war, however, he turned increasingly to animal studies and it is in this field that he is best known today. A figure of an Afrikanischer Ram by Marcks fetched £18,000 at Sotheby's in 1969.

Of the sculptors born in the present century, the older generation have worked in a more impressionistic, almost abstract, style, so that their inclusion in this book is borderline. In this category come Francois Stahly (born in Constance in 1911) and Priska von Martin (born in Fribourg, Switzerland in 1912). Stahly, a pupil of Malfray in Paris, was drawn to the abstract forms of sculpture in the years before the Second World War but in more recent years has returned

Herbert Haseltine
Foal (gold-bronze
patination)
Herbert Haseltine
Picador

131

Harry Jackson
Ropin' 13½″

Harry Jackson
Bronc Stomper 17″
Harry Jackson
Settin' Perty 16″

132

to a more naturalistic approach. Most of his work in the early years was carved in wood or stone but latterly he has worked in steel or aluminium, having established a studio at Meudon as a teaching centre for young craftsmen-artists. Stahly is inspired not so much by the animal world of reality but by the notions and concepts of animals and birds as represented in the myths and folklore of the world and this is seen in such works as his Fire-birds, Serpents, Unicorn and the Sphinx. Miss Martin trained under Fernand Leger in Paris and later studied at the Munich Academy under Joseph Wackerle, also receiving help and encouragement from the sculptor Toni Stadler whom she married in 1942. She was awarded the cultural prize of the city of Munich in 1958 and since then her work has been represented in many important exhibitions in Germany and elsewhere. Her forte is animal sculpture invariably cast in bronze by the *cire perdue* process. She takes pains to preserve as far as possible the characteristics of the original wax model and, as a result, her bronzes are left in a relatively rough state with little or no attempt to chase the marks of the casting process. In contrast with the degree of interest imparted by the rough texture of her bronze is the simple sculptural form of the subject itself. Miss Martin tries to achieve a balance between the simplification of abstraction and realistic representation.

Among the older sculptors at work in the postwar years Hsiung Ping-ming (born 1922), Robert Clatworthy (born 1928) and Elizabeth Frink (born 1930) still show a tendency towards the abstract in their animal sculpture. Hsiung was born in Peking and studied philosophy at Nanking University before moving to Paris in 1947 and taking up sculpture. His art is an interesting blend of traditional Chinese of the Han and Wei periods, and the influence of Rodin and Picasso. For some time he worked under Jeanniot and then joined the *Académie de la Grande-Chaumière* where he was taught by Auricoste. Since 1954 he has exhibited his work regularly at the Salons. In the mid-Fifties he worked in wrought metal, but both before and since he has shown a preference for modelling in plaster and his figures of animals and birds are then cast in bronze. His sculptures contain an attractive combination of severity and humour, whether they have the unpolished, austere appearance of iron or the richer, more subdued quality of bronze.

Clatworthy was born in Bridgewater, Somerset and studied art at the West of England College of Art and the Chelsea School of Art, London between 1944 and 1950. Clatworthy belongs to the Expressionist branch of the Animalier movement, handling the modelling of his subject to the very limit without Altogether losing contact with the objective image. Men with dogs, horses and bulls are among his favourite subjects and the roughened, rococo appearance of his sculptures does not detract from his ability to render the character and movement of animals.

Elizabeth Frink was born in Thurlow, Suffolk and studied art at the Guildford School of Art and the Chelsea School of Art from 1947 to 1953. Her first exhibition was held in 1952 and since then she has been represented in many major national and international exhibitions in Britain and Europe. She was one of the twelve sculptors selected to represent Britain in the international competition for a monument to the Unknown Political Prisoner. Today Elizabeth Frink is the most outstanding woman sculptor of the younger generation. Her Animalier work has been compared with that of Germaine Richier but this is merely a superficial resemblance on account of the rough texture of her surfaces. She has shown an affinity with animals and birds of all kinds, and depicts them without any trace of sentimentality – birds, cats, dogs and horses in particular are recurring subjects. Her more recent work, however, has shown a tendency towards the anti-rational search for expressive images in which the normal frontiers between human and animal form are broken down

133

and her sculpture is moving away from the Animalier field into the realms of the abstract.

During the past decade the interest of the general public, collectors and dealers in Animalier sculpture has increased enormously, and while much of this interest is directed at the works of the nineteenth century Animaliers it has inevitably encouraged the return to a more naturalistic approach to sculpture among some of the younger artists of the present day. Prior to the Sixties, however there were several sculptors specialising in animal subjects. W. Tim Timym, born in Vienna but a naturalised British subject since 1949, received his formal art training at the *Kunstgewerbe Schule* under Cizek and Strnad and was strongly influenced by Kokoschka. While his main work is in oils or crayon, producing animal posters and paintings, he has also turned to sculpture, modelling wild and domestic animals for casting in bronze. The Sladmore Gallery Wildlife Exhibition of November 1970 contained a fine group of Chimpanzees by this artist.

One of the most outstanding Animalier sculptors at work today is the American Harry Jackson whose life and artistic career is not unlike that of Remington and Elwell. Jackson was born in Chicago in 1924, in an urban environment, but with influences of the animal world which were to be reflected in his art. His father had served with the horse artillery in the First World War and as a small boy Jackson recalled visits with his father to the 124th Field Artillery armoury near their home to watch the polo team practising. When he was still very young Jackson's father deserted his mother and in order to support herself and her boy Mrs Jackson ran a cafe at the Chicago stockyards. Here Harry was able to see cattle and horses at close range and study their characteristics and movements almost instinctively. At the age of five he began learning to ride, and at the same time was continually drawing horses and cattle. A great aunt noted his talent and saw that he was enrolled at the weekly children's class of the Chicago Art Institute. He was almost obsessed with the glamour of the Old West but while most youngsters would have been content with Western novels and films Harry would pay frequent visits to the Harding Museum where many paintings and bronzes by Remington are preserved.

As a boy he had a collection of over 3,000 toy soldiers which he re-modelled, adapted and painted in order to convert them into the cavalry of the British Indian Army, another subject on which he spent endless hours of study and research. Jackson had little use, however, for formal education and often played truant from school. Eventually, when threatened with a spell in a reformatory, he ran away from home altogether and went out West, ending up, like Elwell, in Wyoming where he worked in a lumber yard before turning to cattle-ranches for employment. For four years he "wrangled horses, milked cows, built fences and rounded up cattle" in Wyoming before enlisting in the US Marine Corps in 1942. He saw active service in Europe and the Pacific and at the age of 20 was appointed the youngest official Combat Artist with the American forces. He also took part in several broadcasts and narrated the film *To the Shores of Iwo Jima,* a documentary about the Pacific campaign.

In October 1945 Sergeant Jackson was discharged from the Marines and for a time worked as a radio actor in Los Angeles before returning to Wyoming and resuming the life of a cowboy. Both before and after the war he was encouraged to paint by the artist Ed Grigware and in 1946 he went to New York to study art under Tamayo and Hans Hoffmann. He spent much of 1949 in Mexico painting the people, animals and scenery and the following year became a member of the Artists' Club in New York. In New York he worked as a jack of all trades while furthering his artistic career. For a time he worked for the Metropolitan Opera, the New York City Ballet and Columbian Broad-

Jonathan Kenworthy
Impala at the Waterhole

Jonathan Kenworthy
Two Flamingoes on Lake
Naivasha

Jonathan Kenworthy
Two Dik Diks Running
Under a Thorn Tree

casting Service as a staff artist, painting sets and backdrops. In 1950 he met
Jacques Lipchitz and under his influence became an abstract expressionist
painter during the ensuing two years. In 1952 he returned to Wyoming on an
extended visit and as a result of conversations with his life-long friend, Cal Todd,
he abandoned expressionism and returned to more figurative work. His one-
man show at the Tibor de Nagy Gallery contained paintings which were more
figurative and less abstract than his earlier work.

In 1954 he went to Europe, touring the great museums and galleries and
sketching and studying the works of the great masters. On his return to New

135

York he continued the trend back towards more naturalistic work. *Life* (9th July 1956) contained an article entitled *Painter Striving to Find Himself* which described Jackson's change from abstract to realist art. A Fulbright scholarship enabled him to visit Italy in 1957 and on his return to America he received commissions to paint large, 'heroic' murals for the Whitney Museum in Cody, Wyoming. The result was the great mural paintings of *The Stampede* and *The Range Burial* which subsequently provided Jackson with the inspiration for some of his best-known bronzes. In 1958 he visited Italy again and began learning the techniques of modelling and bronze-casting at the Vignali-Tommasi foundry in Pietrasanta. This was followed by a highly successful exhibition of his paintings and bronzes at Knoedler's in New York in 1960. In the interim he showed his versatility by issuing, under the Folkways label, an album of traditional music entitled *Harry Jackson, the Cowboy, His Songs, Ballads and Brag Talk,* a definitive work which is already recognised as a collector's item.

In 1961 Jackson moved to Italy, building a house and studio at Camaiore where he has lived since 1962 with his wife and family, commuting between Italy and Wyoming at regular intervals. In 1964 he established his own bronze foundry near his studio and thus, unlike most other sculptors, takes a very close interest in every aspect of his work right down to the chasing and finishing of each bronze. Since 1952 he has had almost a score of one-man exhibitions and been a regular contributor to numerous others on both sides of the Atlantic. His great bronze group of the Stampede, over 60 inches in length and standing 16 inches high and 25 inches across is the most remarkable *tour de force* ever attempted by an Animalier sculptor. The sense of drama and movement is masterfully conveyed by the stampeding herd. Near the front a cowboy tries to turn the herd by firing his pistol, but the focal point of the group is the luckless rider who has been unseated and is being dragged along with one foot caught in the stirrup. On the extreme right is another cowboy trying to handle the herd, but momentarily distracted in his efforts not to trample the body of his fallen comrade. This great bronze was executed in 1958–59 and was followed by two other large groups, The Range Burial and The Plantin', both with the theme of burying the rider who was trampled to death by the stampeding cattle. Many of the figures in both these groups were similar but The Range Burial is more elaborate and contains more figures. Since 1960 Jackson has produced

Lorne McKean
Lady's Hack
Lorne McKean
Lippizaner 'Pluto Nautika'
12"

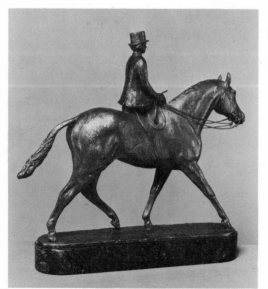

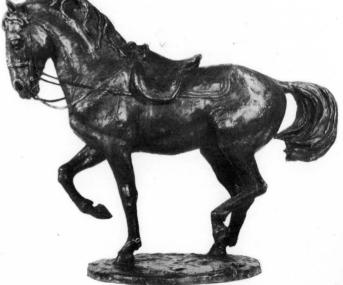

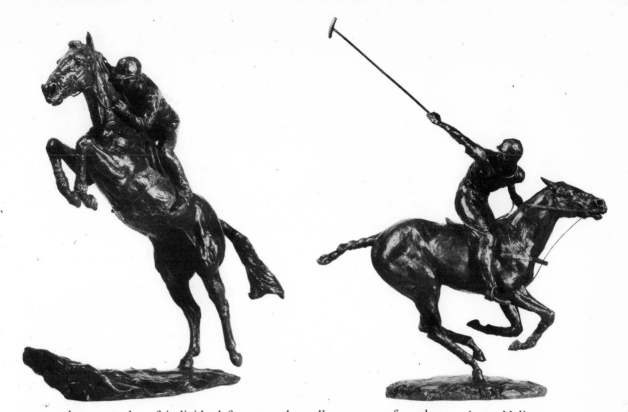

Lorne McKean
Marion Coakes on 'Stroller'
11"
Lorne McKean
Polo Player No. 3
(off-side backhander) 19½"

many other examples of individual figures and smaller groups of cowboys, on foot or on horseback. His sense of movement and action surpasses that of Remington and is seen at its best in such groups as Bronc Stomper, Settin' Perty, Steer Roper and Ropin', all executed in 1959. Since then he has concentrated more on studies of horsemen in repose, such as his splendid Indian group To the Gods and Lone Hand (both 1961). Much of his most recent work is non-Animalier and non-Western – peasants, dancers and musicians of Mexico and Europe – but the old flair for Animalier sculpture is still present in such work as his bronzes featuring riders of the Pony Express. An interesting feature of much of Jackson's work is his use of paint to colour his bronzes after casting and finishing. The old tradition of painted sculpture, used by the Greeks and the Romans, was not retained in the Renaissance. The sculptors of the late Middle Ages began studying newly excavated bronzes and marbles of antiquity. These pieces, found in the sea or in the soil, had been painted originally but centuries of chemical action by salt water or the earth had eliminated the pigmentation, leaving the surfaces of stone and bronze beautifully patinated instead. For centuries we have accepted unpainted stone and metal, but with the painted bronzes of Harry Jackson we may witness a general revival of the use of coloration in sculpture.

At the present time England, rather than France, is the home of the best Animalier sculpture. One of the foremost sculptors in this field is Lorne McKean who is noted for her figures and groups of horses and wild animals. As a child she modelled in plasticine and at the age of eleven her work came to the notice of Prince Serge Yourievitch, a contemporary and friend of Rodin. Under his guidance and encouragement she modelled in his studio and subsequently spent four years at the Guildford School of Art and a further four years at the Royal Academy Schools where she won the Leverhulme Scholarship, the silver medal for Sculpture combined with Architecture and the Feodora Gleichen Scholarship. This enabled her to visit Florence where she studied

137

Jean Walwyn
Horse's head 9¼″
Jean Walwyn
Circus Horses 13″

drawing at the studio of Signorina Simi.

At the age of twenty she had two of her sculptures – Dancer at Rest and the portrait head of Sonja Henei – accepted by the Royal Academy and since then she has been a regular contributor. Many of her portrait busts and heads are in public collections and she was elected to the Society of Portrait Sculptors in 1969. In the early 1960s, however, she turned to animal sculpture and in 1964 produced such notable groups as Rolling Zebra, Leaping Impala, Kudu, Kongoni and Calf, Hunting Cheetahs and Caracal Lynx. Since then she has sculpted an Otter (1968), an Eagle (1969) and Fennec Fox, Silver-backed Jackal and Dik-Dik (all 1970). In between she modelled equestrian groups and figures of horses, such as Arab Stallion (1966), Hunter Champion 'Peterboy' (1967), the Lipizzaner 'Pluto Nautika', the polo group "Riding Off", three individual Polo Players in different poses (1969) and Marion Coakes on 'Stroller', the Hunter 'Running Bear' and Horse and Jockey (1970). Some of her earlier works were produced in epoxy resin with a bronze finish but since 1965 the *cire perdue* process has been used; those works which originally appeared in resin-bronze are to be cast eventually by the *cire perdue* method.

In strange contrast with the nineteenth century Animaliers this is a field of sculpture which seems to have attracted a fairly high proportion of women artists. Jean Walwyn and Gillian Wiles are both making names for themselves in this field with sculptures of horses. The latter, born in Johannesburg, belongs to the fourth generation of a celebrated family of painters and sculptors. Miss Wiles studied art at Capetown University and, on coming to Britain, spent three years at the Heatherly School of Art. In the best traditions of the nineteenth century Animaliers she also attended the Royal Veterinary College in London to study and dissect animals. Her innate love of animals and the influence of her early environment in South Africa have given her the inspiration to portray them in paintings and sculpture. In the latter medium she has so far produced bronzes entitled "Interception" (Lioness in pursuit), Leaping Impala, Ram and Ewe, "Elegance in Motion" (Giraffe), and Charging Rhinoceros. Among domestic animals she has produced several sculptures of horses. She began riding at the age of six and later took instruction in dressage, so that her intimate knowledge of horses has been an asset in her sculpture.

138

Most of the Animalier sculpture being produced today is cast by the lost wax process and is therefore confined to very small editions which have a consequent bearing on the price of the sculpture. The economics of sculpture today differ fundamentally from those affecting the nineteenth century Animaliers who employed the sand-casting technique in order to produce low-priced objects for the mass market. The nearest approach to the *bronzes d'edition* of the nineteenth century are the small bronzes produced by modern cold-casting techniques and sold by Heredities of Kirkby Stephen in Westmorland. The animals sold by this company are modelled by father and son, Richard and Gareth Fisher. Their figures of dogs, hedgehogs and otters are cast in bronze, but other metals such as polished aluminium and nickel-silver are also employed. Although these figures have only appeared on the market since 1969 they have caught the public eye and already they have been exported to Europe and America in large quantities. The success of this venture is indicative of the general revival of interest in the small animal bronzes which decorated the majority of upper and middle class homes a century ago.

The most outstanding of the younger sculptors engaged in this field today is Jonathan Kenworthy, born in Westmorland in 1943. In the immediate postwar years, when toys were difficult to come by, Jonathan's main pastime was modelling with plasticine. He was brought up in a country district where a love of animals was early inculcated, and thus it was logical that he should turn to modelling animals. At the age of eleven he was brought to the notice of John Skeaping, then Professor of Sculpture at the Royal College of Art. From then onwards his artistic training was carefully developed, culminating in the period from 1961 to 1964 when he attended the Royal Academy Schools and studied sculpture. During this time he modelled greyhounds at the White City Stadium and from this experience produced a Cheetah which he sub-sequently showed to Aylmer Tryon of the Tryon Gallery in London, who encouraged him to specialize in animal sculpture, at a time when the revival of the Animalier movement was only just beginning to get under way.

Although he had a predilection for animals Kenworthy was somewhat deterred by the academic disregard for this field of sculpture. He felt he had to prove to himself that he was at least capable of other forms of sculpture, so he worked at human figures and portraits and entered them in the Schools' annual competition, surprising himself by taking the first prizes, right across the board. As well as the Gold Medal and many other awards he received three travelling scholarships which enabled him to visit East Africa in order to study the movement of animals in their natural habitat.

Kenworthy's earliest ambition was to become a surgeon, and from this springs his instinct for anatomy which has proved invaluable to him as an Animalier sculptor. In Nairobi he met Dr. Reinhold Hofmann of the Veterinary College who was very much impressed by him and permitted him to dissect various animals, including a two-year-old male lion. Kenworthy sketched the dead beast at every stage of the dissection – first whole, then after the skin was removed, and successive stripping away of the subcutaneous fat and the layers of musculature, down to the skeleton itself. His folio of anatomical drawings of head, fore-paws, hind-quarters and other parts of the body indicate the care with which he approaches the subject.

Every year since 1963 he has returned to East or South Africa, spending several months working intensively on animals. Dissection and anatomical study is still a prerequisite of his work on every animal, but much of the time is spent on safari, observing the animals at close quarters in their natural surroundings. The development of Kenworthy's art in a relatively short space of time is startling. The early figures, such as his Cheetah, are finely modelled but statuesque. The detail is meticulously close to life and the result has an

139

Gillian Wiles
Charging Rhinoceros 8″
Gillian Wiles
Elegance in Motion 9″

almost photographic quality in three dimensions. More lively but still adhering closely to the actual appearance of the animal is his Sable Antelope, sculpted in 1966.

Gradually, however, his work has become more Impressionistic and the fine detail once lavished on the coats of animals has now been sacrificed in favour of a more vigorous technique. At the same time Kenworthy has concentrated his skill on conveying a sense of movement, seen at its best in such figures as the cheetah swerving at full speed, or even the wart-hog. More recently he has experimented with groups of animals to create actual movement, as in the sequential frames of a cine film. This is demonstrated forcibly in his groups showing a cheetah disturbing a group of three antelope who are depicted at the point of scattering in all directions. A later development of this theme has the leopard springing from the undergrowth into the midst of the antelopes resulting in an 'explosion' of frightened animals.

He is pre-occupied with the attitudes, both physical and mental, of the animals, particularly in analysing their traits and characteristics. "For thousands of years", says Kenworthy, "man has invested the animals around him with human traits and has tried to depict them accordingly, from the cave paintings of pre-history to Landseer. Thus the nobility of the lion is emphasised. To us he is the King of Beasts, but how he sees himself and how the other animals see him, may be quite different altogether." Kenworthy's aim is to get under the skin (both literally and metaphorically) of his animals and faithfully portray the psychological aspects as well as the physical attributes.

Both the animals and Africa itself have impressed him immensely; above all the timeless quality of the Continent, which he is also seeking to convey in his sculpture. In the vast game reserves and in the semi-arid districts of northern Kenya the feeling of timelessness has inspired much of Kenworthy's latest work. Animals come to the water hole at certain times of day, as they and their forbears have done for countless centuries. They sleep, feed or hunt at fixed times, as they have always done, and in his latest sculpture Kenworthy is attempting to illustrate this fixity and continuity. Perhaps the best example in this *genre*, however, is his group of Sambum tribesmen under an acacia tree. This tree, which is in a sense symbolic of Africa, with its branches in parallel layers, imparts the suggestion of immense distance while the human figures, tall, stately and self-assured, convey the impression of the immutability of life in the heart of Africa, that they and their ancestors have been living in that area for the past six centuries at least.

Human figures are relatively few in his work so far, but the range of animals which he has worked on is enormous, from the great predators, the lions, leopards and cheetahs, to antelopes and gazelles, dik-dik and gerenuk, impala and nyala. He is equally at home with the birds of Africa – fish-eagle, Bateleur

140

Gillian Wiles
Lioness in Pursuit 5"

eagle, and others – and has overcome the problems of depicting them in motion. His bronze of a Secretary Bird killing a snake has captured the characteristic movement of the bird as it 'plays' its prey, almost as a matador tires the bull, before stamping it to death. Flamingoes on Lake Nakuru are one of the most impressive sights of Africa and inevitably this has formed the subject of a bronze in which Kenworthy depicts two birds in the act of taking-off – the birds are frozen at that split second of time as they beat clumsily across the water before they are fully airborne and transformed into graceful creatures in flight.

His first exhibition was held at the Tryon Gallery in 1965 at which all his bronzes were sold; in this exhibition he included a life-sized carving in black marble of a leopard which is now in the Carnegie Museum in Pittsburgh. The Tryon Gallery next showed his work at the Pieter Wenning Gallery in Johannesburg in an exhibition of African subjects by English artists which was also extremely successful; and, in 1967, organised a similar exhibition at the Incurable Collector in New York in which he included a life-sized carving of a lion, and once again all his works were sold. As a result of this exhibition, Mrs Ernest Hemingway, who kindly opened the exhibition, commissioned Jonathan Kenworthy to model an Impala for a memorial for her husband's grave in Idaho.

Over a thousand hours were spent carving the leopard. Although he enjoys the challenge which life-size sculpture presents, Kenworthy regretfully finds it too time-consuming and has therefore concentrated on the small bronze. Likewise he has also dabbled with portrait heads in bronze but regards this very much as a sideline to his main work.

Like the other modern Animaliers Kenworthy has rejected the bronze-casting methods of his nineteenth century predecessors and returned to the lost wax process as the only one which can really do justice to his work. More than most, he is intensely interested in following through his sculpture, closely supervising the casting at the bronze-foundry, and the chasing and patination of the bronzes. "It is important", he says "that the sculptor should understand the metal, not only as a medium in which his work is preserved, but as the material which gives substance to his art. It is essential therefore to know the limitations and the advantages of bronze, not to expect the impossible, yet exacting the maximum which can be achieved with it."

141

Appendix

The following list of the animal bronzes of A. L. Barye is based on the *Catalogue des Oeuvres de Barye* compiled by Eugene Guillaume and published by the *École des Beaux Arts* in 1889. This catalogue listed all the works of Barye, including paintings, watercolours and drawings. Moreover, instead of producing a single unified list it set out the holdings of Barye bronzes in various important collections (Barbédienne, Binder, Doria, Lucas, Bonnat, Lutz and an anonymous owner) as well as diverse groups in smaller collections. The lists overlap considerably and many bronzes inevitably appear on several lists. The list which follows sets out merely to enumerate the animal bronzes by Barye which the collector or student is likely to encounter.

1 Senegal Elephant
2 Elephant of Cochinchina 15cm/6″
3 Elephant crushing a Tiger 22cm/8¾″
4 Elephant of Asia 14cm/5½″
5 Indian on Elephant hunting a Tiger 28cm/11″
6 Jaguar grasping a Cayman
7 Jaguar seizing the head of a Horse 8cm/3¼″
8 Sleeping Jaguar 9cm/3½″
9 Jaguar devouring a Hare 44cm/17½″
10 Jaguar devouring an Agouti 7cm/2¾″
11 Jaguar walking
12 Jaguar walking (no. 2) 12cm/4¾″
13 Jaguar attacking an Antelope (terra cotta)
14 Jaguar devouring a Crocodile 8cm/3¼″
15 Jaguar standing (no. 1) 13cm/5¼″
16 Rearing Bull 22cm/8¾″
17 Bull surprised by a Tiger 22cm/8¾″
18 Standing Bull 17cm/6¾″
19 Bull brought down by a Bear 15cm/6″
20 Ocelot carrying away a Heron 17cm/6¾″
21 Lynx (bas relief) 7cm/2¾″
22 Caracal on branch of a tree (wax model)
23 Panther seizing a Stag 39cm/15½″
24 Panther of India (no. 1) 10cm/4″
25 Panther of India (no. 2)
26 Panther of Tunis (no. 1) 13cm/5¼″
27 Panther of Tunis (no. 2)
28 Panther lying down 7cm/2¾″
29 Panther (bas relief) 8cm/3¼″
30 Panther surprising a Zibet 11cm/4½″
31 Panther seizing a Muntjac Deer 11cm/4½″
32 Tiger and Hind (plaster model)
33 Tiger devouring a Gazelle 13cm/5¼″

34 Tiger and Fawn (plaster model)
35 Tiger walking 23cm/9″
36 Tiger seizing a Peacock
 (wax and plaster)
37 Tiger seizing a Stag 15cm/6″
38 Tiger surprising an Antelope
 35cm/14″
39 Tiger seizing a Pelican
 (wax and plaster)
40 Tiger devouring a Gavial (no. 1)
 20cm/8″
41 Tiger devouring a Gavial (no. 2)
 11cm/4$\frac{1}{2}$″
42 Lion *affamé* 9cm/3$\frac{1}{2}$″
43 Lion and Serpent (no. 1)
 26cm/10$\frac{1}{4}$″
44 Lion and Serpent (no. 3 –
 sketch model) 15cm/6″
45 Two Young Lions 18cm/7$\frac{1}{4}$″
46 Lion and Tiger walking
47 Lion devouring a Hind
 14cm/5$\frac{1}{2}$″
48 Algerian Lion 21cm/8$\frac{1}{4}$″
49 Lion walking 23cm/9″
50 Lion sitting (no. 1) 37cm/14$\frac{3}{4}$″
51 Lion sitting (no. 2) 21cm/8$\frac{1}{4}$″
52 Lion sitting (no. 3) 18cm/7$\frac{1}{4}$″
53 Lion sitting (no. 4) 19cm/7$\frac{1}{2}$″
54 Lion, bas relief
 (from the Bastille Column)
 2cm × 41cm long/$\frac{3}{4}$″ × 16$\frac{1}{2}$″ long
55 Lion devouring a
 Giuba Antelope 12cm/4$\frac{3}{4}$″
56 Lion devouring a Boar
 25cm/9$\frac{3}{4}$″
57 Lion and Boar 38cm/15$\frac{1}{4}$″
58 Lion and Antelope 40cm/16″
59 Algerian Lioness
60 Standing Lioness 18cm/7$\frac{1}{4}$″
61 Senegalese Lioness 23cm/9″
62 Juno and the Peacock
 31cm/12$\frac{1}{4}$″
63 Theseus combatting the
 Minotaur 46cm/18$\frac{1}{4}$″
64 Theseus fighting the Centaur
 Bienor
65 Hercules lifting a Boar
 13cm/5$\frac{1}{4}$″
66 Hercules strangling a Lion
 (plaster and wax)
67 Sketch model in bronze for
 Theseus fighting the Centaur
 35cm/13$\frac{3}{4}$″
68 Angelique and Roger on the
 Hippogriff 53cm/21″

69 Wolf gripping a Stag by the
 throat 21cm/8$\frac{1}{4}$″
70 Wolf (334) 12cm/4$\frac{3}{4}$″
71 Wolf Walking 27cm/10$\frac{3}{4}$″
72 Tartar Warrior on Pony
 37cm/14$\frac{3}{4}$″
73 Equestrian figure of Charles VII
 29cm/11$\frac{1}{2}$″
74 General Bonaparte 29cm/11$\frac{1}{2}$″
75 Duc d'Orleans
76 Head of Chimpanzee 'Jacques'
 8cm/3$\frac{1}{4}$″
77 Gaston de Foix 35cm/14″
78 Whipper-in, in the costume of
 the Louis XV period
79 Arab Horseman surprised by a
 Serpent 22cm/8$\frac{3}{4}$″
80 Arab Horseman hunting a Lion
 39cm/15$\frac{1}{2}$″
81 African Horseman surprised by
 a Serpent 27cm/10$\frac{3}{4}$″
82 Child on Horseback 9cm/3$\frac{1}{2}$″
83 Turkish Horse (no. 1)
84 Turkish Horse (no. 2) –
 right foot raised 29cm/11$\frac{1}{2}$″
84a Turkish Horse (no. 2) –
 left foot raised 30cm/12″
85 Turkish Horse (no. 3) 20cm/8″
86 Turkish Horse (no. 4) 13cm/5$\frac{1}{4}$″
87 Turkish Horse (un-numbered)
 29cm/11$\frac{1}{2}$″
88 Little Half-bred Horse
 with lowered head 13cm/5$\frac{1}{4}$″
89 Half-bred Horse
 with head raised 14cm/5$\frac{1}{2}$″
90 Percheron Horse 20cm/8″
91 Horse attacked by a Tiger
 27cm/10$\frac{3}{4}$″
92 Horse surprised by a Lion
 40cm/16″
93 Dead Wild Goat
94 Goat (silvered bronze) 7cm/2$\frac{3}{4}$″
95 Goat with pensive expression
 7cm/2$\frac{3}{4}$″
96 'Tom' an Algerian Hound
 (plaster model) 17cm/6$\frac{3}{4}$″
97 Sitting Basset-hound 14cm/5$\frac{1}{2}$″
98 Sitting Long-haired
 Basset-hound
99 Basset-hound standing
 11cm/4$\frac{1}{2}$″
100 Basset-hound
101 English Basset-hound (no. 1)
102 English Basset-hound (no. 2)
103 Dog and Duck 15cm/6″

9cm/3½″
191 Stork
192 Eagle seizing a Serpent
13cm/5¼″
193 Eagle and Serpent (bas-relief)
10cm/4″
194 Eagle and Chamois (bas-relief)
10cm/4″
195 Eagle with spread wings
28cm/11″
196 Eagle holding a Heron
32cm/12¾″
197 Eagle holding a Heron
29cm/11½″
198 Eagle with open beak 24cm/9½″

199 Eagle on a rock
200 Pheasant 13cm/5¼″
201 Pheasant 11cm/4½″
202 Pheasant in an arbour (torch)
20cm/8″
203 Wounded Pheasant
204 Parrot in an arbour 21cm/8¼″
205 Parrot 13cm/5¼″
206 Family of Bouquetins 7cm/2¾″
207 Partridges
208 Little Camel of Persia
12cm/4¾″
209 Hemioné 21cm/8¼″
210 Chimera

EMMANUEL FRÉMIET

1 Wounded Dog 9cm/3½″
2 Seated Dog 15cm/6″
3 Seated Hound 24cm/9½″
4 Stretching Dog 9cm/3¾″
5 Dog and Tortoise 8cm/3″
6 Recumbent Husky 10cm/4″
7 Reclining Husky 7cm/2¾″
8 Two seated Hounds 25cm/9¾″
9 Basset Hound 15cm/6″
10 Two Basset Hounds 18cm/7″
11 Setter 15cm/6″
12 Staghound dying in bed of straw
20cm/8″
13 Two Barge Horses 23cm/9″
(known in terra cotta as well as
bronze)
14 Two Racehorses and Jockeys
46cm/18¼″
15 Dray Horse 40cm/15¾″
16 Le Grand Conde 32cm/13″
17 Roman on horseback 43cm/17″
18 Roman charioteer 35cm/14″
19 St. George and the Dragon
54cm/21½″
20 St. Hubert 34cm/13½″
21 Medieval Knight 36cm/14½″
22 Joan of Arc 34cm/13½″
23 Napoleon III on 'Philippe'
38cm/15″
24 Dromedary 29cm/11½″
25 Goat and Kid 18cm/7″
26 Cat with two Kittens 8cm/3″
27 Cat 8cm/3¼″

28 Dog Fox 18cm/7″
29 Hyena 8cm/3″
30 Bear grasping a Man 30cm/12″
31 Centaur capturing a Bear
36cm/14¼″
32 Wading Bird and Frog 7cm/2¾″
33 Heron 18cm/7″
34 Griffon
35 Marabou holding a Cayman in
its feet
36 Artilleryman on horseback
37 Showman's Horse 28cm/11″
38 'Forester', Hunter from the
stable of M. le Comte
d'Oultremont
39 Horse with Crow
40 Tethered Horse
41 Arab Horse
42 Gallic Horseman
43 Arab Chief on Horseback
44 Louis d'Orleans on Horseback
45 Falconer
46 Knight Errant
47 Equestrian figure of
Stefan-al-Mare,
Prince of Moldavia
48 Marabou and Snake
49 Monkey and Butterfly
50 Running Dogs
51 Cat with newborn Kittens
7cm/2¾″
52 Seated Cat 7·5cm/3″

ISIDORE BONHEUR

1 Hen Pheasant 44cm/17½″
2 Hound leaping on to a Boar
53cm/21″

3 Racehorse 33cm/13″
4 Arab Stallion 35cm/13¾″
5 Docile Stallion 48cm/19″

6 Mare and Foal 30cm/12″
7 *Ecorché* Horse 30cm/12″
8 Pack Pony 21cm/8¼″
9 Mule braying 31cm/12½″
10 Edward VII on horseback (silvered bronze) 40cm/16″
11 Horse and Jockey 63cm/25″
12 Horse striding forward 27cm/10½″
13 Boy, Smith and Horse 32cm/12¾″
14 Groom riding a Carriage Horse and urging on a second Horse 38cm/15″
15 Groom showing off the paces of a Stallion 43cm/17″
16 Peasant Woman and Donkey 28cm/11″
17 Bedouin on horseback 56cm/22″
18 Bull 27cm/10¾″
19 Bull with lowered head and swishing tail 13cm/5″
20 Camargue Bull 'Bailaor' 35cm/14″
21 Bull in determined attitude 54cm/21″
22 Bull and Cow 31cm/12¼″
23 Cow looking to the right with docile expression 26cm/10″
24 Milkmaid and grazing Cow 40cm/16″
25 Merino Ram 18cm/7″
26 Merino Ram 25cm/9½″

27 Ram 20cm/8″
28 Ram and Ewe 13cm/5″
29 Ewe 25cm/9½″
30 Two Pigs 28cm/11″
31 Sow and three Piglets 14cm/5½″
32 Lion 18cm/7¼″
33 Gnu galloping past a cactus 14cm/5½″
34 Standing Bonassus 27cm/10½″
35 Bear with bones at his feet 21cm/8½″
36 Bear 14cm/5¾″
37 Stag with eight-point crown 23cm/9″
38 Gazelles 11·5cm/4½″
39 Zebra attacked by a Panther
40 Bull and Bear
41 Cow and Wolf
42 Dog and Sheep
43 Postillion
44 Dromedary
45 Lioness and Cubs
46 Pépin the Short in the Arena
47 Huntsman of the Era of Louis XV
48 Jockey
49 Horse-dealer
50 Mare
51 African Hunter
52 Family of Lions
53 The Game of Polo
54 Horses
55 Goose drinking from a Bucket 6·5cm/2½″

CHRISTOPHE FRATIN
1 Two Eagles fighting over a dead Chamois 50cm/20″
2 Greyhound 7cm/2¾″
3 Coursing Greyhounds 10cm/4″
4 Wolfhound on its haunches 14cm/5½″
5 Hound 15cm/6″
6 Retriever with Cock Pheasant 37cm/14½″
7 Retriever 10cm/4″
8 Stalking Setter 39cm/15¾″
9 Two Hounds 20cm/8″
10 Cat 4cm/1½″
11 Pony grazing (plaque) 14cm/5½″
12 Arab stallion prancing 29cm/11¼″
13 Arab Stallion standing 35cm/14″

14 Horse with long mane and tail 17cm/6¾″
15 Mare and Foal 41cm/16½″
16 Mare and Foal 31cm/12½″
17 Mare and new-born Foal 97cm/38″
18 Two Stallions fighting 32cm/13″
19 Horse attacked by Wolves 44cm/17½″
20 Stag Hunt 75cm/30″
21 Stag 10cm/4″
22 Stag lying down 9cm/3½″
23 Stag walking in undergrowth 58cm/23″
24 Stag seated on a grassy mound 13cm/5″
25 Deer and Young 9cm/3¾″
26 Boar 7cm/3″
27 Wolf 12cm/4¾″

28 Tiger with Kill (Monkey) 9cm/3½″
29 Tiger killing a Deer 24cm/9¼″
30 Prowling Tiger 26cm/10½″
31 Tiger licking paw 11cm/4½″
32 Prowling Lion 30cm/12″
33 Lion with Kill 16cm/6½″
34 Lion carrying an Antelope 55cm/21½″
35 Lion killing a Crocodile 42cm/17″
36 Lioness carrying a dead Antelope 45cm/18″
37 Lioness 8cm/3″
38 Bull walking 8cm/3¼″
39 Docile Bull 41cm/16½″
40 Angry Bull 40cm/16″
41 Bull 27cm/10¾″
42 Bull 43cm/17″
43 Bull 15cm/6″
44 Resting Cow 20cm/8″
45 Billy Goat 26cm/10½″
46 Goat 16cm/6½″
47 Bears playing 17cm/6¾″
48 Bear reading a book and smoking a pipe 16cm/6½″
49 Bear dentist and patient 15cm/6″
50 Dancing Bear 19cm/7½″
51 Bear cook 16cm/6½″
52 Paper-knife bearing three Bears 26cm/10½″
53 Door handles in form of heads of Wolf, Bear, Staghound and Donkey 8cm/3¼″ each
54 Candle-sticks in shape of Cranes standing on Turtles and holding Fish 29cm/11½″
55 Bulldog
56 Vulture devouring a Gazelle
57 Tiger bringing down a young Camel
58 Elephant killing a Tiger
59 Dead Horse
60 Stallion 'Rainbow'
61 Horse 'Tony'
62 Thoroughbred Horse
63 Eagles
64 Horse attacked by a Lion

PIERRE JULES MÊNE

The basis of this list is the catalogue published by P. J. Mêne giving details and illustrations of the bronzes which he and his son-in-law, A. N. Cain, had for sale. Unfortunately no complete copy of this catalogue has been found. I am indebted to the Sladmore Gallery of London for a sight of a fragment of this catalogue, comprising sixteen pages of illustrations. The majority, but not all, of the bronzes, were illustrated in this catalogue. The first part of the list which follows therefore adheres to the numbering of the Mêne catalogue, from 1 to 137. The bronzes listed after that number are those which have been featured in recent auctions or have been shown in exhibitions and which do not correspond to any of the bronzes illustrated in the Mêne catalogue. Certain bronzes will be found to have the same number. The reason for this is, at present, quite inexplicable, but it is likely that *two* lists existed at one time.

1 Huntsman and pack of Hounds (Louis XV period) 67cm/26¾″
1 Fighting Cocks 61cm/24¼″
2 After the Hunt in Scotland 50cm/20″
3 Picador on horseback 72cm/29″
4 Arab Falconer on horseback 75cm/30¼″
5 Huntsman (Louis XV period) 64cm/25½″
6 Huntsman and Two Hounds (Louis XV period) 45cm/18″
6 Pair of English Foxhounds 33cm/13¼″
7 Bloodhound and Handler 47cm/18¾″
7 Pair of St. Hubert Hounds 33cm/13¼″
8 African Huntsman 64cm/25½″
8 Pheasant and Young 29cm/11½″
9 Toreador 52cm/20¾″
9 French Cock Crowing 46cm/18½″
9 French Cock Crowing 90cm/35½″
10 Kilted Huntsman holding two Scottish Griffons 50cm/20″
10 Vulture perched on the head of Sphinx 50cm/20″
11 Caron Hound 40cm/16″
11 Arab Falconer on foot 65cm/26″
12 Jockey and Derby Winner 35cm/14″
13 Jockey and Derby Winner

147

35cm/14″

14

15

16 Jockey on a Racehorse
42cm/16¾″

17

18 Stag attacked by four Dogs
40cm/16″

19 Boar seized by four Dogs
28cm/11″

20

21 Stag attacked by three Dogs
28cm/11″

22 Duck seized by two
Spaniel-Griffons 26cm/10¼″

23 Two Dogs seizing a Hare in a
Vineyard 21cm/8¼″

24 Group of Terriers seizing a
Rabbit 20cm/8″

25 Two Dogs chasing a Partridge
21cm/8¼″

26 Tired Hunter and Small Griffon
45cm/18″

27 Pair of Arab Horses 44cm/17½″
or 33cm/13″ or 20cm/8″

28

29

30 Normandy Mare and Foal
44cm/17½″

31 Arab Mare and Foal 30cm/12″

32

33 Normandy Mare Alone
44cm/17½″

34 Stable Mare playing with a Dog
25cm/9¾″

35 Racehorse 30cm/12″
or 24cm/9½″

36

37

38 Arab Mare 'Nedjibe' 28cm/11″

39 Wild Horse 30cm/12″

40

41 Chest decorated with Birds in
the Saxon manner

41 Spahi Horse on guard duty
27cm/10¾″

42 Chest decorated with Pheasant
and Rabbits

42 Horse and Palm-tree 20cm/8″
or 28½cm/11¼″

43 Candelabra decorated with
Game

43 Racehorse 'Djinn' 29cm/11½″

44

45 Breton Horse 34cm/13½″

46 Candelabra decorated with
hunting-horns

47 Arab Horse 'Ibrahim'
32cm/12¾″

47 Candelabra decorated with
Nests of Warblers

48 Candelabra decorated with a
Bear 32cm/12¼″

49–56 Unknown, but probably
racehorses or dogs–see
supplementary list

57 Group of Santonge Dogs at rest
25cm/9¾″

58 Dog guarding the Game
31cm/12¼″

59 Basset Hounds searching the
undergrowth 15cm/6″

60 Hound with her Pups 18cm/7¼″

61 Group of Hounds in the
undergrowth 11cm/4½″

62 Group of Little Hounds at a loss
13cm/5¼″

63 Spaniel Griffon seizing a Duck
15cm/6″

64

65 Warwick Dog holding a whip
in its mouth 20cm/8″

66 Curly-coat Retriever 20cm/8″

67 Bloodhound 24cm/9½″

68 Setter retrieving a Hare
21cm/8¼″

69 Spaniel 'Sylphe' 20cm/8″

70 French Bitch 'Bellotte' 20cm/8″

71 Setter 'Trim' 19cm/7½″

72

73 Irish Setter 'Medor'
15cm/6″

74

75

76 Panting Bitch 'Milla' 21cm/8¼″

77 Setter 'Marly' 22cm/8¾″

78 Setter Alone 21cm/8¼″
(three sizes)

79–82 Unknown, but probably
hunting dogs–see
supplementary list

83 French Spaniel 'Fabio'
17cm/6¾″

84–89 Unknown, but probably
hunting dogs–see
supplementary list

90 Setter 'Tac' 12cm/4¾″

91

92

93 Two Greyhounds playing with

94 a ball 16cm/$6\frac{1}{2}$"

95 Cock standing on a Panier
18cm/$7\frac{1}{4}$"

96 Setter 'Tac' 11cm/$4\frac{1}{2}$"

97

98

99

100 Lion and Lioness quarrelling
over a Boar (*Jardin des Tuileries*)
37cm/$14\frac{3}{4}$"

101 Tigress bringing a Peacock to
her Cubs (*Jardin des Tuileries*)
43cm/$17\frac{1}{4}$"

102

103

104 Ox (*Trocadero*) 68cm/$27\frac{1}{4}$"

105 Pheasants (panel)
78cm × 1·28m/$31\frac{1}{4}$" × 50"

106 Fox seizing a Duck (panel)
78cm × 1·28m/$31\frac{1}{4}$" × 50"

106 Greyhound playing with a ball
10cm/4"

107 Eagle seizing a Partridge (panel)
78cm × 1·28m/$31\frac{1}{4}$" × 50"

108 Falcon chasing a Rabbit (panel)
78cm × 1·28m/$31\frac{1}{4}$" × 50"

109–115 Unknown

116 Stags in Combat 30cm/12"
or 17cm/$6\frac{1}{2}$"

117

118 Stag browsing at a branch
38cm/$15\frac{1}{4}$"

119–134 Unknown

135 Cow and Calf 30cm/12"
(three sizes)

136 Normandy Bull 24cm/$9\frac{1}{2}$"
(two sizes)

SUPPLEMENTARY LIST

1 Bedouin Hunter on Arab Pony
35cm/14"

2 Young Stag 19cm/$7\frac{1}{2}$"

3 Muntjac Deer 18cm/$7\frac{1}{4}$"

4 Stag and Hind 16cm/$6\frac{1}{2}$"

5 Stag seated on grassy mound
13cm/5"

6 Stag with eight-point crown
18cm/7"

7 Reindeer 18cm/7"

8 Horse sniffing the breeze
13cm/5"

9 Horse, head up and ears pricked
25cm/$9\frac{3}{4}$"

10 Stallion and Mare (*L'Accolade*)
51cm/$20\frac{1}{2}$"

11 Alert Horse 15cm/$5\frac{3}{4}$"

12 Frightened Stallion 15cm/$5\frac{3}{4}$"

13 Arab Gelding and Cairn Terrier
66cm/26"

14 Surprised Horse 37cm/$14\frac{3}{4}$"

15 Horse beside rustic fence
(silvered bronze) 9cm/$3\frac{1}{2}$"

16 Stallion with tousled mane
and tail 13cm/5"

17 Mare and gambolling Foal
48cm/19"

18 Pointer and Setter 20cm/8"

19 Pointer 13cm/5"

20 Retriever and Pointer seeking
out a Partridge 36cm/$14\frac{1}{2}$"

21 Retriever and Pointer in the
undergrowth 13cm/5"

22 Retriever with right paw raised
32cm/13"

23 Retriever creeping stealthily
forward 32cm/13"

24 Retriever running forward
looking right 28cm/11"

25 Retriever running forward
looking left 27cm/$10\frac{1}{2}$"

26 Excited Retriever standing over
a clump of grass 18cm/7"

27 Bull Terrier Bitch with ball
13cm/5"

28 Three Hunt Terriers 39cm/15"

29 Labrador with head turned back
23cm/9"

30 Crouching Labrador 28cm/11"

31 Labrador and Pointer 39cm/15"

32 Beagle 27cm/$10\frac{3}{4}$"

33 Pinscher 11cm/$4\frac{1}{2}$"

34 Excited Dog 29cm/$11\frac{1}{2}$"

35 Cavalier King Charles Spaniel
8cm/$3\frac{1}{4}$"

36 Family of Goats 13cm/5"

37 Billy Goat 25cm/$9\frac{3}{4}$"

38 Billy Goat (*Bouc de l'Inde*)
13cm/$5\frac{1}{4}$"

39 Nanny Goat 23cm/9"

40 Goat and Kid 25cm/$9\frac{3}{4}$"

41 Ewe suckling her Lamb 23cm/9"

42 Sheep lying down 20cm/8"

43 Reclining Ram 7cm/3"

44 Rabbits browsing 9cm/$3\frac{3}{4}$"

45 Hare 7cm/3"

46 Fox guarding reclining Vixen
16cm/$6\frac{1}{4}$"

47 Fox with a dead Duck 26cm/10"
48 Two Antelopes (dated 1859) 27cm/10¾"
49 Two Eagles with a dying Antelope (gilt-bronze) 46cm/18½"
50 Hen and Four Chicks 14cm/5½"
51 Snipe 4cm/1¾"
52 Cock Pheasant 10cm/4"
53 Dead game birds – Duck and Snipe (panel) 32cm/13"
54 Fish (panel) 24cm/9½"
55 Scotsman with Hound, holding up Fox (the figure from After the Hunt in Scotland, No 2 in Mêne's Catalogue)
56 Fox held by two Hounds
57 Horse attacked by a Wolf
58 Arab Mare 'Nedjibe' Tethered
59 Percheron Horse
60 Griffon with two Pigeons 16·5cm/6½"
61 Pointer carrying a Hare
62 Seated Pointer guarding a Rabbit
63 Dog attacking a Fox
64 Basset or Dachshund (legs twisted)
65 Pointer with Duck
66 Spanish Greyhound (1844) 9cm/3½" or 22cm/8¾"
67 Spanish Greyhound and King Charles Spaniel 16·5cm/6½"
68 Spanish Greyhound with Fan 16·5cm/6½" (separate figure, as above)
69 King Charles Spaniel 8·5cm/3¼" (separate figure, as above)
70 Spanish Greyhound with Hare
71 Dog 'Mignonette'
72 Greyhound 'Giselle' with a Ball (separate figure as group, No. 93 in Mêne's list)
73 Seated Griffon
74 Long-haired Terrier lying down
75 Griffon 'Casca'
76 Basset hound 'Trompette'
77 Spaniel 'Sultan'
78 Hound 'Wagram'
79 Wounded Hound
80 Terrier 'Tom' Ratting
81 Terrier Licking its Paw
82 Spaniel 'Diane' 9cm/3½"
83 Dog 'Lutine'

84 Dog 'Frisette'
85 Crop-eared Terrier with Ball 11·5cm/4½"
86 Stag, Stabbed
87 Stag rubbing against a Tree
88 Frightened Stag
89 Group of Stags
90 Group of Deer
91 Frightened Hind
92 Frightened Hing lying down
93 Axis (Roe Deer) lying down
94 Roebuck 19cm/7½"
95 Half-bred Ram
96 Mountain Sheep standing
97 Mountain Sheep lying down
98 Browsing Goat
99 Goat lying down
100 Baby Goat
101 Jaguar and Alligator 17·5cm/7"
102 Group of Roe Deer
103 Roe Deer on the Alert
104 Roe Deer drinking
105 Roe Deer
106 Young Roe Deer (Carabit)
107 Foxes and Pheasant
108 Family of Foxes
109 Two Foxes 10cm/4"
110 Arctic Fox and Dead Cock 9·5cm/3¾"
111 Arctic Fox seated
112 Panting Fox
113 Standing Fox
114 Fox at a Fence
115 Fox lying down
116 Fox in a Snare 7·5cm/3"
117 Boar
118 Leaping Chamois 21cm/8¼"
119 Racoon killing a Duck
120 Cat and Kittens
121 Cat
122 Tufted Fowl
123 Hen
124 Rabbit in Repose
125 Rabbit Outstretched
126 Pair of Ducks 6·5cm/2½"
127 Duck and Ducklings 8cm/3¼"
128 Duck going forward
129 Duck drinking
130 Dead Duck
131 Group of Pigeons
132 Panther and Gazelle
133 Panther
134 Brazilian Jaguar
135 Algerian Gazelle
136 Desert Gazelle drinking

137	Pheasant going forward	144	Roebuck and Heron (panel)
138	Pheasant turning	145	Stag's Head (panel)
139	Standing Cock 14cm/5½″	146	Fox (panel)
140	Hare at rest	147	Hare and Pheasant (panel)
141	Partridge	148	Hare and Fish (panel)
142	Dead Partridge	149	Dead Cock (panel)
143	Nest of Squirrels	150	Dead Rabbit (panel)

MOIGNIEZ

1. Golden Pheasant 41cm/16½″
2. Pheasant 32cm/13″
3. Cock Pheasant frightened by a Stoat 49cm/19½″
4. Eagle 26cm/10″
5. Partridge 31cm/12½″
6. Partridge 19cm/7¾″
7. Two Partridges 21cm/8½″
8. Pair of Partridges and Young 37cm/15″
9. Partridge with ear of wheat 16cm/6½″
10. Godwit with Fish 20cm/8″
11. Heron strutting over rocks 86cm/34″ long
12. Heron with a struggling Frog 89cm/35½″
13. Dying Heron 35cm/14″
14. Wading Bird 53cm/21¼″
15. Ruff 24cm/9½″
16. Two Birds fighting 14cm/5¾″
17. Pair of Sandpipers 24cm/9½″
18. Sandpiper 25cm/9¾″
19. Two Birds 21cm/8½″
20. Dead Bird 6cm/2¼″
21. Pair of Polish Bantams 18cm/7″
22. Two small Birds and a Fieldmouse 10cm/4″
23. Two Swallows 18cm/7″
24. Turkey and Cock 21cm/8½″
25. Corncrake and Butterfly 29cm/11½″
26. Small Bird 12cm/4¾″
27. Lark 21cm/8¼″
28. Cock 13cm/5¼″
29. Quail with Mouse 12cm/5″
30. Pair of Quail 18cm/7″
31. Dead Snipe 19cm/7¾″
32. Snipe swooping 26cm/10½″
33. Pair of Snipe 16cm/6½″
34. Pointer and Setter 31cm/12½″
35. Pointer and Retriever hunting a Rabbit 35cm/14″
36. Pointer and Partridge 13cm/5″
37. Pointer looking at a Partridge 19cm/7¾″
38. Pointer and Partridge 28cm/11″
39. Pointer walking 29cm/11¾″
40. Pointer standing 23cm/9″
41. Long-haired Retriever catching the scent 36cm/14½″
42. Irish Setter 21cm/8¼″
43. Setter with Rabbit 19cm/7¾″
44. Setter in an enquiring attitude 29cm/11¾″
45. Standing Setter 23cm/9″
46. Greyhound 21cm/8½″
47. Greyhound and Hare 17cm/6¾″ long
48. Dachshunds hunting 10cm/4″
49. Terriers ratting 9cm/3½″
50. King Charles Spaniel 36cm/14½″
51. Basset Hound 48cm/19″
52. Thoroughbred Mare 'My Star' *(Mon Etoile)* 34cm/13¾″
53. Stallion 'Persan' 38cm/15″
54. Stallion with flowing mane and tail 34cm/13¾″
55. Mare and Stallion 33cm/13″
56. Carthorse
57. Horse attacked by Wolves 15cm/6¼″
58. Racehorse and Greyhound at Chantilly Racecourse 40cm/16″
59. Horse and Jockey, inscribed *'Avant la Course'* 25cm/9¾″
60. Boar Hunt – The Kill 58cm/23″
61. Boar Hunt 35cm/14″
62. Merino Ram 24cm/9½″
63. Ram, two Ewes and Young Sheep 41cm/16½″ (also known as individual pieces)
64. Ram and Ewe 29cm/11½″
65. 19cm/7¾″
66. Inkstand in form of a trough with two sheep (silvered bronze) 28cm/11″
67. Inkwell decorated with a Lion 14cm/5½″
68. *La Fontaine* – the fable of the Tortoise and the Hare

26cm/10½″
69 Hare with Cock and Hen
 19cm/7¾″

70 Hare *(Chasse Ouverte)*
 29cm/11½″

EDGAR DEGAS

The numbers given below are the serial numbers assigned to each bronze by Hebrard. It should be noted that these serial numbers do not correspond with the *exhibition* numbers adopted by Paul Bitry when cataloguing the bronzes for the 1921 Paris exhibition. In this exhibition the bronzes were grouped more logically, according to their subjects: dancers (1–37), horses (38–54), studies of women (55–68), miscellaneous (69–72). Vitry's arrangement has been followed by the majority of Degas exhibitions held since that time, but for the purpose of this appendix it is felt that the Hebrard numbering should be retained.

 4 Rearing Horse 30·5cm/12″
 10 Horse Walking 21cm/8¼″
 11 Horse Walking 22cm/8¾″
 13 Horse at Trough 16cm/6½″
 21 Study of a Mustang 22cm/8¾″
 22 Horse with head lowered 19cm/7¼″
 25 Horse with Jockey: horse galloping on right foot, the back left only touching the ground 24cm/9½″
 30 Draught Horse 10cm/4″
 32 Horse with Jockey; horse galloping, turning the head to right, the feet not touching the

ground 28·5cm/11¼″
 35 Identical to No. 25. Same dimensions
 36 Identical to No. 32. Same dimensions
 38 Horse Standing 29cm/11½″
 47 Horse Galloping on right foot 30cm/11¾″
 48 Horse clearing an obstacle 28·5cm/11¼″
 49 Horse Trotting, the feet not touching the ground 22cm/8¾″
 56 Prancing Horse 26·5cm/10½″
 66 Thoroughbred Horse Walking 13cm/5¼″

FRANÇOIS POMPON

The list of Pompon's works given below is based on the catalogue published by the *Musée des Beaux Arts de Dijon* (1964) whose numbering is retained. Where known the dates of execution are given. Except where otherwise stated the works in this list are bronze casts. Conversely the existence of sculpture in plaster, stone or terra cotta does not preclude the likelihood of it having been edited in bronze, though not preserved in the Dijon Museum in this form. The sculptures are grouped under wild animals, domestic animals, birds and miscellaneous, in chronological order.

 1 Dromedary 15cm/6″ 1906
 2 Giraffe 20cm/8″ 1907
 3 Bison 20cm/8″ 1907
 4 Pair of Moles (sketch model) plaster 13cm/5¼″ 1907
 5 Spotted Hyena (sketch model) plaster 17cm/6¾″ 1908
 6 Mole plaster 45cm/18″ 1908
 7 Chamois (sketch model) plaster 28cm/10¾″ 1913
 8 Hippopotamus stone 21cm/8¼″ 1918
 9 Striped Hyena (sketch model) plaster 17cm/6¾″ 1918
 10 Brown Bear (sketch model) plaster 10cm/4″ 1918

 11 Polar Bear (sketch model) patinated plaster 15cm/6″ 1920
 12 Polar Bear (marble reduction of the figure exhibited at the *Salon d'Automne*) 25cm/9¾″ 1922
 13 Polar Bear (sketch model) plaster 16cm/6½″ 1921
 14 Little Panther (sketch model) 15cm/6″ 1922
 15 Tigress giving a blow with her paw 25cm/9¾″ 1922
 16 Head of a Panther (sketch model) 13m/5¼″ 1924
 17 Large Panther (sketch model)

plaster 25cm/9$\frac{3}{4}$″ 1924

18 Large Panther plaster
 28cm/11″ 1925

19 Large Panther 22cm/8$\frac{3}{4}$″ 1925

20 Little Panther (sketch model)
 plaster 9cm/3$\frac{1}{2}$″ 1925

21 Panther stone 27cm/10$\frac{3}{4}$″ 1925

22 Boar 25cm/9$\frac{3}{4}$″ 1925

23 Seated Hare (sketch model)
 22cm/8$\frac{3}{4}$″ 1927

24 Seated Panther (sketch model)
 plaster 10cm/4″ 1927

25 Seated Panther (sketch model
 differing from No. 24) plaster
 10cm/4″ 1927

26 Sleeping Panther (sketch model)
 plaster 13cm/5$\frac{1}{4}$″ 1927

27 Panther (sketch model)
 10cm/4″ 1927

28 Panther at Play (sketch model)
 silver 8cm/3$\frac{1}{4}$″ 1927

29 Panther with raised Head
 (sketch model) 20cm/8″ 1927

30 Panther with lowered Head
 (sketch model) 21cm/8$\frac{1}{4}$″ 1927

31 Hind lying down (sketch model)
 plaster 5cm/2″ 1928

32 Young Hind with raised Head
 (sketch model) plaster
 22cm/8$\frac{3}{4}$″ 1928

33 Hind with lowered Head
 (sketch model) 15cm/6″ 1928

34 Stag (sketch model) plaster
 6·5cm/2$\frac{1}{2}$″ 1928

35 Stag original plaster model of
 the bronze exhibited at the
 Salon d'Automne, 1929 and
 now in the National Museum of
 Modern Art. A proof in bronze
 was taken from this model for
 the city of Arnhem in 1954.
 2·59m/102″

36 Stag (reduction of the
 preceding) 60cm/24″ 1929

37 Running Rabbit plaster
 57cm/22$\frac{3}{4}$″ long 1929

38 Rabbits running
 22cm/8$\frac{3}{4}$″ 1929

39 Large Panther 25cm/9$\frac{3}{4}$″ 1929

40 Hippopotamus (exhibited at the
 Colonial Exhibition) plaster
 1·92m/74″ 1931

41 Orang-utang head in black
 marble 35cm/14″ 1931

42 Wild Cat (sketch model) plaster

 19cm/7$\frac{1}{2}$″ 1932

43 Head of a Lion (sketch model)
 plaster 8cm/3$\frac{1}{4}$″ 1932

44 Lion resting (sketch model)
 plaster 3·5cm/1$\frac{1}{4}$″ 1932

45 Lion resting (sketch model)
 plaster 9cm/3$\frac{1}{2}$″ 1932

46 Standing Lion (sketch model)
 plaster 17cm/6$\frac{3}{4}$″ 1932

47 Standing Lion (sketch model)
 plaster 9cm/3$\frac{1}{2}$″ 1932

48 Standing Lion (sketch model)
 21cm/8$\frac{1}{4}$″ 1932

49 Elephant (sketch model) unique
 proof in bronze cast after
 Pompon's death
 30cm/12″ 1933

50 Rhinoceros (sketch model)
 15cm/6″ 1933

51 Fox's head wax relief
 10cm/4″ 1933

52 Dog 'Kaddour' seated
 (sketch model) 8cm/3$\frac{1}{4}$″ 1904

53 Basset Hound (sketch model)
 plaster 23cm/9″ 1906

54 Young Pigs pair of figures in
 terra cotta, both 5cm/2″ 1908

55 Piglet (sketch model) plaster
 2cm/$\frac{3}{4}$″ 1908

56 Piglet (sketch model) plaster
 3cm/1$\frac{1}{4}$″ (undated)

57 Sow (sketch model) terra cotta
 7cm/2$\frac{3}{4}$″ 1908

58 Sow (sketch model)
 7cm/2$\frac{3}{4}$″ 1908

59 Heifer silver 11cm/4$\frac{1}{2}$″ 1909

60 Calf silver 11cm/4$\frac{1}{2}$″ 1909

61 Yorkshire Hog 12cm/4$\frac{3}{4}$″ 1911

62 Sow (plate) plaster
 21·5cm/8$\frac{1}{4}$″ diameter 1911

63 Buck's head (sketch model)
 plaster 10cm/4″ 1913

64 Head of Goat (sketch model)
 plaster 5cm/2″ 1913

65 Bitch 'Nenette' (sketch model)
 plaster 11cm/4$\frac{1}{2}$″ 1920

66 Nenette (sketch model)
 9cm/3$\frac{1}{2}$″ 1920

67 Rabbit (sketch model) plaster
 13cm/5$\frac{1}{4}$″ 1920

68 Rabbit (sketch model) pewter
 13cm/5$\frac{1}{4}$″ 1920

69 Young Pig (sketch model)
 plaster 11cm/4$\frac{1}{2}$″ 1925

70 Young Pig (sketch model)

153

15cm/6″ 1925

71 Couple of Young Pigs (sketch model) plaster 5cm/2″ 1925

72 Head of a Cow (sketch model) plaster 12cm/4¾″ 1927

73 Cow 'Fleur d'Amour' plaster 25cm/9¾″ 1929

74 Sow and her Young high relief in stone 25cm/9¾″ 1929

75 Ram (sketch model) 13cm/5¼″ 1930

76 Plump Ox 13cm/5¼″ 1930

77 Stallion (sketch model) plaster 20cm/8″ 1930

78 Stallion (sketch model) plaster 8cm/3¼″

79 Stallion (sketch model) plaster 20cm/8″

80 Bull (sketch model) plaster 6cm/2½″ 1930

81 Bull, with ears forward (sketch model) plaster 23cm/9″ 1930

82 Bull (sketch model) 13cm/5¼″ 1930

83 Head of a Bull (sketch model) 17cm/6¾″ 1930

84 Seated Dog (sketch model) plaster 9cm/3½″ 1931

85 Dog lying in front of a tombstone (sketch model) plaster 5cm/2″ 1931

86 Bulldog 19cm/7½″ 1931

87 Foal (sketch model) plaster 17cm/6¾″ 1931

88 Bull 22cm/8¾″ 1931

89 Greyhound (sketch model) plaster 13cm/5¼″

90 Greyhound 24cm/9½″ 1932

91 Bull plaster 56cm/22¼″ 1932

92 Chickens (sketch model) plaster group, from 5cm/2″ to 11cm/4½″

93 Cayenne Chicken plaster 30cm/12″ 1906

94 Duck (bas-relief) plaster 14cm/5½″ 1907

95 Cock 29cm/11½″ 1907

96 Head of a Chicken (sketch model) terra cotta 21cm/8¼″ 1907

97 Head of a Cock (bas-relief) plaster 13cm/5¼″

98 Weather-cock 47cm/18¾″ 1908

99 Emu (sketch model) plaster

24cm/9½″ 1908

100 Young Goose walking 26cm/10¼″ 1908

101 Roman Pigeons (sketch models) plaster 27cm/10¾″ and 23cm/9″ 1908

102 Turtle-dove (sketch model) plaster 23cm/9″ 1908

103 Turtle-dove (sketch model) stone 20cm/8″

104 Turtle-dove limestone 25cm/9¾″ 1908

105 Young Plucked Cock running plaster 34cm/13½″ 1910

106 Head of a Chicken (sketch model) plaster 11cm/4½″ 1910

107 Nightingale holding a Fly (sketch model) plaster 15cm/6″ 1910

108 Duck (plate) plaster 21cm/8¼″ diameter 1911

109 Standing Duck 19cm/7½″ 1911

110 Duck on the water 16cm/6½″ 1911

111 Cock (plate) plaster 21cm/8¼″ diameter 1911

112 Turkeys (sketch models) plaster 8 and 19cm/3¼″ and 4″ 1911

113 Turkey (sketch model) silver 9cm/3½″ 1911

114 Young Turkeys (sketch models) plaster 7 and 8cm/2¾″ and 3¼″ 1911

115 Young Turkey (plate) plaster 21·5cm/8¼″ diameter

116 Young Turkey 25cm/9¾″ 1911

117 Chicken (plate) plaster 21cm/8¼″ diameter 1911

118 Waterhen (sketch model) plaster 8cm/3¼″

119 Waterhen 27cm/10¾″ 1911

120 Indian Hen with head raised plaster 27cm/10¾″ 1911

121 Cock (sketch model) terra cotta 7cm/2¾″ 1911

122 Chickens (sketch models) terra cotta 5 and 7cm/2″ and 2¾″ 1912

123 Chicken (sketch model) plaster 22cm/8¾″ 1912

124 Young Cock 26cm/10¼″ 1913

125 Cock and Hen mating (sketch model) plaster 3cm/1¼″ 1913

126 Coot 28cm/11″ 1913
127 Pelican (sketch model) plaster 18cm/7¼″ 1913
128 Group of Chickens (sketch model) plaster 3·5cm/1¼″ 1913
129 Group of Pullets (sketch model) plaster 3·5cm/1¼″ 1913
130 Little Rapace stone 18cm/7¼″ 1913
131 Owl 18cm/7¼″ 1913
132 Cock on a flag (sketch for the war memorial of Cuy-Saint-Fiacre) 12cm/4¾″ 1919
133 Cock on a flag as above, but in silver 9cm/3½″ 1919
134 Cock on a flag (plaster maquette for the memorial at Cuy-Saint-Fiacre) 10cm/4″
135 Parrokeet (sketch model) plaster 5cm/2″ 1919
136 Marabou Stork (sketch model) plaster 32cm/12¾″
137 Marabou Stork (sketch model) 16cm/6½″ 1921
138 Cranes (sketch models) plaster 17 and 18cm/6¾″ and 7¼″ 1921–27
139 Cocks (small studies for a clock by Paul Bablet) plaster and silver 9cm/3½″ 1922
140 Large Condor (plaster original of the figure on Pompon's tomb) 99cm/39″ 1923
141 Cock standing on one foot (sketch model) plaster 8cm/3¼″ 1923
142 Cock standing on one foot (sketch model) plaster 21cm/8¼″ 1923
143 Cock standing (sketch model) plaster 24cm/9½″ 1923
144 Cock sleeping (sketch model) plaster 25cm/9¾″ 1923
145 Sleeping Cocks (sketch models) bronze and silver 9cm/3½″ 1923
146 Partridge (sketch model) plaster 26cm/10¼″
147 Red Partridge 25cm/9¾″ 1923
148 Broody Hen (sketch model) plaster 3cm/1¼″ 1923
149 Chicken foraging (sketch model) plaster 20cm/8″ 1923
150 Couple of Chickens

(sketch model) plaster 5cm/2″ 1923
151 Chickens running in the rain (sketch models) bronze and silver 5·5cm/2¼″ 1923
152 Hocco 25cm/9¾″ 1924
153 Pelican (exhibited at the *Salon d'Automne,* 1924) 1·13m/44½″ Another example was cast for Arnhem in 1954
154 Swan (sketch model) plaster 12cm/4¾″ 1925
155 Peacock (sketch model) plaster 9cm/3½″ 1925
156 Peacock (sketch model) plaster 21cm/8¼″ 1925
157 Peahen (sketch model) plaster 17·5cm/6¾″ 1925
158 Spatule (sketch model) plaster 14cm/5½″ 1925
159 Owl (bas-relief) plaster 34cm/13½″ 1926
160 Crowned Crane 1·08m/42½″ 1926
161 Homing Pigeon 31cm/12½″ 1926
162 Pigeon 'Nicolas' 30cm/12″ 1936
163 Fighting Cock (sketch model) silver 18cm/7¼″
164 Fighting Cock 53cm/21″ 1927
165 Pigeon (sketch model) plaster 11cm/4½″ 1927
166 Pigeon (sketch model) silver 12cm/4¾″ 1927
167 Tumbler Pigeon plaster 29cm/11½″ 1927
168 Tumbler Pigeons (sketch models) plaster 16 and 24cm/6½″ and 9½″ 1927
169 Pair of Pigeons (sketch model) plaster 6cm/2½″
170 Pair of Pigeons (sketch model) silver 5·5cm/2¼″
171 Large Horned-Owl 52cm/20½″ 1928
172 Crow (sketch model) plaster 8·5cm/3¼″ 1929
173 Crow 38cm/15¼″ 1929
174 Ara (sketch model) plaster 13cm/5¼″ 1930
175 Ara plaster 86cm/34½″ 1930
176 Ducks on the water (sketch models) plaster 5 and 6cm/2″ and 2½″ 1932
177 Duck taking to flight

(sketch model) plaster
16cm/1932

178 Ara (last sketch model) plaster
32cm/12¾″ 1933

179 Golden Pheasant (last finished
work) polished bronze
44cm/17½″ 1933

180 Pheasants (sketch models)
plaster 6 and 9cm/2½″ and 3½″
1933

181 Hen Parrot rose-tinted marble
37cm/14¾″ 1933

182 Little Bird (sketch model)
plaster 8cm/3¼″ 1933

183 Lucane (sketch model)
terra cotta 5cm/2″ 1874

184 The Broken Egg marble
8cm/3¼″ 1892

185 Snail (sketch model) plaster
5cm/2″ 1927

186 Snail (small sketch model)
plaster 3cm/1¼″ 1927

REMBRANDT BUGATTI

1 Small Elephant walking
29cm/11½″
2 Small Elephant at rest 16cm/6½″
3 Elephant at Rest 22cm/8½″
4 Elephant at Play
5 Baby Elephant and Camel
26cm/10½″
6 Baby Elephant 16cm/6½″
7 Young Stag 32cm/12¾″
8 Two Stags 45cm/18″
9 Stag 48cm/19″
10 Two Fawns 23cm/9″
11 Fawn 34cm × 28cm/13½″ × 11″
12 Fawn 49cm/19½″
13 Fawn 34cm × 37cm/13½″ × 15″
14 Two Antelopes
15 Gazelle 37cm/15″
16 Jabirou
17 Panther walking 29cm/11¾″
18 Panther crouching 24cm/9½″
19 Small Panther
20 Two Panthers 38cm/15¼″
21 Walking Leopard 19cm/7½″
22 Leopard at rest
23 Two Leopards in file
24 Puma
25 Seated Jaguar 19cm/7½″
26 Great Tiger
19cm × 54cm/7½″ × 21¼″
27 Tiger 43cm/17″
28 Tiger 28cm/11″
29 Nubian Lion 16cm/6½″
30 Lioness 30cm/12″
31 Crouching Lioness 13cm/5½″
32 Lioness with kill 16cm/6½″
33 Royal Buffalo
34 Giraffe
35 Monkey with a carrot
36 Monkey holding a ball
37 Baboon
38 Rhinoceros 41cm/16½″
39 Zebra and Antelope
40 Bear 20cm/8″
41 Baby Goat 29cm/11¼″
42 Percheron Horse
43 French Bulldog 13cm/5¼″
44 Two Hogs 16cm/6½″
45 Gnu 34cm/13½″
46 Tapirs 30cm/12″
47 Bison 40cm/16″
48 Ostrich 40cm/16″
49 Ostrich bending its head
13cm/5″
50 Cock and Frog 25cm/10″
51 Secretary Bird 32cm/13″
52 Pelican scratching
53 Pair of Pelicans 29cm/11¾″
54 Stork 43cm/17¾″
55 Vulture 36cm/14¼″
56 Three Cassowaries 42cm/16¾″

FREDERIC REMINGTON

The bronzes by Remington were registered by him for copyright purposes. Thus it is possible to give not only the title in each case but also Remington's own descriptions and the dates of registration. Unfortunately the measurements of the bronzes are given in only one or two cases.

1 The Bronco Buster. "Equestrian statue of cowboy mounted upon and breaking in wild horse standing on hind feet. Cowboy holding onto horse's mane with left hand while right hand is extended upwards." 1st October, 1895.

2 The Wounded Bunkie. "Two horses in full gallop, side by side. Each horse carries a cavalryman, one of whom has been wounded and is supported in

his saddle and kept from falling by arm of the other trooper." Edition of 14. 9th July, 1896.

3 The Wicked Pony. "Shows a cowboy who has been thrown and is lying flat on the ground, holding onto bronco's ear with left hand. The bronco is lashing out with hind legs." 3rd December, 1898.

4 The Scalp. "Represents a mounted Indian reining up his horse as he triumphantly holds aloft a scalp which he has taken from a defeated enemy." 10th December, 1898.

5 The Norther. "Cowboy on horseback in snow storm. Severe wind blowing from the rear. Both man and horse almost frozen." Edition of 3. 2nd July, 1900.

6 The Cheyenne. "Indian on pony galloping with all four feet off the ground. Indian grasps spear in left hand and has war shield hung on his back." 21st November, 1901. *Two versions exist of this bronze.*

7 The Buffalo Signal. "Equestrian statue of Indian on pony with head held high and right front foot raised. Indian holds aloft a buffalo robe on a pole and has a gun across his lap." Unique edition. 17th December, 1901.

8 Coming Through the Rye. "Bronze group of four cowboys on running horses. Men shooting pistols and shouting. Men represented as being on a carousel." 8th October, 1902.

9 The Mountain Man. "Man on horse coming down mountain side. Man fitted out with traps, knife, gun, cup, powder horn, etc." 10th July, 1903.

10 Sergeant. "Bust of Rough Rider Sergeant (*sic*), height from bottom of base to rim of hat 10 inches. Stern face, sharp nose, heavy moustache, prominent chin, cheeks somewhat sunken, hat tilted on back of head. Handkerchief around neck." 30th July, 1904.

11 Polo. "Group of three horses and riders in game of polo. One horse has fallen and rider is caught under him. The second horse and rider are leaping directly over the fallen man. Third horse is standing with two hind legs upon the belly of fallen horse." 21st July, 1904.

12 The Rattlesnake. "Bronze group of cowboys on bronco—twenty inches high to top of head or rider. Rattlesnake on ground ready to attack horse. Horse shying and in a position denoting fright. Forefeet both in air." 18th January, 1905. *Two versions of this bronze.*

13 Bronco Buster. Similar to No. 1 but in a larger scale. 1905.

14 Dragoons—1850. "Two Dragoons and two Indians on horses in running fight. One single horse without rider in lead. Foremost soldier with raised sword in right hand ready to strike foremost Indian who is protecting himself with spear and shield." 6th December, 1905.

15 Paleolithic Man. "Being a representation of a human figure bordering on an ape, squatting and holding a clam in right hand and a club in left hand." 30th June, 1906.

16 The Outlaw. "Cowboy on a pitching bronco horse, same jumping in air and balanced on 'off' forefoot only. Cowboy leaning back with hand down on side of horse." 3rd May, 1906.

17 The Horse Thief. "Nude Indian on horse holding buffalo skin with right arm as a protection. Buffalo robe flying in air. Horse running with three legs in air." Total height 30 inches, total length 27 inches. 22nd May, 1907.

18 The Buffalo Horse. "Bronze group 36 inches high of a bull buffalo reared on hind legs with a pony on his right shoulder being tossed and above all the Indian rider being hurled upward with hands and one toe in contact with pony." 12th December, 1907.

19 The Fairmount Park Cowboy. "A bronze equestrian statue of cowboy on a Spanish horse. Reigning sharply up, squatted behind—right front leg off ground. Cowboy thrown slightly forward away from saddle." 27th April,

157

1908.

20 The Savage. "A bronze head of an Indian with long hair parted in middle, shells in ears and a wry expression on face. Total height 11 inches." 14th December, 1908.

21 Trooper of the Plains – 1868. "A U.S. Cavalry Soldier, with drawn revolver, on a running horse, all feet off the ground and supported by sage brush. 27 inches high, on base 20 inches long by 7½ inches wide." 13th January, 1909.

22 The Stampede. "Bronze groups of stampeding cattle with mounted cowboy in their midst." 13th April, 1910.

23 Indian Dancer. "Full figure of Indian dancer wearing ceremonial attire of elaborate bustle, belts of bells around ankles and below knees, wand in hand and decorative head-dress." (no date given).

Select Bibliography

Alexandre, Arsène *A. L. Barye* (Librairie de l'Art, Paris, 1889)

Ballu, Roger *L'Oeuvre de Barye* (Paris, 1890)

Beiz, Jacques de *E. Frémiet un Mâitre Imagier* (Paris, 1896)

Bellier de la Chavignerie *Dictionnaire Général des Artistes de l'Ecole Emile and Auvray, Louis Francaise* (Librarie Renouard, Paris, 1885)

Bellier de la Chavignerie, Émile & **Auvray, Louis** *Dictionnaire General des Artistes de l'École Française* (Librairie Renouard, Paris, 1885)

Bénézit, E. *Dictionnaire critique et documentaire des Peintres, Sculpteurs Dessinateurs et Graveurs* – 8 vols. (Librairie Gründ, Paris, 1923–55)

Bonnefon, P. *Rosa Bonheur* (Paris, 1905)

Brodzky, Horace *Henri Gaudier-Brzeska* (Faber, London, 1933)

Caffin, Charles H. *American Masters of Sculpture* (Doubleday, New York, 1913)

Champeaux, A. de *Dictionnaire des Fondeurs, Ciseleurs, Modeleurs en Bronze et Doreurs* (Librairie de l'Art, Paris, 1886)

Ciechanowiecki, Andrew *The Animliers* (in Antiques International London, 1967)

158

Crevel, Réné *Renée Sintenis* (Klinkhardt and Biermann, Berlin and Leipsiz, 1930)

De Kay, Charles *Barye* (Barye Monument Association, New York, 1889)

Des Courières, Edouard *Francois Pompon* (Librairie Gallimard, Paris, 1926)

Dijon, Musée des Beaux-Arts *Francois Pompon: Sculpteur animalier Bourgignon* (1964)

Fauré-Frémiet, Philippe *Frémiet* (Librairie Plon, Paris, 1934)

Getlein, Frank *Harry Jackson* (Kennedy Galleries, New York, 1969)

Grant, Col. Maurice H. *A Dictionary of British Sculptors* (Rockliff, London, 1953)

Grolier Club of New York *Exhibition of Bronzes and Paintings by Antoine Louis Barye* (New York, 1909)

Guillaume, Eugène *Catalogue des Oeuvres de Barye* (Maison Quantin, Paris, 1889)

Hird, Frank *Rosa Bonheur* (Bell's Miniature Series of Painters, London, 1904)

Horswell, Jane K. (1) *The Animaliers*
(2) *The Animaliers II*
(3) *The Animaliers: Barye to Bugatti*
(4) *The Horse in Bronze*
(5) *The World's Wildlife*
(Sladmore Gallery, London, 1968–70)
Bronze Sculpture of 'Les Animaliers' Reference and Price Guide (Antique Collectors' Club, Clopton, Woodbridge, Suffolk, 1971)

Kiel, Hanna *Renée Sintenis* (Rembrandt-Verlag, Berlin, 1956)

Klumke, A. *Rosa Bonheur, sa vie, son oeuvre* (Paris, 1908)

Lami, S. *Dictionnaire des Sculpteurs de l'École Française au XIXs* (Paris, 1914)

Lapelle de Bois-Gallais, F. *Biography of Mlle Rosa Bonheur* (Paris, 1856)

Louvre, Musée du *Barye: Sculptures, Peintures et Aquarelles* (Editions des Musées Nationaux, Paris, 1957)

McCracken, Harold *Frederic Remington: Artist of the Old West* (Lippincott, New York, 1947)

Maillard, Robert (ed) *A Dictionary of Modern Sculpture* (Methuen, London, 1962)

Peyrol, R. *Rosa Bonheur: her life and work* (The Art Annual, London, 1889)

Proctor, Hester Elizabeth *Alexander Phimister Proctor, Sculptor in Buckskin* (University of Oklahoma Press, 1970)

Read, Herbert *A Concise History of Modern Sculpture* (Thames & Hudson, London 1964)

Rewald, John *Edgar Dégas: Works in Sculpture* (Pantheon Books, New York, 1944)

Saunier, Alfred *Barye* (Librairie Plon, Paris, 1925)

Savage, George *A Concise History of Bronzes* (Thames & Hudson, London, 1968)

Schiltz, Marcel *Rembrandt Bugatti* (Société Royale de Zoologie d'Anvers, 1955)

Silvestre, Theophile *Histoire des Artistes Vivantes* (Paris, 1857)

Skeaping, John *Les Sources de l'Art: Les Animaux* (Editions Pierre Amiot, Paris, 1968)

Smith, Charles Sprague *Barbizon Days* (Hutchinson, London, 1903)

Stanton, Theodore *Reminiscences of Rosa Bonheur* (1910)

Taft, Lorado *American Sculpture* (Macmillan, various edns 1903, 1924 and 1930)

Thieme-Becker *Allgemeines Lexikon der bildenden Kunstler* (Leipzig, 1933)

Index